Smashing Pots

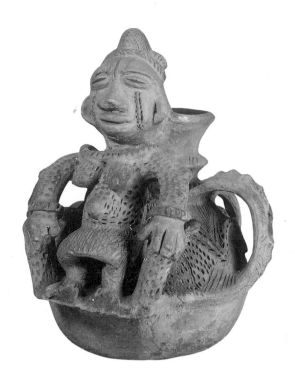

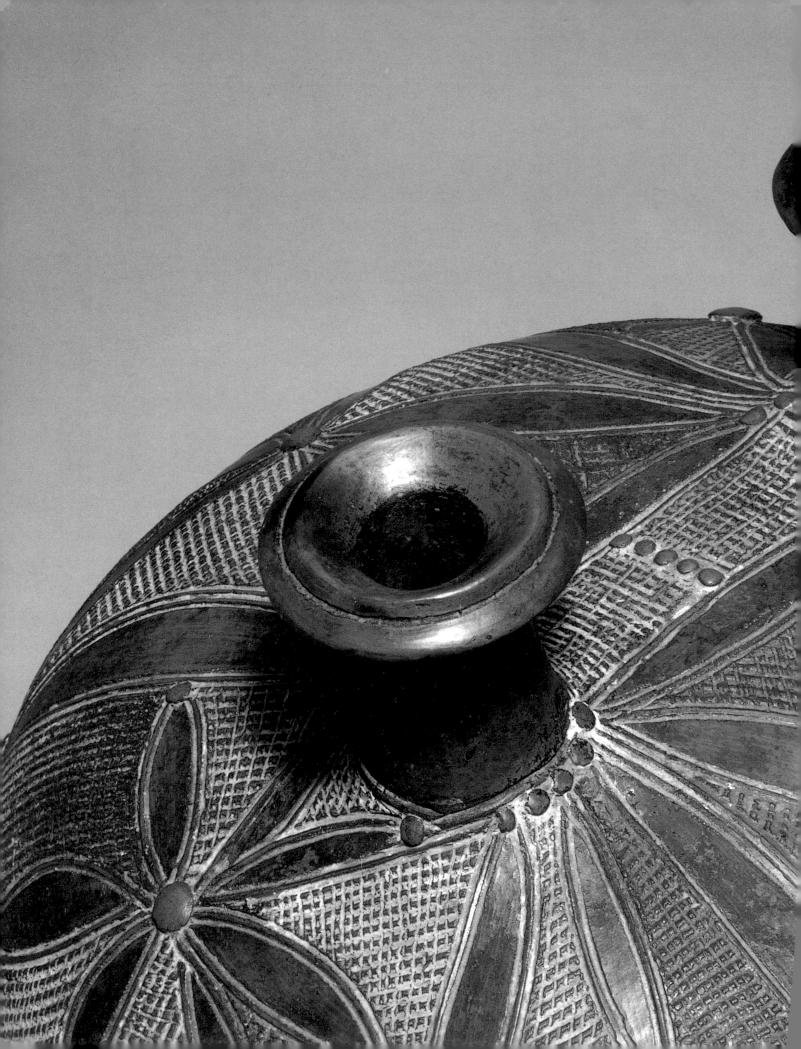

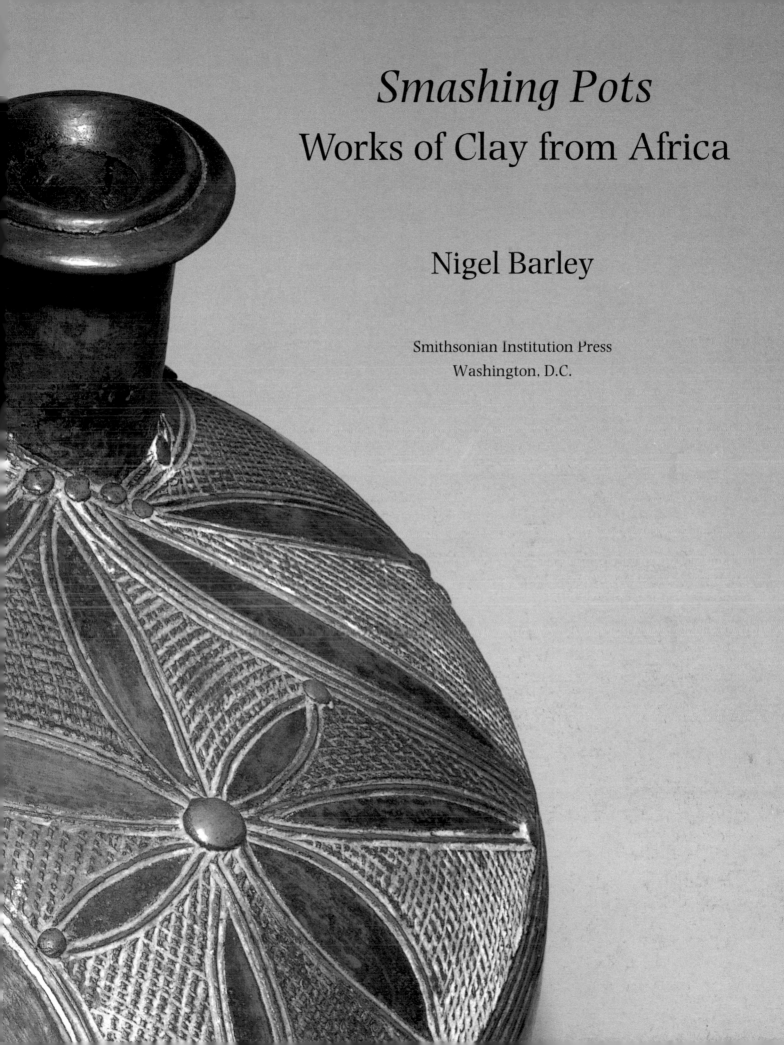

Smashing Pots
Works of Clay from Africa

Nigel Barley

Smithsonian Institution Press
Washington, D.C.

Published in the United States of America
by Smithsonian Institution Press

ISBN 1-56098-419-8

Library of Congress Catalog
Number 94-65294

First published in Great Britain
by the British Museum Press 1994

Designed by Roger Davies

Photography by David Agar

Phototypeset by Southern Positives and
Negatives (SPAN), Lingfield. Surrey

Printed in Italy by
New Interlitho SpA, Milan

Front cover Pedestal cup and a stirrup-
necked pot. Sotho people, Lesotho
(see p.26).

Back cover Water vessel in the form of
a cockerel from Sudan (see p.152).

Half-title page Pot with moulded and
incised decoration. Edo people, Benin,
Nigeria (see p.83).

Title page Burnished pottery vessel.
Probably Ekoi people, Southern Nigeria
(see pp.10–11).

This page Red pottery water vessel.
Bagirmi people, Chad (see p.100).

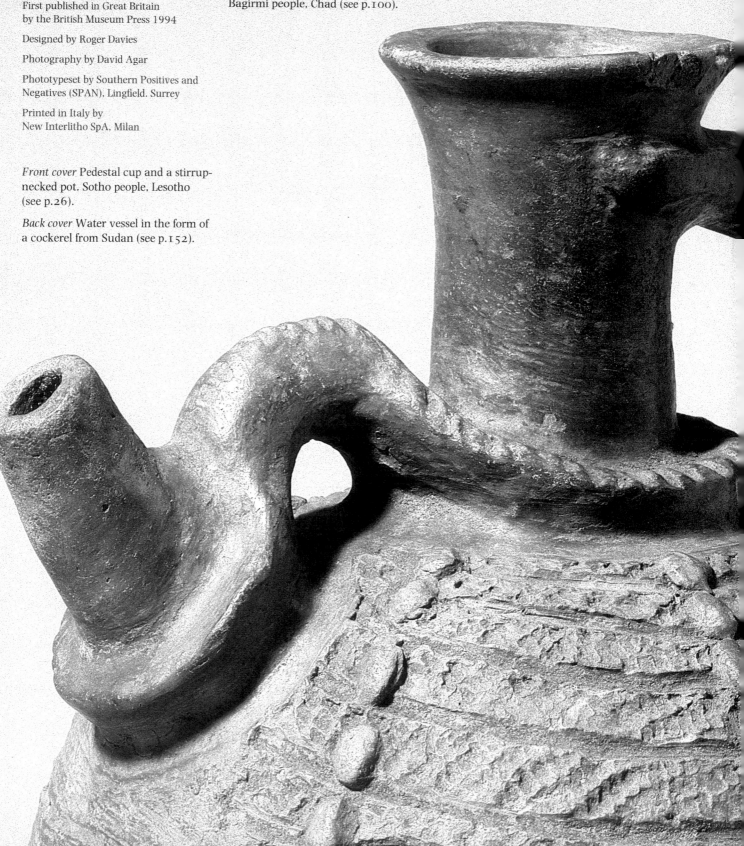

Contents

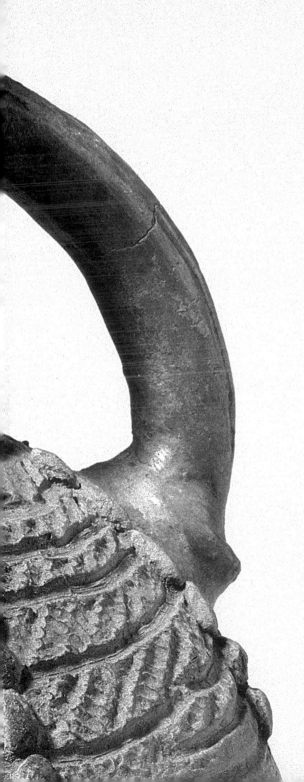

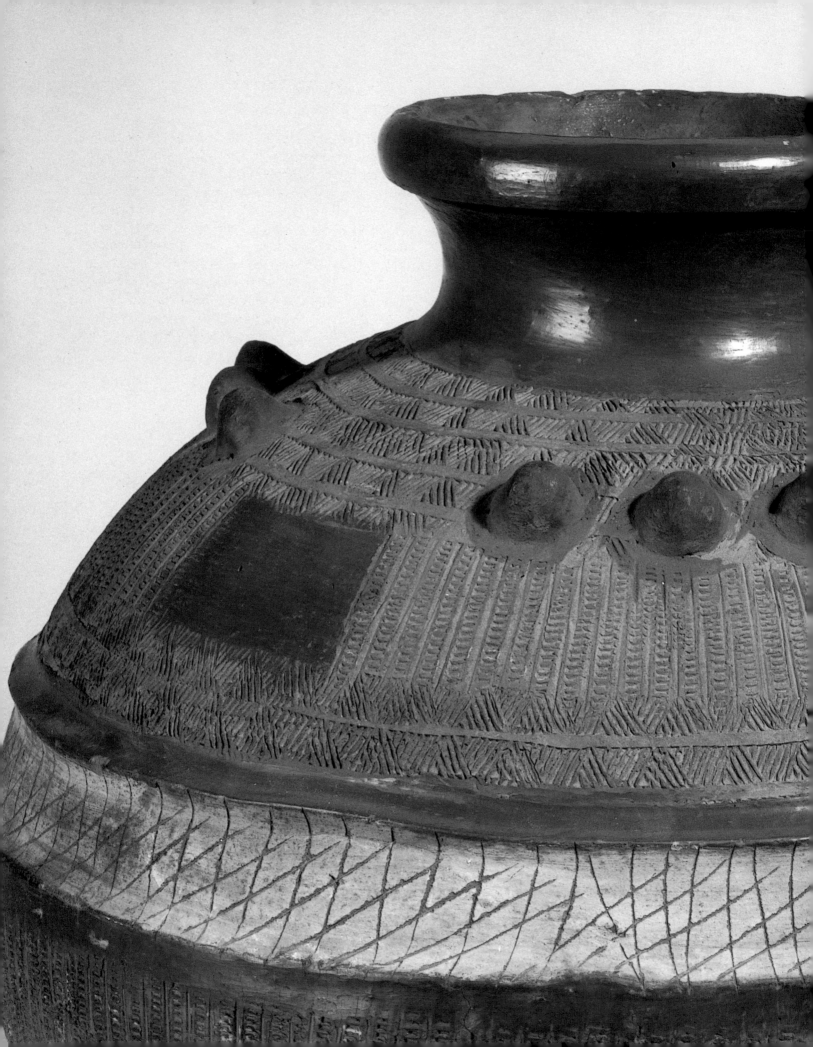

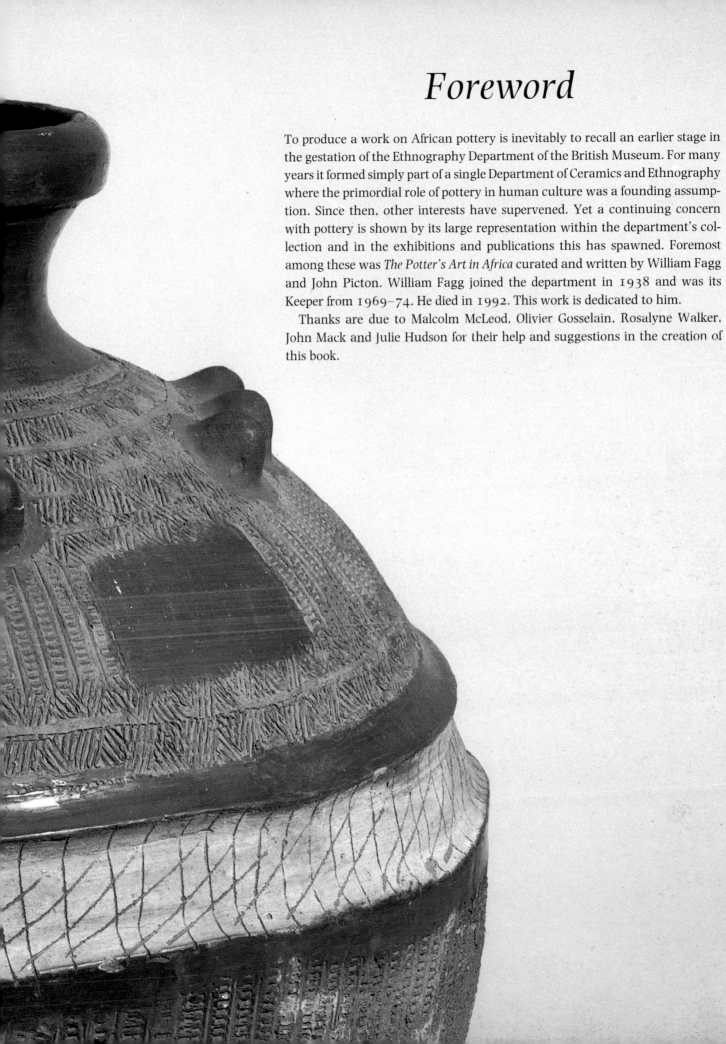

Foreword

To produce a work on African pottery is inevitably to recall an earlier stage in the gestation of the Ethnography Department of the British Museum. For many years it formed simply part of a single Department of Ceramics and Ethnography where the primordial role of pottery in human culture was a founding assumption. Since then, other interests have supervened. Yet a continuing concern with pottery is shown by its large representation within the department's collection and in the exhibitions and publications this has spawned. Foremost among these was *The Potter's Art in Africa* curated and written by William Fagg and John Picton. William Fagg joined the department in 1938 and was its Keeper from 1969–74. He died in 1992. This work is dedicated to him.

Thanks are due to Malcolm McLeod, Olivier Gosselain, Rosalyne Walker, John Mack and Julie Hudson for their help and suggestions in the creation of this book.

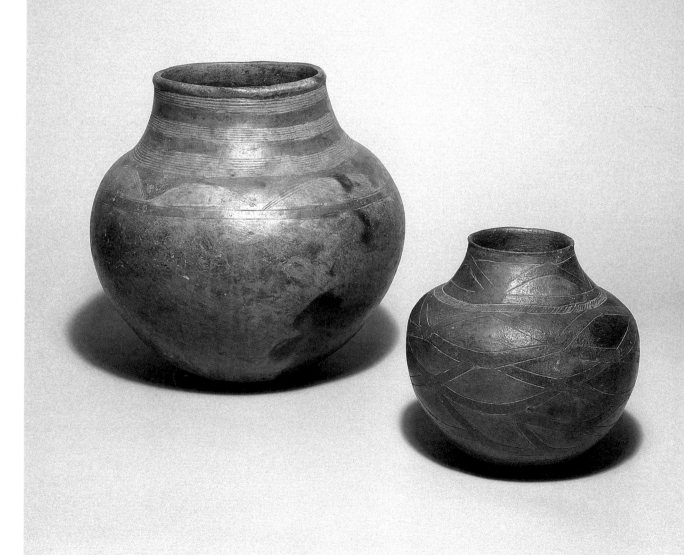

Introduction

In Africa, pottery[1] is part of everyday experience. In urban homes, it may seem as if traditional pots are everywhere being displaced by modern vessels of aluminium, enamelware and plastic or more informal containers scavenged from Western-style industrial packaging. Pottery is seen as dramatically endangered. It is probably more than a coincidence that it is this 'disappearing' pottery that is the latest African artefact to enter the Western art market. The beauty, elegance and ingenuity of African pottery are beginning to gain wider appreciation just as the sales catalogues announce its imminent extinction.

But this is not a new phenomenon. In the nineteenth century, European visitors to West Africa were struck by the inroads made by imported crockery into the local pottery trade. They were particularly exercised by the use of Western chamber pots for the serving of food and the enthusiasm of coastal peoples for Staffordshireware and blue Venetian glass. Even benevolent colonial interest in local craft did not help. After examples of Elmina (Ghana) pottery were sent to the 1925 British Empire exhibition the local market was flooded with cheap European-made enamel copies and domestic production virtually destroyed.[2] Since then, the disappearance or complete re-invention of the African pot has been confidently predicted on numerous occasions.[3] Yet even in modern urban markets, earthenware pots jostle mugs, kettles and yam-steamers imported from China and Japan and in certain contexts they are the only possible vessel. Pots are practical and above all cheap and easily replaced. Over the whole continent, indigenous production is enormous and probably increasing.[4] Pottery is now known and used even by pygmy and San groups as well as many of the classic transhumant cattle-raising peoples of eastern and southern Africa who traditionally disdained it (Drost, 1968:135).

Pottery is also amongst the oldest arts of mankind. In Kenya it is documented since the upper Paleolithic era and in Saharan sites has been dated to the eighth millenium BC. In Nigeria, it is traceable at least until the early fourth millenium BC.[5] Being one of the most enduring materials, the contribution of pottery to our general knowledge of the past is second to none. Archaeology without potsherds is unthinkable.

It is true that the archaeological study of pottery in Africa has not produced great insights into ways of life or movements of peoples[6] and this book will concern itself more with the present and the 'ethnographic present' than the past. For it seems that stylistic provinces and periods of prehistoric African pottery are so large and vague as to seem almost mythical. Recent – largely illegal – excavations in Jenne (Mali) and Koma (Ghana) have done little to redress this situation but show the enormous archaeological riches still awaiting systematic exploration. It is to be expected that pottery will play a major role in the reinterpretation of African prehistory that is long overdue. Yet while the ancient cultures of Sao, Jenne and Igbo-Ukwu have all produced excellent pots, they have been largely overlooked in the Western enthusiasm for bronze-casting and sculptural terracotta.

Even in Europe, while we have a primordial Stone Age, and revolutionary Iron and Bronze Ages, there is no glamorous Pottery Age. Instead, we have whole ethnicities named after the shape of their pots and Beaker People still confidently stalk the pages of European prehistory. From the almost infinite

Left Large buff pot, *ndondo*, used for beer or water, with incised and red slip decoration. On the *right* is a round pot incised with latticework and coloured with red, black and yellow slip. Lozi people, Zambia. H. 23.5 cm, W. 15 cm. 1953.Af10.7. Presented by B. Carp Esq. 1940.Af9.15. Presented by F. Worthington Esq.

Double-spouted, burnished, pottery vessel. Probably Ekoi people, Southern Nigeria. This pot was collected in Southern Nigeria in the 1920s. The incised designs and simulated studs recall those of Ekoi calabashes and brasswork. Chalk has been rubbed into the cross-hatching for contrastive effect, a technique frequently used on calabashes from this area. H. 27 cm, W. 30 cm. 1971.Af23.1. Presented by Rev. J. Slater.

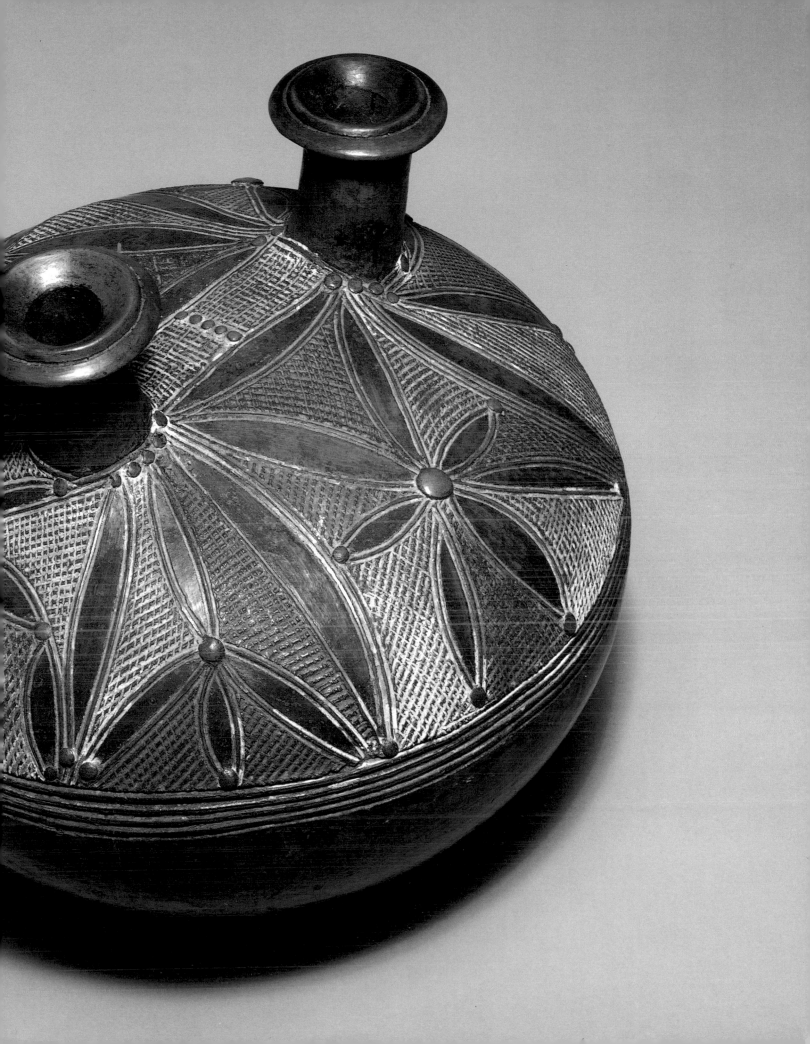

Right Pottery impaled on a grave marker. The markers at the rear are of carved wood and recall the heads of animals killed by a man and the pots used to make hunting medicine. Tonj, Bongo people, Sudan. Photo: J. Mack.

Left, above Drinking beer through straws from a communal pot. Butsotso-Kavirondo people, Kenya. Photo: Dr. Wagner.

Left, below Potter's compound at Kano, Nigeria. Photo: B. Fagg.

Overleaf Bowls of dried clay and dung made by unmarried girls of the Nuba people, Jebel Kadero, Sudan. They are unfired and merely dried in the sun before decoration with natural colours. Their recorded use as containers for perfumed herbs and grain suggests that they are locally classed as calabashes, whose form they imitate, rather than fired pottery. H. 11 cm, D. 28 cm; H. 14 cm, D. 30 cm; H. 15 cm, D. 33 cm. 1948.Af6.2, 3, 5. Presented by N. Corkill Esq.

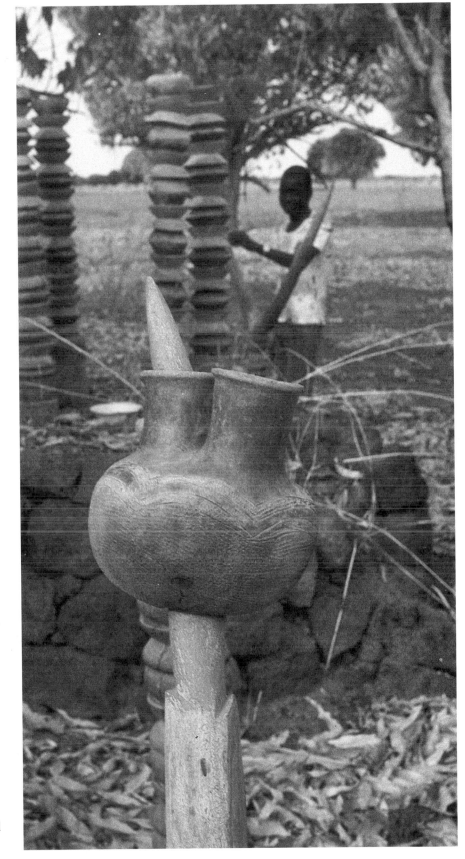

Potters on their way to market. Zarandu mountains, Bauchi, Nigeria.
Photo: W. Gray.

Below Pots in a woman's cooking hut. Gbaya people, Cameroon.
Photo: Cambridge University Expedition.

possibilities offered by clay, each culture has opted to develop only a few and so pottery becomes the embodiment of style and the key to studies of diffusion.[7] The presumption of the inward-looking domesticity of pots is written – in advance – into the archaeological maps so that metals are cast in a techno-innovative role while pots are conservative and passive bearers of culture. It is but a small further step to link metallurgy with men and pottery with women as indeed many Africans do.

Such shared official ideologies of African villagers and Western archaeologists show that humble pots are involved in other levels of culture than the practicalities of everyday life and enter into maps of human knowledge. They lend themselves to the embodying of power relations.

In Africa, as we shall see, they also provide models for thinking about the human body, the seasons of the year, processes of procreation and reincarnation. They are, as Levi-Strauss would say, eminently 'good to think'. In his own (1988) study of Amerindian potting, Levi-Strauss explores the mythical relationships between potting and the cooking of food and indeed the nature of mythology itself. While his conclusions are not directly applicable to African material they go some way towards showing how deep are the cultural roots of the simple potter.

No single book can comprehensively survey pottery over such a vast and ethnographically diverse area as Africa. Coverage is necessarily very partial and most examples are drawn from the collections of the Museum of Mankind (the Ethnography Department of the British Museum) whose large holdings provide what is still a very patchy archive. Even so, comparison requires one to paint with a broad brush so that it is difficult to avoid an almost nineteenth-century disregard for time and place. I attempt to counterbalance this by constant reference to specific examples in specific cultures so that this book becomes to some degree also a guide to some of the major pieces in the British Museum collection. Illustrations and captions deal with particular pots and seek to nail generalisations to concrete examples.

Figurative terracotta sculpture is not included, except incidentally, for in Africa it raises questions that place it outside the concerns of this book. Nevertheless, it has proved impossible to exclude it utterly since African pots may incorporate human figures or indeed be blatantly anthropomorphic while representational figures may be regarded as acting as containers of powers. The line between a pot and a sculpture is very much a matter of local definition. Also untreated here are the unfired vessels for the storage of grain, so pervasive in North Africa. South of the Sahara they are usually replaced with mud buildings although these too may have much in common with the techniques of potting and be conceptually closely related.

Shallow white bowl with brown,
geometric pattern, and white, double-
handled bowl with brown geometric
pattern. Berber people, Rif, Morocco.
D. 18 cm, W. 21 cm. 1979.Af1.22.
H. 16 cm, W. 21 cm. 1917.12–4.1.
Presented by Lieut. G. Adams.

1

The Techniques of Potting

Pottery vessel with incised decoration and beaten metal ornament. Nupe people, Nigeria. Pots such as this are for the transport of water. The present vessel had a metal lid, now missing. H. 40 cm, W. 31 cm. Af1990,17.1.

The most striking fact about African potting is the sheer simplicity of the raw materials required. Using earth, a few stones or pieces of calabash, a twig or corn stalk, and some firewood, largely unnamed African potters[8] create objects of enduring and breathtaking beauty and absolute utility. The primary tool is the experienced human hand.

A number of basic factors bear on the ways in which pots are made. Suitable clay is widely distributed over Africa with, it is said, the exception of the central Kasai area of Zaire.[9] In Africa, clay comes largely from secondary alluvial deposits, a significant fact in the symbolic placing of the material since it associates it with water.

Clay is rarely suitable for use as found and must undergo treatment prior to being formed. In many areas (Ghana, Kenya, Angola) much of this preliminary processing is done by termites whose mounds are excavated for worked clay. Various techniques are used to alter the plasticity and chemical composition of the material.[10] Lumps and stones have to be picked out and clay may have to be dried and pulverised or weathered and puddled by the addition of water so that coarser material falls to the bottom of the pit. Pounding and kneading give it the right homogeneous consistency and remove trapped air that would expand on firing and burst the pots. Occasionally (Nupe, Luba) this will be done with the wooden pestles and mortars otherwise used for grain. Potting in Africa has little of the genteel craft associations of modern European potting. It is hard physical labour.

Often other material is mixed in with the clay to provide the correct quality for potting. In Africa, grog – ground-down broken pottery – may be added to reduce the stickiness of the clay before forming, or dung, ash, straw and sand – even mussel shells (Dyula) – may be used.[11] This reduces the water content of the clay, making handling easier and preventing shrinkage and cracking during drying and firing.[12] The low firing temperature of most pottery and the coarseness of its constituent structure means that it can be placed directly on the fire without risk of cracking. This characteristic of African pots was noted by early European travellers though the reason was not understood.[13]

Fuel used in firing varies widely. Straw or wood may be the basic combustible material, sometimes bark may be needed to increase the temperature of combustion or green vegetation may be required to damp down heat and create a reducing (oxygen-poor) environment. Many African clays contain iron oxides and a reducing environment changes its colour from red to black. In North Africa, especially in Fes, a favoured fuel for final firing is the residue left after oil has been extracted from the olive. This burns at a very high temperature. In parts of North East Africa, dung may be the main fuel for potting as it is for cooking. Among the Luo of Kenya, papyrus is used.

A number of different techniques may be used in the shaping of the pot itself. A fundamental distinction is often drawn between potters using a potting wheel and those working without. In fact, the line is difficult to maintain, being one of relative speed and the application of centrifugal force as opposed to manual pressure to draw up the walls of the vessel. While fully developed wheels are only found in an urban North African setting,[14] many potters use a roundel – often the bottom or neck (Igbo) of a broken pot or a basket of wet leaves (Ovim-

Pottery vessel. Hausa people, Northern
Nigeria. This is a water-jar in a basic
design widely distributed over Africa
that combines extreme simplicity and
elegance. The bottom of the vessel is
covered with a red slip which makes it
waterproof. Incised grooves in the
unburnished area around the neck allow
evaporation through the clay that cools
the contents. H. 41 cm, W. 34 cm.
1946.Af18.381.

Opposite Red pottery vessel with metal
lid, ornament and stand from
Omdurman, Sudan. This is a coffee pot,
gebana, made for formal serving of
guests. H. 17 cm (including stand),
W. 11 cm. 1958.Af7.1. Presented by
Mrs. G. Barter.

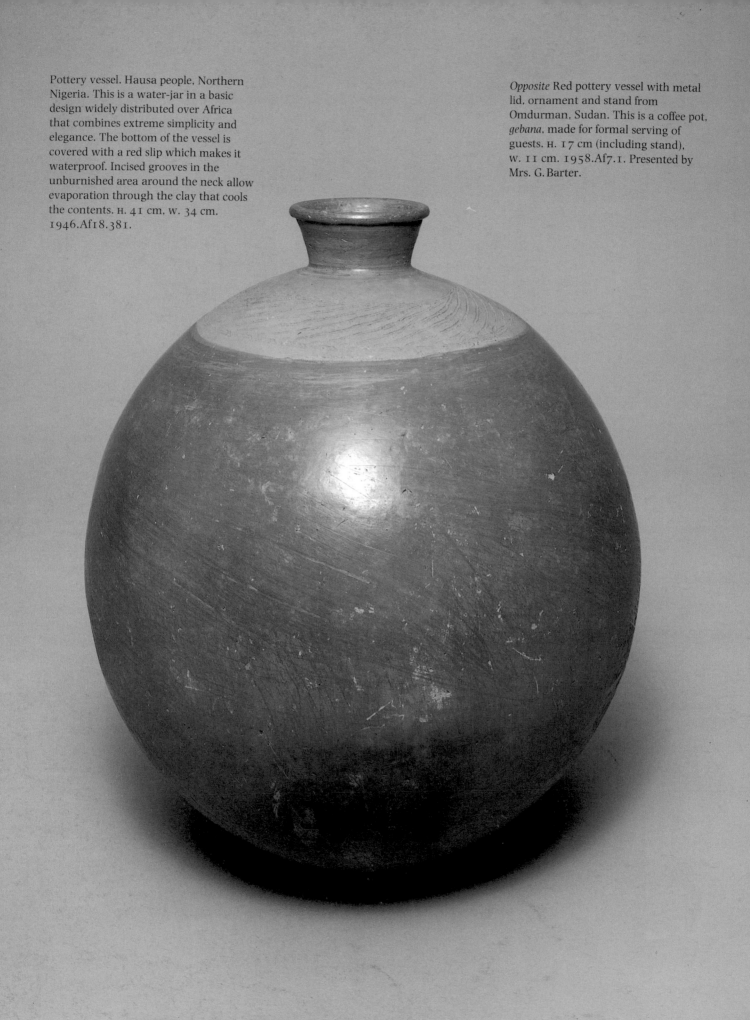

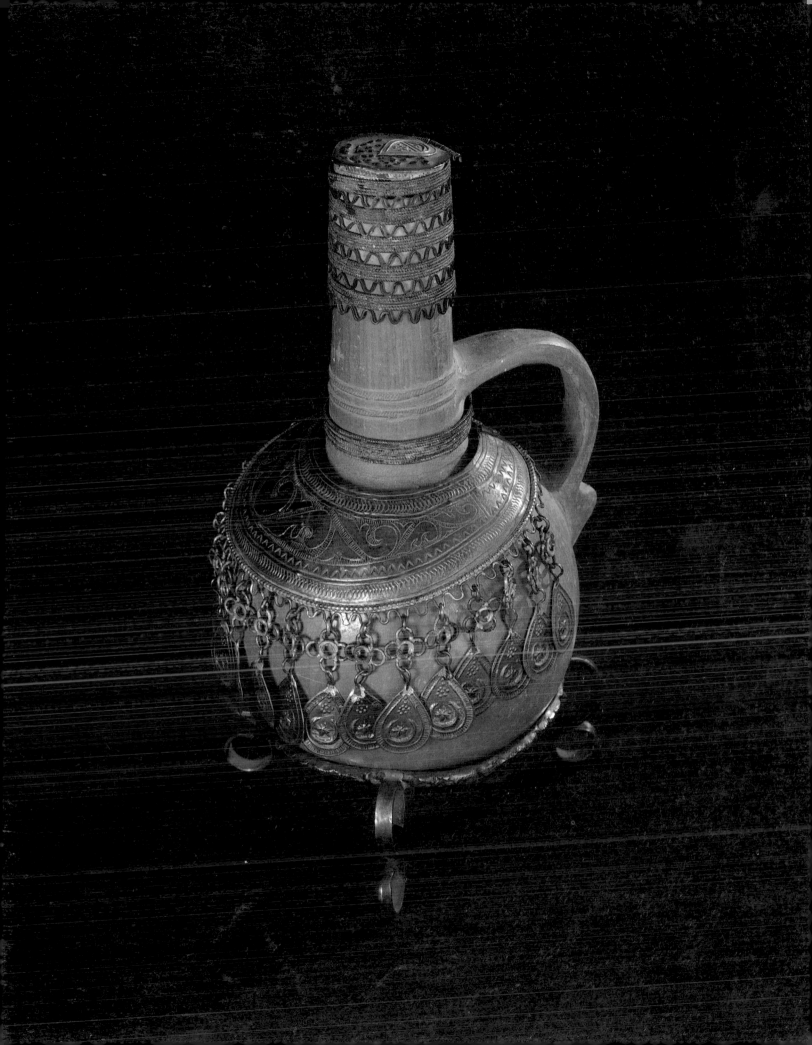

Spherical water-pot with long ridged neck and incised decoration. Abarambo people, Zaire. H. 32 cm, w. 16.5 cm. 1954.+23.3061. Presented by the Trustees of the Wellcome Historical Medical Museum.

bundu) – as the base for their pots which may be turned by hand during form-ing. Elsewhere, special clay (Mossi) or wooden (Fang) supports may be made on which to seat the clay as it is turned and worked.

Even in urban North Africa, there is great variation in the process of forming with everything from electric through foot-propelled to hand-turned wheels. Rotation is implicit in all pots. Fast wheels require a moister, finer clay which in turn cannot be fired at low temperatures and has not the thermal tolerance of low-fired pots. Potting wheels tend, therefore, to be associated with the build-ing of kilns but not vice versa.

A prevalent technique is by pulling. A ball of clay is placed on a broken pot base and one side is simply pulled and squeezed upwards as the centre is hollowed out. The roundel is turned and the process repeated. The wall of the pot may be scraped against a 'rib' – any hard object will serve – while it is supported on the inside by the other hand. Thus, the walls are compressed and built higher. Unless further finishing is carried out such pots tend to show vertical striations. This technique is used, for example, by the Lobi (Burkina Faso), the Asante (Ghana) and the Fon (Republic of Benin).

Alternatively, clay may be rolled into sausages which will be coiled into a spiral. The body of the pot may be rotated as the coils are flattened and squeezed together or they may be simply laid spirally over a mould. In the case of larger pots, the potter will retreat backwards, walking round the pot as each new section of the coiled structure is added. Pots made by this technique usually show residual spiral patterning on the inside since this surface receives less final

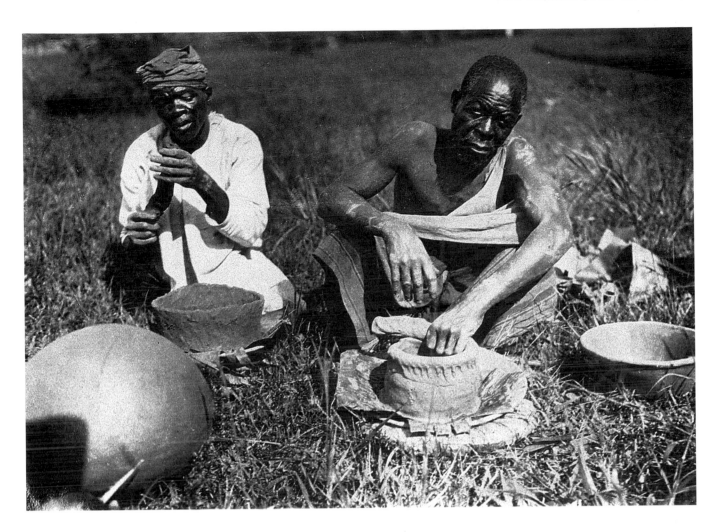

Above Ganda potters using the coil technique. Entebbe, Uganda.
Photo: H. Braunholtz.

Urban potter using a foot-powered wheel. Safi, Morocco. Photo: N. Barley.

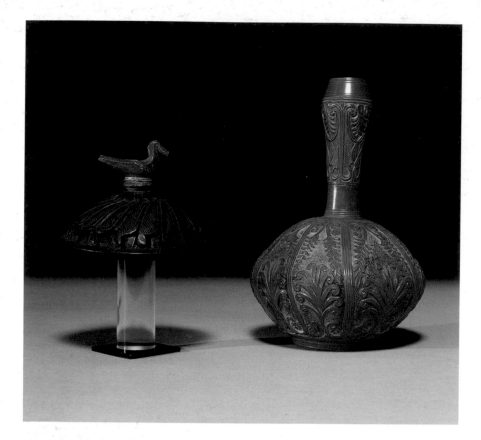

Left Lid of vessel in black clay, with a red bird attached by a screw thread and a red, wheel-turned pottery flask with incised floral motifs, both made in Egypt in the nineteenth century. H. 9 cm, D. 12 cm. 3396. H. 22 cm, W. 14.5 cm. 5968. Presented by J. Henderson Esq.

Right Rectangular, red water-pot, *moringo*, on a pedestal base. Manjako people, Cachungo, Guinea-Bissau. H. 35 cm, W. 20 cm, L. 23 cm. Af1989,5.46.

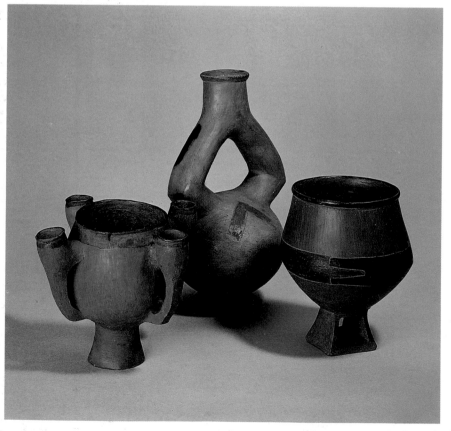

Left, from left to right Pedestal cup with four supplementary spouts, decorated with Reckitt's blue; stirrup-necked pot of yellow clay with red slip chevron; and pedestal vessel for beer drinking with black and red slip decoration on a square base. Sotho people, Lesotho. *Left and right* H. 20.5 cm, W. 17 cm. 1954.+23.3126. H. 18 cm, W. 19.5 cm. 1954.+23.3123. Presented by the Trustees of the Wellcome Historical Medical Museum. Centre H. 33 cm, W. 20 cm. 1970.Af10.11. Presented by Mrs. Blair.

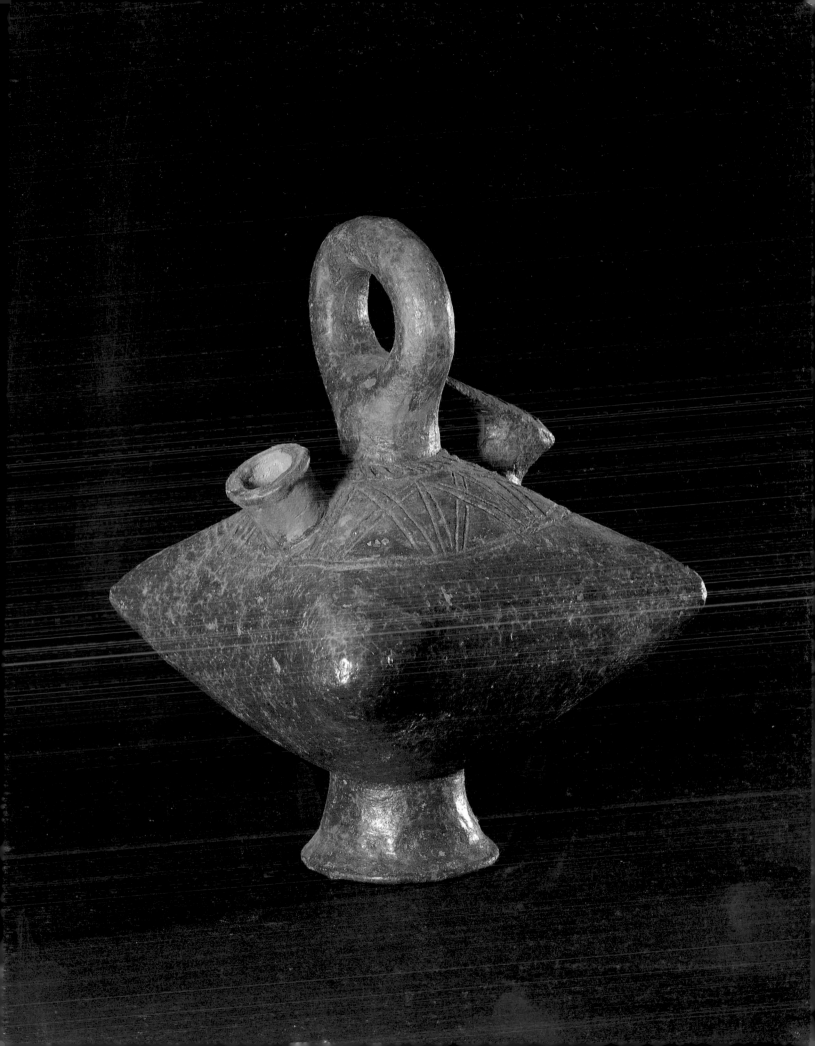

smoothing than the outside. This technique is used by the Dan (Liberia), the Edo (Nigeria) and the Fang (Gabon) to name just a few. A further variation is that pots may be formed upside down, that is from the rim up. Such is the case with certain Yoruba potters (Nigeria) and the Kamba of Kenya. A variant is to build up pots from rings of clay that are subsequently smoothed together (Lobi, Ekoi).

It is often not clear from the literature whether the different sexes pot in the same posture. Thus, it seems to be the case that in some cultures women frequently form the pot between splayed legs while men do not. The 'sexuality' of the resulting female pot may be marked in this way. In contemporary Morocco it is immediately clear that 'traditional' and 'modernising' urban potters have entirely different postures and techniques of the body. Traditionally, these have been developed to allow the handling of pottery at different stages of decoration without leaving fingermarks. They involve the whole body in the production process in a way that contrasts strikingly with the methods of the modern co-operative whose workers sit at a table working at arm's length.

Clay may be beaten using a paddle and anvil technique. This normally requires rather dry clay so that it may be necessary to use a different, wetter

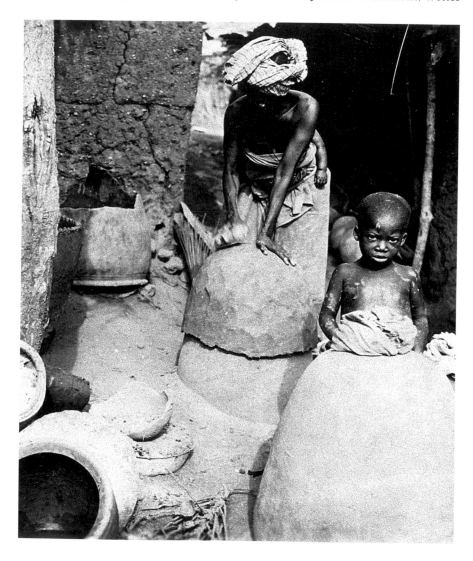

Yoruba potter moulding a dye-vat by beating clay over another pot. Abeokuta, Nigeria. Photo: H. Braunholtz.

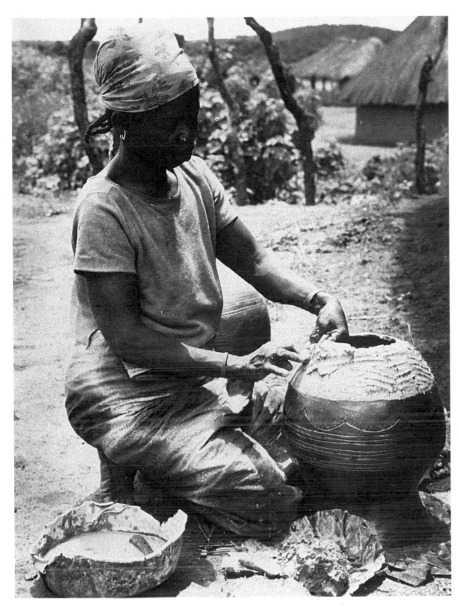

Building a pot upside-down. The top of this pot has already been smoothed, dried and decorated. Now the potter forms the bottom, gradually adding clay until the aperture is closed. Gbaya people, Meiganga, Cameroon. Photo: Cambridge University Expedition.

clay for the hand-forming of the necks of the vessels. A hard smooth surface supports the clay from behind while it is beaten with a flat implement or the hand from the other side. Curiously, it is predominantly the interior surface that is beaten with the passive anvil on the outside. As a technique, it is less common than pulling or coiling. It is used, for example, by the (male) Hausa potters of Sokoto (Nigeria) but may be found widely in Africa coupled with any of the other techniques. Often it involves the use of a mould, as among the Zaghawa and Berti of Sudan and the Mossi (Burkina Faso), and a special beater of fired clay.

The mould may be made of any suitable material, concave or convex, sometimes another pot, sometimes the potter's knees (Tikar) but most commonly a layer of clay is let into a depression in the floor of the house or yard. The mould is in the form of a segment of a sphere. As soon as one part of the pot has been formed, it is slid upwards as the potter completes the next section. Gradually,

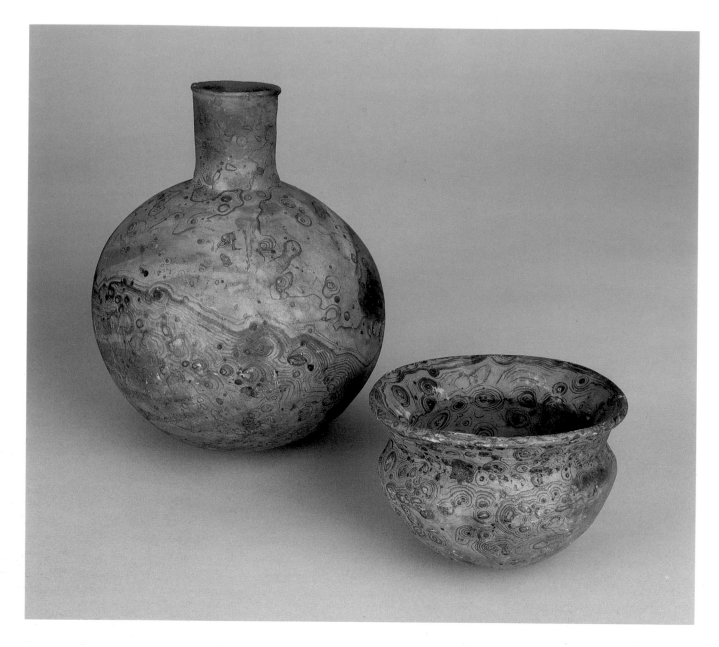

Above Pots with marbled effect from the Lower Congo. Several related peoples near the mouth of the River Congo make pots of this kind from an unusual pale yellow clay. The surface decoration is achieved by splashing a thick infusion of resinous vegetable matter on to the pots while still hot so that it boils off unevenly.

This form of decoration is peculiar to pottery. It is perhaps significant that body designs in this region are shared with basketry and woven mats (Laman, 1953:69). H. 24 cm, W. 20 cm; H. 11 cm, D. 15 cm. 1910.10–26.1 and 3.

Right Large pottery vessel with multiple spouts. Bagishu people, Uganda. Pots such as this are used by Bagishu elders for beer drinking. Each participant inserts a drinking-straw in a mouth of the vessel. H. 43 cm, W. 37 cm. 1939.Af25.7. Presented by Mrs. K. M. Trowell.

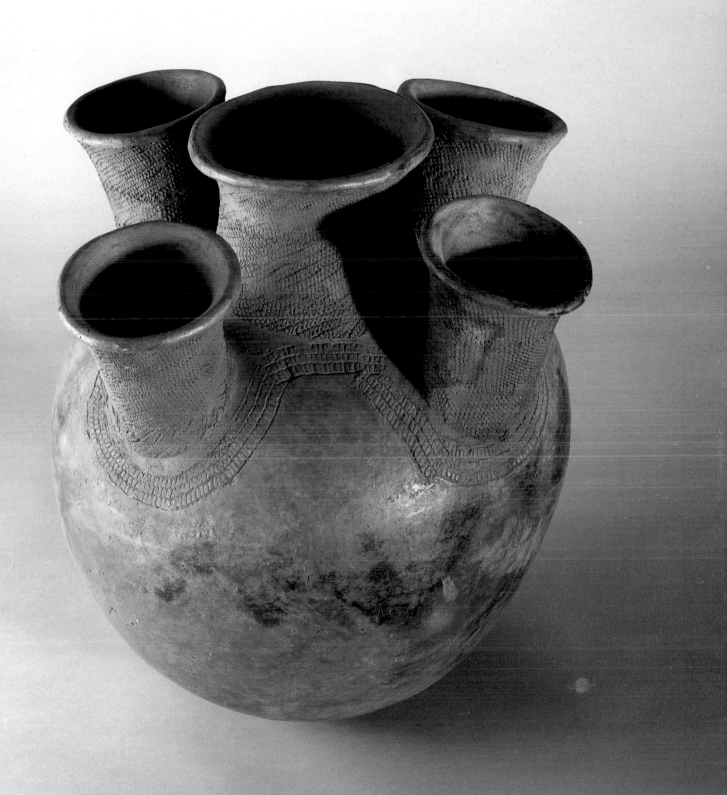

almost a complete sphere is formed and a neck can be added to the small aperture left. Such pots are extremely thin and symmetrical. These techniques are used by northern Mossi women (Burkina Faso), southern Mossi men, the Dogon (Mali) and the Marghi of the Nigeria-Cameroon border. The Tiv (Nigeria) form a flat-bottomed pot first by drawing up its walls and only impart the final smoothing and round base by beating in a mould. Often the process is reversed so that the original base may be beaten and the rest of the pot formed upon it. An unusual technique of the Chokwe (Zaire) is to form the clay into a cylinder that will be stood upright while the top is hollowed out and decorated. The bottom is then beaten shut.

Such technology has often been characterised as 'primitive'. It is striking, however, that it suffices to produce pots of more uniform thickness and with greater rapidity than could be made using a wheel.[15] The compressed walls combine maximum strength with minimum weight. Like much else in Africa, it is just complicated enough.

Elsewhere, the convex outside of a pot is commonly used. It is dusted with dry sand and spread with a sheet of wet clay to form a half-sphere. This is allowed

Karamajong water carriers, Uganda.
Photo: E. Wayland.

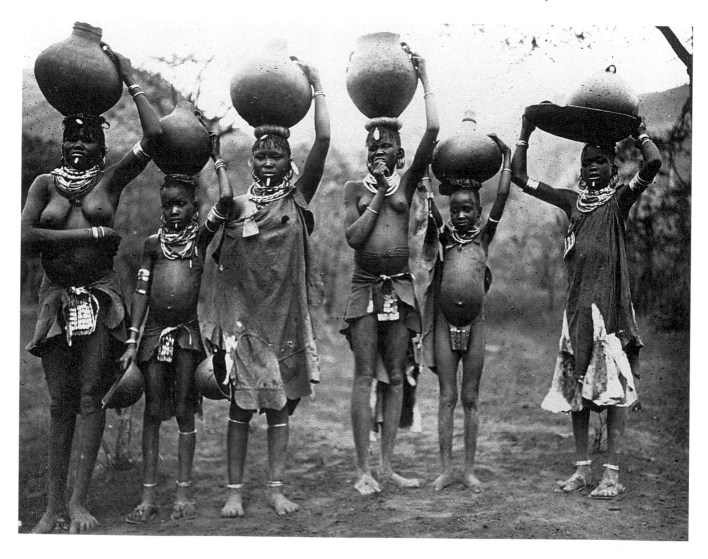

to dry before being removed. The pot may then be built up higher using other techniques and a rim may be added. This method is found amongst Yoruba and Nupe potters (Nigeria) as well as many other peoples.

In North Africa and Nigeria slip moulds are found. These may well be made from pots that have been formed by hand so that irregularities are reproduced, making them difficult to distinguish from hand-made pots. A thin clay suspension is poured into the moulds which absorb large quantities of water so that clay is deposited around the edges. Excess clay is poured off, the mould is opened and the pot can be hand-finished. Such techniques are typical of the modernising pottery co-operatives that have been set up alongside traditional potters in Fes and Safi.

Large pots may have to be made in separate sections that are subsequently married together. Quite often rims, handles and other attachments will be made individually and joined later or the body of the pot alone will be dried before such elements are tacked on in fresh clay. A curious technique in nineteenth-century Egypt was to marry together complex pieces, such as potlids or candlesticks, from already baked pieces with screw threads.

In much of Africa, pots are predominantly round-bottomed and are stood either in depressions in the ground or on rings. Alternatively, a hearth may be incorporated into their design. Round bottoms considerably increase strength and spread heat evenly when pots are used for cooking over the traditional three-stone African hearth. Where pots are not required to stand on tables and other hard surfaces, a round bottom has the advantage that the pot can be set at any angle convenient to the user. Occasionally pots have slightly conical bases that fit snugly in the gap between neck and raised arm for carrying. The traditional round, sub-Saharan water-jar balances easily on the head. Its narrow neck gives a good handhold and cuts down loss during transport. Evaporation through the unglazed surface keeps its contents cool even on the hottest day.

Many of the features of pots correlate with the way in which they are formed. Thus, Balfet (1984:171–98) shows that the coiling method tends to produce continuous curves without the breaks in profile that mark wheel-made pottery. Moreover, in coiled pots, apparently irregular features such as handles often lie on the arc of a circle that encompasses all the secondary additions of the pot.

Most pots in sub-Saharan Africa will be decorated before firing. In North Africa pots may be fired twice, once before decoration and once after, and the kiln is divided in two to provide a different temperature for pots at different stages.

The beauty of much African pottery derives from its stark simplicity and functional efficiency. Yet what Europeans perceive as surface 'decoration' may occur in many forms. The outside will often be burnished, polished with leather, leaves, beads, pebbles or other hard objects to give a compact, shiny surface or the vessel may be dipped in slip, a thin suspension of clay that gives a smoother finish or contrasting colour effects. Occasionally both processes are combined (Yoruba). Rubbing with oil or animal fat before or after baking helps reduce porosity but it occasionally falls to the purchaser to render the pot waterproof after purchase (Ethiopia).

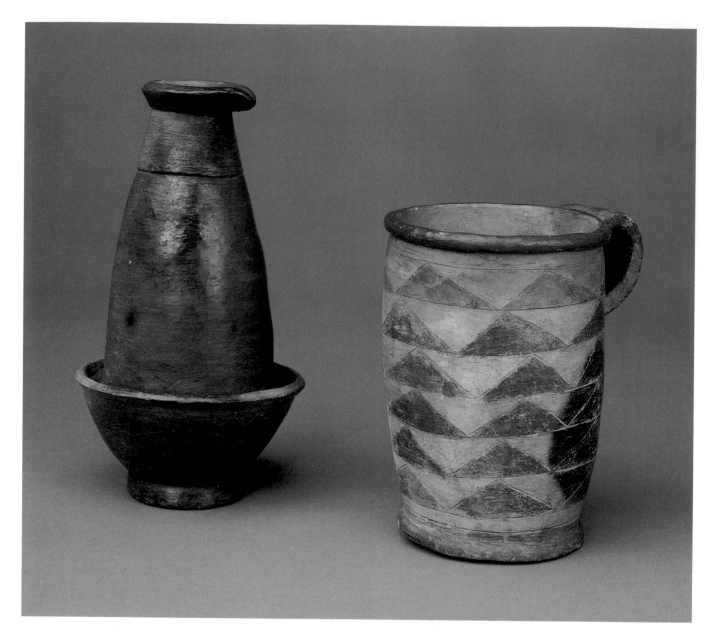

Above Tall jug without handles, with red and white slip decoration, and a mug of yellow clay with a pattern of red triangles. Lozi people, Zambia. H. 23.5 cm, W. 13.5 cm. 1947.Af7.10. Presented by Mrs. Wharton. H. 17 cm, W. 16.5 cm. 1924–7.

Right Elaborate, coloured pottery vessel with lid, *randa*. Hausa people, possibly Kano. The vessel is exuberantly decorated with strapwork and francolins (?) and has a pierced pedestal base. It has been dipped in a suspension of lime before painting. Black and purple colours have been used – probably ink or imported dyes. Containers of this form are used by Muslim Hausa as water-pots at weddings and other festivals. Neighbouring non-Muslims use them as beer containers. Increasingly they are being redesigned to appeal to the tourist market (Kandert, 1974:119).

Leith-Ross (1970:22) states that such vessels are purely decorative and may be given to a bride, the birds being interpreted as bringing luck. H. 53 cm, W. 44 cm. 1951.Af25.1.

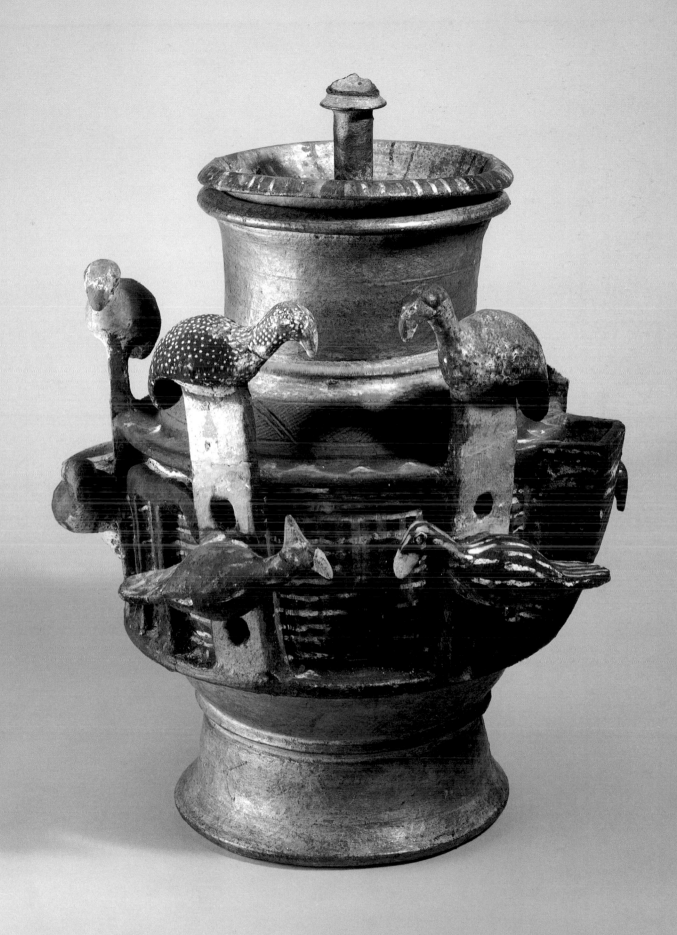

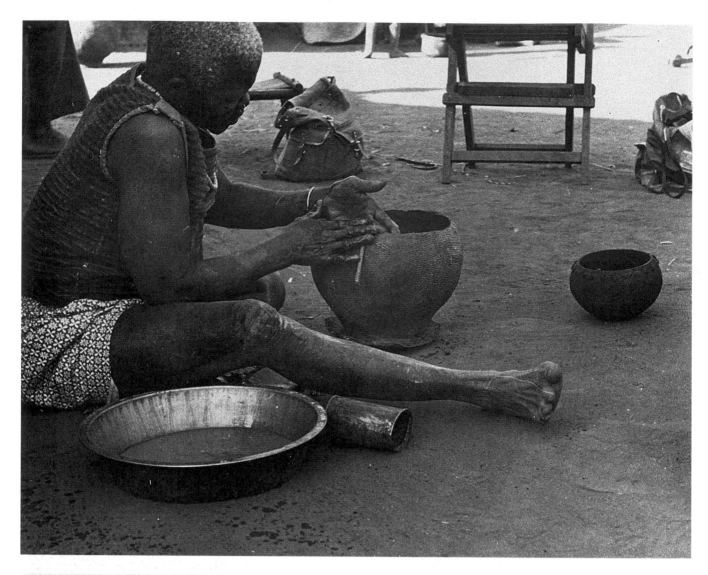

Moru potter applying a pattern to her pot with a roulette. Sudan.
Photo: J. Mack.

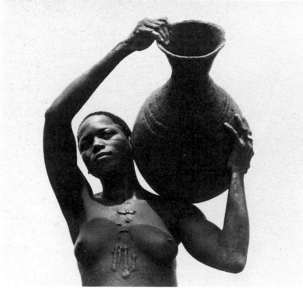

Woman of the Chip people with a water-pot. Plateau State,
Nigeria. Photo: E. Denfield.

All manner of patterns may be impressed into the surface of the pot before firing. Usually this occurs after a preliminary drying. The Zulu are unusual in scratching patterns on already fired vessels. The Dogon, however, form pots by a paddle and anvil technique that leaves the imprint of mats on their surface since a mat is used to prevent the clay sticking to the mould. Important pots may have to be carefully smoothed to remove this 'decoration'.

An extraordinary diversity of objects may be employed to imprint pattern. Feathers, grass, textiles, baskets, thorns, shells, nets, bracelets, twigs, nails, pieces of calabash, carved and woven roulettes, string, fruits, corncobs, bones and, of course, fingers are recorded as being used. Corbeil (1942:29) records the use of a bicycle gear wheel to flute the rims of pots in Guinea. In Egyptian and old Moroccan pottery, stamps may impress patterns into the damp clay. Altern‑atively applied decoration may be added to the body. In Africa, this may range from rounded pellets of clay to complete high-relief animal and human figures. The Igbo of Nigeria perhaps show the greatest range of these techniques, employing figures and incised lines and often sculpting pots into great swirls of raised ridges.

Rarely, pots may be completely pierced – as in North African lamps where holes are carved in spherical vessels to create Koranic texts whose shadows stand out against the light and are cast upon the walls.

True glazes are again limited to urban North Africa. In Morocco, the distinc-

Pots being stacked on wood and covered with grass in northern Nigeria. Photo: B. Fagg.

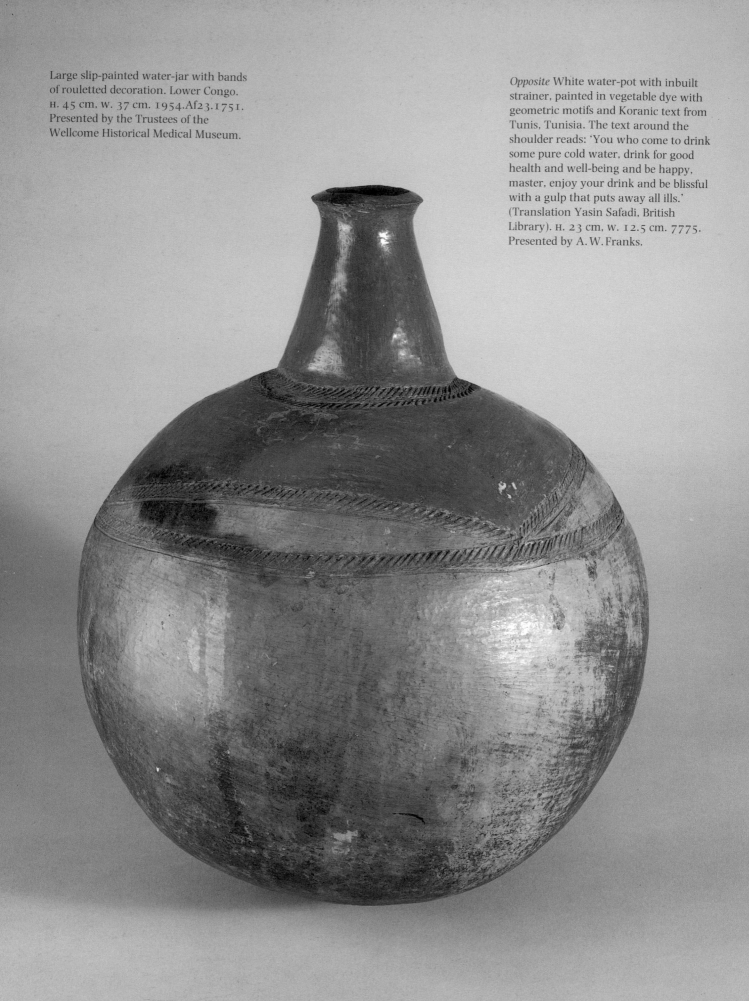

Large slip-painted water-jar with bands
of rouletted decoration. Lower Congo.
H. 45 cm, w. 37 cm. 1954.Af23.1751.
Presented by the Trustees of the
Wellcome Historical Medical Museum.

Opposite White water-pot with inbuilt
strainer, painted in vegetable dye with
geometric motifs and Koranic text from
Tunis, Tunisia. The text around the
shoulder reads: 'You who come to drink
some pure cold water, drink for good
health and well-being and be happy,
master, enjoy your drink and be blissful
with a gulp that puts away all ills.'
(Translation Yasin Safadi, British
Library). H. 23 cm, w. 12.5 cm. 7775.
Presented by A. W. Franks.

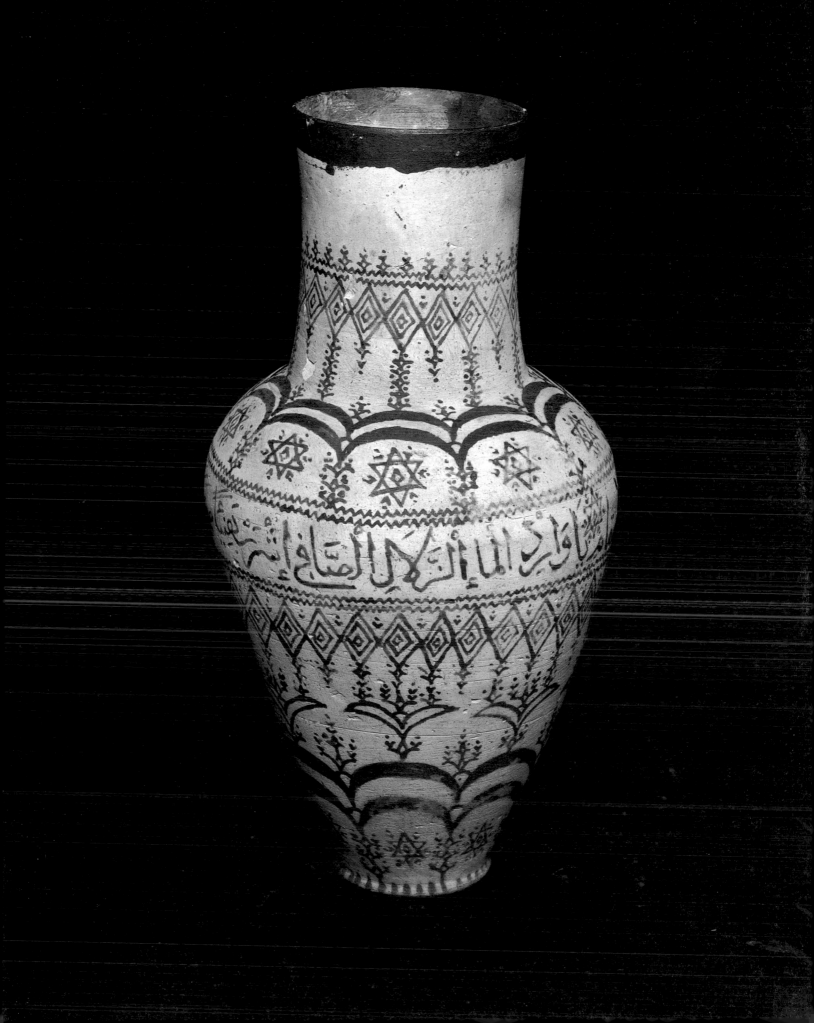

Black pottery vessel with flared mouth and graphite glaze, incised with lines, crescent motifs and rouletted decoration. Gbaya people, Meiganga, Cameroon. Made by Pauline Bazama. H. 36 cm, W. 31 cm. 1969.Af35.84.

Kiln filled with pots ready for firing. Fes, Morocco. Photo: N. Barley.

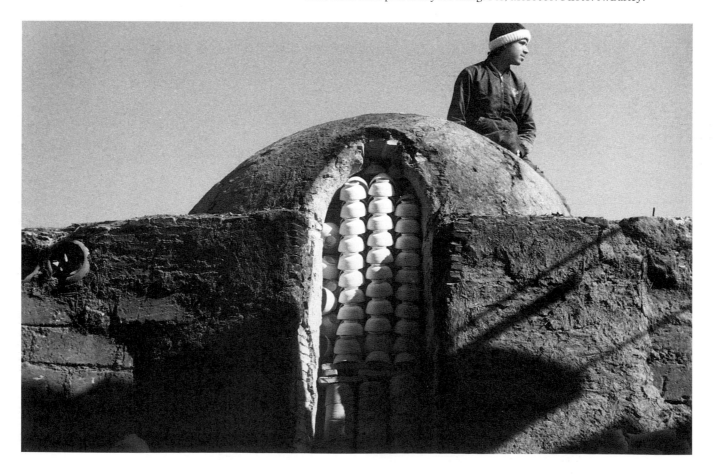

tion between decoration applied under and over the glaze is that between *baldi* (homely pottery used for marriage drums and Ramadan vessels) and *romi* (fancy ware). Some few peoples such as the Gbaya of Cameroon apply a graphite paste to their pots before firing, giving a dark, metallic sheen.[16] Elsewhere, the use of vegetable infusions after baking to waterproof pots is extremely common and the resulting irregular patterns are highly prized as decoration among the Kongo (Zaire). Nowadays, in Southern Africa, pots may be treated after firing with black boot polish, and the application of oil-based paints or polyurethane varnish is increasingly common.

In urban North Africa firing is carried out in a simple updraught kiln. Elsewhere, pots may be baked in a pit, surrounded by a low wall (semi-kiln firing) or simply heaped up in the open on wood with further fuel piled over them (the so-called 'bonfire' method.) In Niger a wall is built up of old broken pots within which the new stock is baked. Temperature may be controlled by intermingling swift and slow-burning fuel, sprinkling water and placing rocks as buffers. Some few peoples (Igbo, Loango) fire pots in two stages, gently, to drive off free moisture, then more fiercely to remove the water in chemical combination in the clay. Occasionally (Tiv) each individual pot will be fired separately, though up to 250 vessels may be baked together (Teke). It is incorrect to say that kilns are not found in sub-Saharan Africa.[17] Pit-kilns, where pots are baked in the ground, often with air fed in through tunnels or even bellows, are documented among the Yombe of the Lower Congo while hollowed-out termite hills are used by the Thonga of Mozambique and South Africa. Cylindrical kilns are found

Pots being fired. Northern Nigeria.
Photo: B. Fagg.

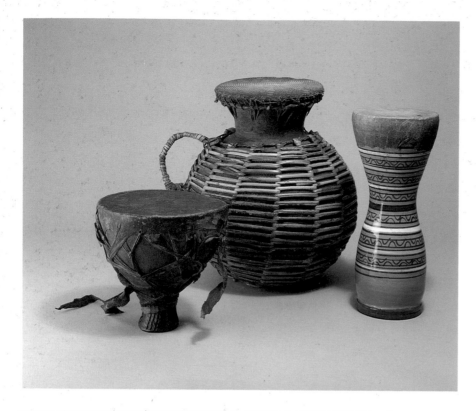

Left, from left to right Pottery drum from the Sotho people, Lesotho, said to be used at girls' initiations. Pottery drum. Bassa, Afo and Kwotto peoples, Nigeria. The body of the vessel is a pot with impressed designs. Around this has been woven a casing of vegetable fibre with a handle. The membrane tied to the neck of the drum is the skin of a monitor lizard. Modern pottery *baldi* drum from Fes, Morocco. H. 21 cm, D. 27 cm. 1006. H. 38 cm, W. 39.5 cm. 1924.12–17.60. Presented by the Secretary to the Government of Nigeria. H. 36 cm, D. 15.5 cm. Af1992.1.72.

Right Glazed ceramic lampholder from Safi, Morocco, made in the innovating Serghini workshop, which specialises in the application of non-traditional glazes and forms to traditional wheel-made pottery. Since most potters are illiterate, they are cautious about copying Koranic inscriptions lest they corrupt them. Moreover, there is no way of being certain that holy writ on pottery may not be used for blasphemous purposes. With this in mind, they often produce forms such as this that include the name of God but simulate Koranic calligraphy rather than accurately reproduce it. H. 27 cm, W. 27.5 cm. Af1992,1.22.

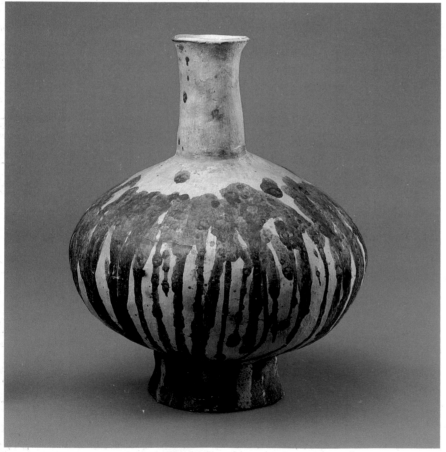

Left White slipware water-jar with 'splash and trickle' decoration in brown. Teke people, Zaire. H. 36 cm, W. 30 cm. 1954.Af23.1757. Presented by the Trustees of the Wellcome Historical Medical Museum.

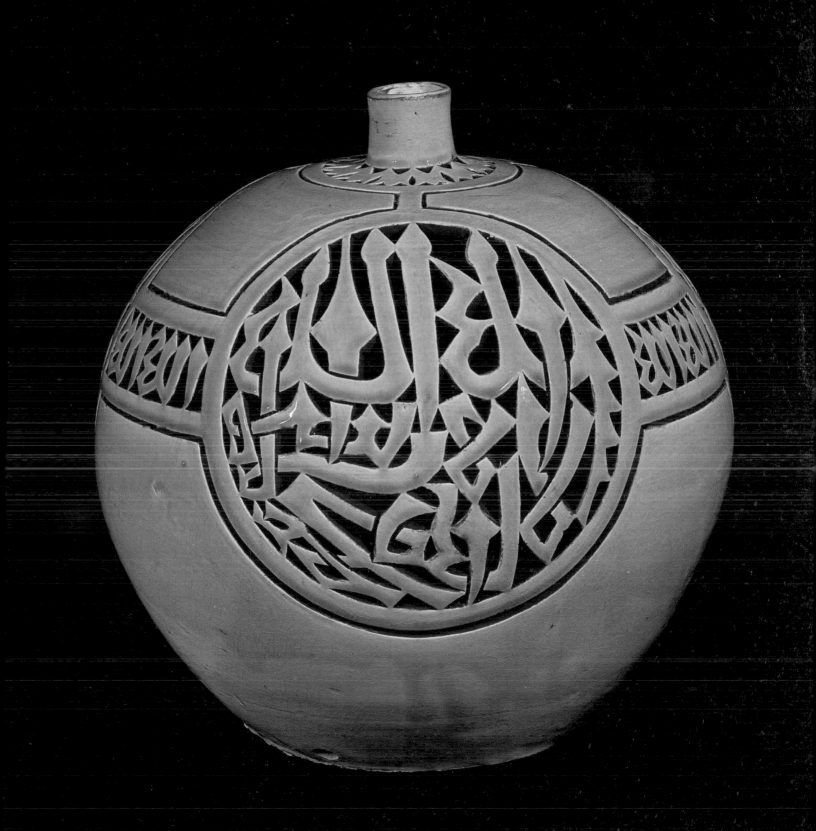

among the Mossi (Burkina Faso) and the Nupe (Nigeria). It would seem obvious to expect a similarity of distribution between peoples smelting metal and those baking pots in charcoal-fuelled kilns.[18] In fact this seems not to be the case and this may have implications for the ways in which different technologies have spread in Africa. It is important to note, moreover, that 'purely technical' aspects such as the method of firing may have important symbolic connotations and refer to maps of knowledge that are not immediately obvious to Westerners. Thus, at least part of the reason that Dowayo potters of North Cameroon refuse to use the semi-kiln method lies in the importance of maintaining parallels with the open threshing floor where millet is processed. This is simply part of a systematic equivalence made between human and natural processes that will be further discussed below. Urban North African potters who use the updraught kiln liken it to the body of a pregnant woman and baking to the process of birth. Likewise, the dividing up of a pot's surface for decoration is spoken of in terms of the way a field is divided up by furrows.[19]

What Westerners see as 'mere decoration' may also have a 'practical' function. Incised patterns allow a firm grip on a handleless pot and are said by potters to reduce cracking during firing and increase the rate at which they heat up over the flames and cool down when taken off the fire. Much of the beauty of African pots results from the subtle gradations of colour due to fluctuations in firing conditions.

Decoration added after firing will usually not be durable. The Baganda (Uganda) produced white patterns with ground snail shells mixed to a paste and rubbed into indentations on the surface. Red patterns could be produced using the clay normally reserved for the decoration of canoes. Both quickly fade. This technique is very old in Africa and has been noted in archaeological material from Jenne (Mali) that may go back to the twelfth century AD. The Grande Kabyle pots of Algeria are painted before firing with vegetable colours but rubbed with resin while still hot to give a semi-permanent effect. Such pots are

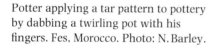
Potter applying a tar pattern to pottery by dabbing a twirling pot with his fingers. Fes, Morocco. Photo: N. Barley.

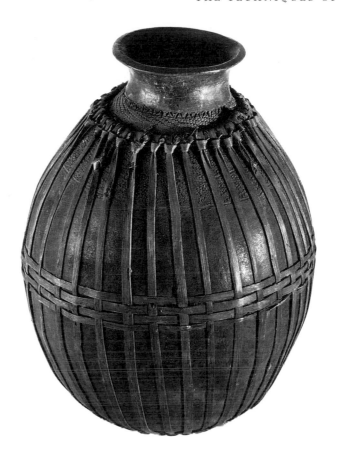

Pot with roulette decoration, covered with raffia basketry, from Kibondo, Tanzania. The vessel was made by a male potter. H. 39 cm, W. 29 cm. 1932.12–3.7. Presented by J. Darling Esq.

not normally placed on the fire since the resin would burn off. Similar usage obtains amongst some Congolese peoples (e.g. Nguli) while some Zairean peoples are said to use pitch in a similar way. The Fang (Gabon) melt resin over the inside to make vessels watertight. Elsewhere, especially in Zaire and Cameroon, basketwork may be tightly woven over pottery vessels for ornament and to give a better grip in the absence of handles.

The Nupe are unusual in applying hammered brass sheeting around the neck of pots. Modern Moroccan pots have developed similar techniques over recent years. Plain country ware is dyed brown and strips of brass are glued to the surface to transform it into spurious orientalised 'antique' souvenirs for European tourists. Another technique uses city ware as its core and solders twisted wire in a rough filligree around an ordinary glazed pot. Polished stones and enamel may be added to further enrich and exoticise the product.

A particularity of urban Morocco is the decoration of pots with resin from the *thuya* tree and other sources. The baked pot is rapidly spun by the (male) potter on his knee with one hand. The fingers of the other hand are dipped in resin that is dabbed up and down the pot as it spins so that a geometric pattern of black marks emerges. Elsewhere on the continent (Ethiopia) strips of leather and cowries may be glued on to a clay vessel. The decorative element of pots may also be wholly detachable. Thus, among the Zulu, pot covers, *imbenge*, of basket- and beadwork – sometimes resembling the necklaces of married women – are of great importance and mark formality and respect in the serving of beer. Nowadays they may be woven in coloured, plastic-coated telephone wire.

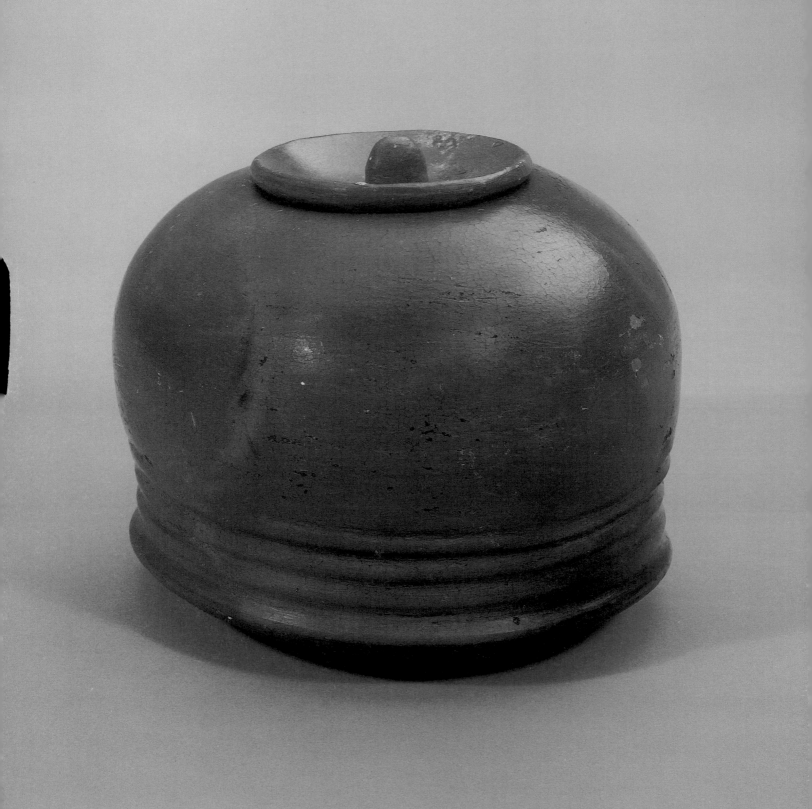

2

Potters and
the Earth

In his discussion of modernising tendencies in the ceramics of contemporary Fes, Chadli (1992:108) remarks:

The potter at the co-operative is transformed from an artisan into a simple technician who is content merely to stand by the machine: when the artefacts are created, for example, it is not the potter's ability which is being demonstrated – the mould 'decides' the shape of the piece. In the case of the traditional potter who works at the wheel, the shape is created somewhere within him and is then transmitted by his manual skills to the clay . . . The articles which are produced in the co-operative have no ritualistic or symbolic value. The material used to make them is a clay-like powder, factory-produced and, for the most part, imported. The clay which is venerated by traditional potters is for modern potters nothing more than ordinary material of no particular significance.

Traditionally, in Islamic thought, potting has had a special place. Noah was the first potter and his work was a sacred charge. Moreover, the potting process, the giving of form to clay and its transformation through fire, has a primeval quality. Small wonder, then, that potting offers ways of thinking about creation and creativity and that God is pictured as making Man from clay. The Judaeo-Christian heritage, in agreement with the Islamic, gives a typical example of a description of the origin of Man – through the creation of Adam ('Clay') – in terms of potting:

And the Lord God formed man of the dust of the ground and breathed into his nostrils the breath of life; and man became a living soul. (Genesis 2,7.)

Such stories find ready parallels in African thought in ways that clearly ante-date missionary influence and clay often plays the part of the primeval matter moulded into human form and infused with spiritual life. In the Judaeo-Christian tradition this only occurred once but then the various other reproductive possibilities are run through. Afterwards Eve was born by parthogenesis, like a plant, and then sexual reproduction took over until the all-male divine creation of Jesus with the Virgin Mary acting as a passive receptacle. However, the Jukun (Nigeria) regard each individual procreative act as having a mystical potting counterpart:

Ama, the second Jukun high god, appears to be a fusion of two or more gods, being sometimes regarded as a male being, at others as a female, sometimes as the Creator, at others as the Earth-goddess or World-Mother . . . Ama sits before Chido [the supreme deity] creating men and things . . . She fashions the human body bone by bone just as a potter builds up her pot strip by strip. If she makes a slip Chido smiles, and it is due to the slips of Ama that some men are born ugly or deformed. Some Jukun say that when Ama has finished fashioning a man, Chido breathes life into his body . . . (Meek, 1931:189–90.)

Among the Yoruba (Nigeria), this explains the sacred status of dwarves:

Among the earliest divinities to be brought into being by the Supreme Being was Obatala or Orisa-nla . . . The divinity is popular for giving children to barren women and for moulding the shape of the child in its mother's womb. Hence it is a common thing to hear people wish a pregnant woman . . . 'May the Orisa . . . fashion for us a good work of art'. . . As a way of explaining how certain people come to be ugly or deformed, the Yoruba claim that the albinos . . . , the dwarfs . . . , the hunchbacks . . . , the cripples . . . and the dumb are created like that by the Orisa to make them sacred to him. (Omasade Awolalu, 1979:21.)

Burnished red pot and lid. Yoruba people, Ilorin, Nigeria. H. 18 cm, w. 23 cm. 1924.11–12.13 a and b.

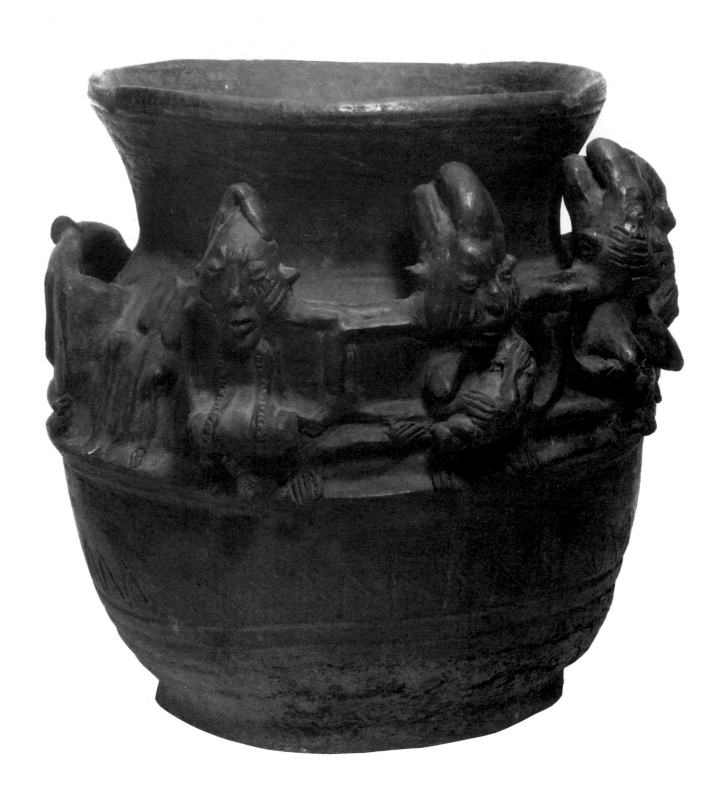

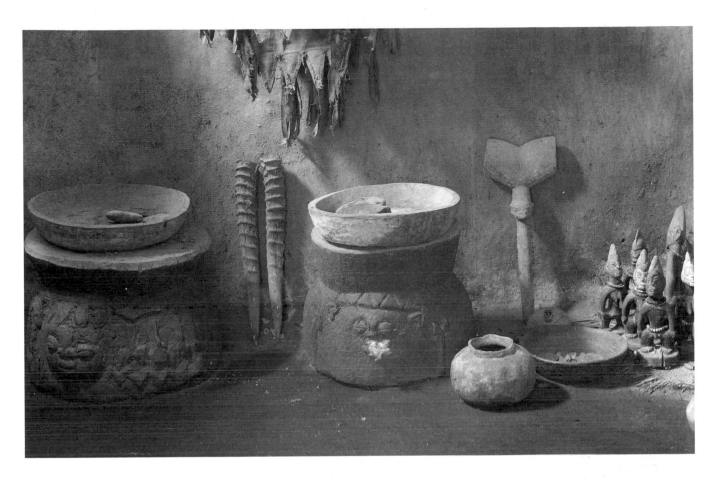

Above Shango and Egungun shrine, Egbe, Yoruba people, Nigeria. Photo: W. Fagg, courtesy of the Royal Anthropological Institute.

Left Large black pot, *ikoko*, with sculpted human forms. Yoruba people, Nigeria. Pots such as this are made for the cult of the god, Shango. Shango is particularly associated with the city of Old Oyo and is said to have been the fourth ruler of the Yoruba but of a fiery disposition and much given to magic. Eventually his power became so great that it threatened all about him and even himself. Shango sank into the earth and became the god of thunder and lightning.

Pots are made for his altar and used both as receptacles for holy water and as stands for calabashes containing sacred regalia such as stone axes. These are regarded as the earthly manifestations of divine thunder. An alternative container is the special carved wooden mortar that associates the god with the noise of thunder. Yoruba pots of this kind share many formal similarities with woodcarvings.

Between the figures here are the double axes that are the symbol of the god and carried by devotees. Shango shrines are usually tended by priestesses or priests in female dress and regalia often represent these. Ideally priestesses would be nursing mothers and sexually continent. One of the female figures here holds her breasts in a gesture conventionally interpreted as manifesting the continuity of life.

Drewal (1987) suggests that the stressing of individual design components over context – as found on Shango containers – is deeply significant for the understanding of Yoruba thought. Designs invoke the complex of spiritual forces inherent in objects and their use rather than telling a serial narrative around the vessel as occurs, for example, in Greek vases. This, however, seems to be a much more widespread phenomenon in African design. Benin plaques seem to illustrate mere episodes, to be snapshots. Even the spiral, linear patterns engraved on Loango tusks give rise, not to narrative, but a depiction of a procession at a single moment. H. 45 cm, W. 48 cm. Af1975,12.7.

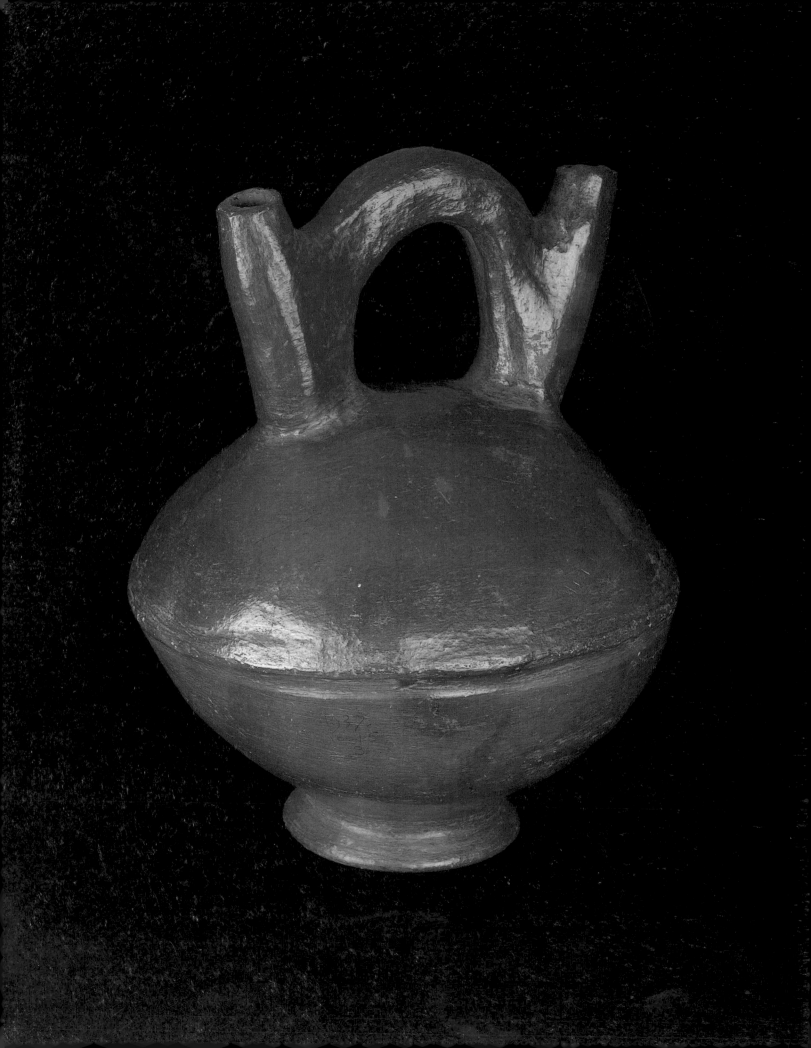

Opposite Stirrup-necked
vessel of clay. Bron people,
Yegi village, Ghana.
H. 31 cm, w. 24 cm.
1937.10–15.3. Presented
by Capt. R. Wild.

Large, two-handled pot with
human face and breasts,
one side painted red, the
other white with applied
representations of cowrie
shells. Yoruba people,
Nigeria.
 Although such vessels are
recognised as having a cult
use, little is known of their
precise significance.
H. 34 cm, w. 26 cm.
1971.Af29.3.

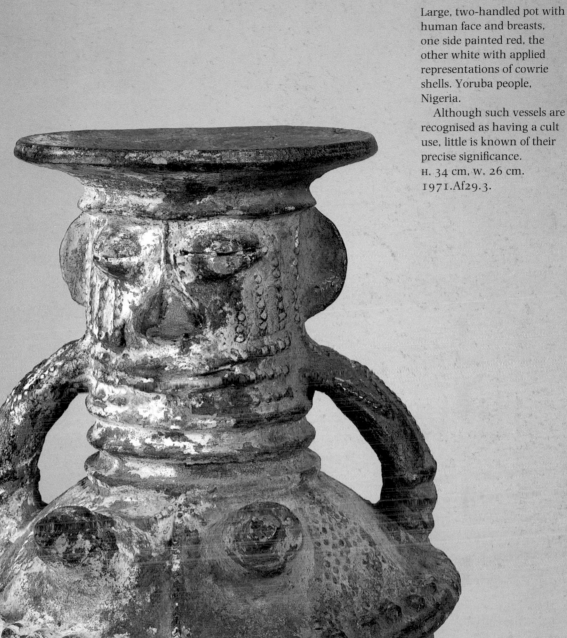

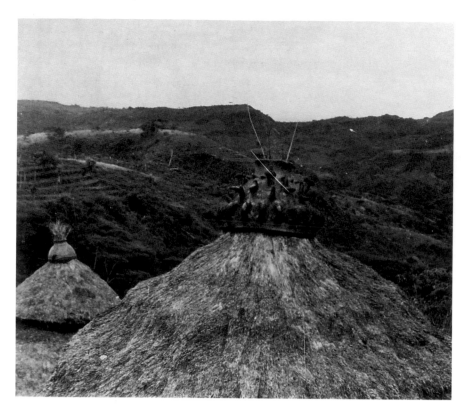

House of Saqara Giva showing phallic roof finial. Konso people, Ethiopia. Photo: C. Hallpike.

Nothing varies more widely around the world than what is known to be universally true concerning conception and the roles of the different agents involved in it. A widespread view in sub-Saharan Africa, however, is that the man places the seed in the woman where it is nourished by her. Thus the Ndembu (Zambia) explain:

The crossing of the father's and mother's blood . . . means a child, a new life, a seed of life . . . To have a child is very lucky for men and women, for a son gives things to his father, and also a daughter. The mother is like a pot only, the child's body comes from the father. God breathes life . . . into a child. A man begets . . . children, but they are the woman's because she nurses them, she feeds them with her breasts. (Turner, 1967:250.)

Often it is considered essential that the father continue to have intercourse with the woman throughout pregnancy to mould the child. In this operation too, an analogy can again be made with the potting process. Thus the Asante (Ghana) warn a man to respect his father in the maxim, 'The one who moulds your head like a water-pot, that one alone can break you.'[20]

In sub-Saharan Africa, the earth is commonly regarded as female and potters may have a special relationship with it. Asante potters were forbidden to gather materials on days sacred to Asase Ya, the Earth Goddess, when breaking the soil was prohibited (Rattray, 1927:305). Commonly, indeed, it is only men who may 'break' the earth and women who form it.[21] In Burkina Faso, female Lobi potters offer part of the payment for each pot sold on the family altar (Labouret, 1931:84). Later the money will go towards paying for a sacrifice to be made to the Earth. Respect for the Earth's sensibilities may affect the potting process itself. Pots for the shrines of the earthly Yoruba (Nigeria) deities Shango and Erinle (Witte, 1982) must not be exposed to celestial light but made – most

inconveniently – inside the hut in darkness, where the 'earth has eyes, where it speaks and breathes' (Beier, 1980:48). The particular goddess of Yoruba potters is Iya Mapo, 'Mother of potters/ Mother of mothers/ Quiet old Mother of silent earth'. She is also a fertility goddess held to live in a vagina-like cleft of rock in the mountains about Igbetti and her name is a euphemism for the female sex organ. The Yoruba seem frequently to contrast her with her husband, Oke ('Rock') so that he is firm, reliable, she pliable, inconstant and the pit from which the potters take their clay is inevitably 'the womb or vagina of Iya Mapo' (Beier, 1989:52).

On death, according to Yoruba belief, the ordinary human individual splits into 'earth and water' (*ile*), 'vital force' (*emi*) and 'destiny' (*ori*). The last of these sets off for the spirit domain but needs help, ceremonies involving *ile*, to attain reincarnation. If unfortunate, it will end up in the 'world of broken pots' with the spirits of witches and suicides (Witte, 1984:245). It is striking that one of the few constant themes in the midst of the extreme complexity and regional variation of Yoruba cults is that the worship of earth and water deities, unlike heavenly deities, involves pottery.

This special attitude may extend even to the sherds of a broken pot used to hold down offerings on ancestral shrines. Gurensi potters (Ghana) remark:

Broken pots help the shrine offerings from being blown away, but they are special; they involve the Earth in these shrines to our ancestors. Without the Earth we could not exist. (Smith, 1988:61.)

The Gurensi, it seems, view houses, pots and graves as merely different sorts of earthen containers, the last being a kind of 'negative pot' sunk into the ground. Funeral pots and houses use similar decorative patterns in a way that further ties them together.

The Konso of Ethiopia also link pots and graves through the notion of the female earth:

Pots, in particular, are very closely associated with women. Pottery is specifically a female craft, and in some areas pots are placed on their graves. It seems likely that the pot is seen as symbolizing fertility (a womb-like vessel), earth (the material from which it is made), women (who make and use it), and nourishment (what it contains). (Hallpike, 1972:289.)

This does not prevent the Konso from producing blatantly masculine pottery forms, such as the famous roof-finials studded with erect phalli (Jensen, 1936:361). These are used on the roofs of men's meeting houses and those of priests who wear a similar, metal, horn or terracotta phallus on the forehead. Yet potting itself is a despised craft, regarded by the Konso as an 'unnatural' treatment of the earth, involving pounding and cooking it as if it were food.

Often the art of potting seems to require its own myth of origin. A Dogon story relates the invention of terrestrial pots:

Pottery was born in the smithy. The smith's wife was drying in the sun a pot which she had modelled like one of the spheres of the bellows; but, finding it did not harden quickly enough, she put it near the fire. She then discovered that the clay was baking and becoming hard, and so she got into the habit of putting the pots she modelled by the fire.

She worked on a small square mat woven with eighty strings on a warp of the same number. First she made a rough model shaped like a section of an inverted cone, into

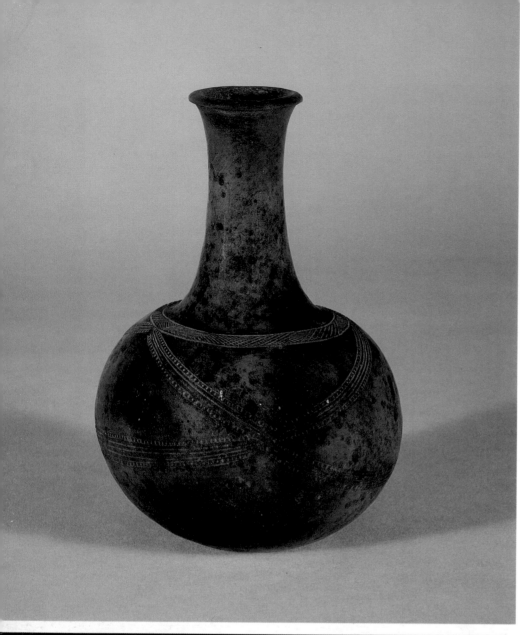

Left Long-necked pot of dappled light and dark brown with bands of incised decoration. Nyamwezi people, Tanzania. H. 20.5 cm, W. 14 cm. 1968.Af3.2. Presented by E. Battiscombe Esq.

Right Large water-jar, *yagala*, with slip and rouletted decoration. Tula people, Nigeria. H. 46 cm, W. 40 cm. 1951.Af12.112.

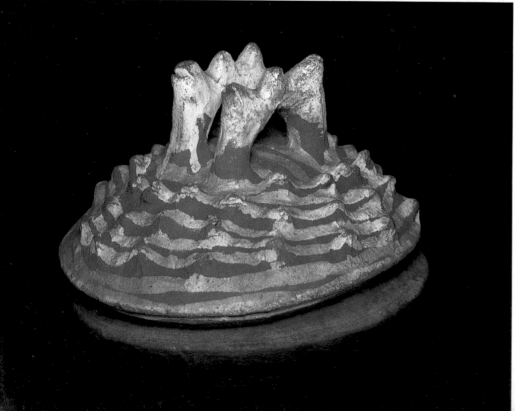

Left Pottery vessel with lid, *lisazen*. Gun people, Republic of Benin. The lid of the vessel has spikes arranged in ridges and is striped with white clay, added after firing. Gun pots are often half-buried in earth altars. This one was made for the *vodun* spirit, *Lisa*, one of the gods of creation. H. 20 cm, W. 23 cm. 1951.Af12.169–70.

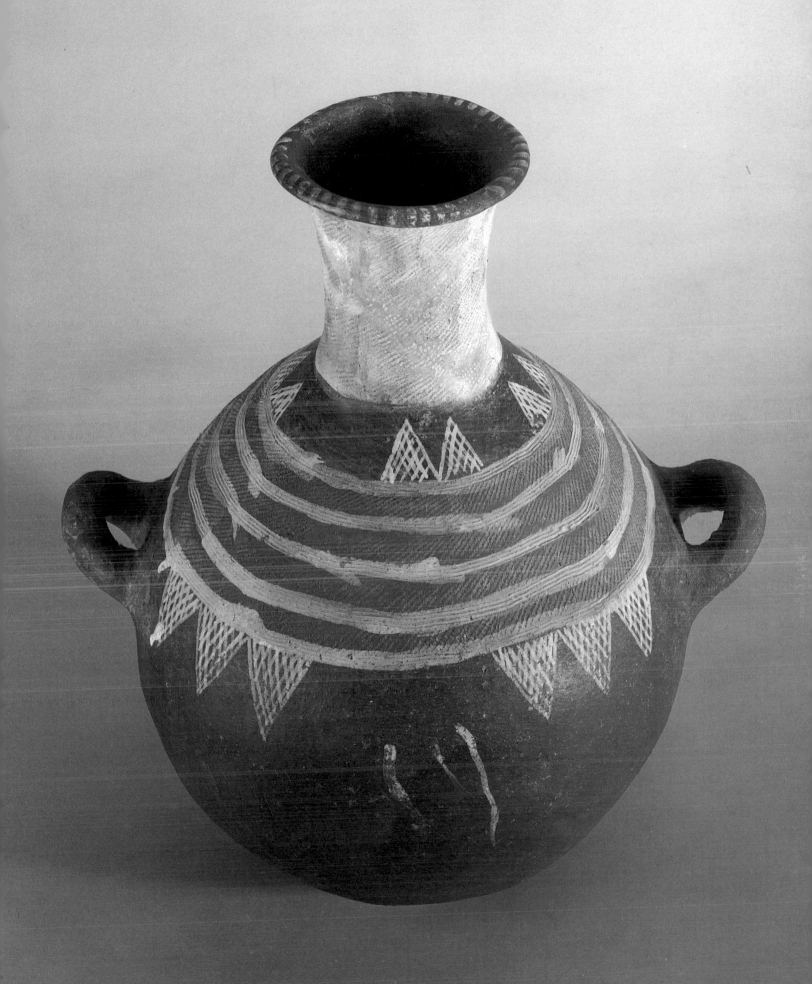

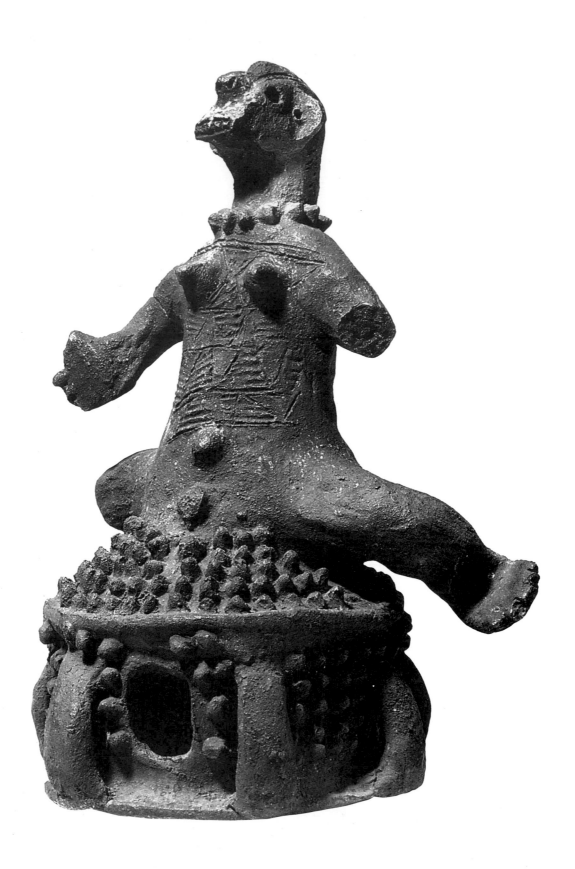

which she threw with considerable force a round pebble, which made a bed for itself in the clay, and this became larger and larger until finally it took the shape of a sphere. When the inside surface of the clay was pressed, it took the pattern of the mat.

Women today copy the same processes of the mythical potteress – beating the pot into shape but the craft is no longer the prerogative of the wives of smiths. Any woman can be a potter, if she wishes. (Griaule, 1965:88.)

From a purely technical point of view, of course, it is metalworking that is dependent on potting technology and not vice versa even if the beating of clay and the beating of metal seem to employ similar techniques. Historically, pottery antedates metalworking in Africa and clay provides furnaces for smelting, tuyere pipes for the bellows, crucibles and moulds for lost-wax castings. In West African mythologies, the technological division of labour often shows male skills as having been taken from women in a sort of act of conquest so the insistence that potting is a spin-off of male technology is particularly striking.

Yet other myths relate how the basis of the whole physical universe is primordial potting:

The stars came from pellets of earth flung out into space by the God Amma, the one God. He had created the sun and the moon by a more complicated process, which was not the first known to man but is the first attested invention of God, the art of pottery. The sun is, in a sense, a pot raised once for all (sic) to white heat and surrounded by a spiral of copper with eight turns. The moon is the same shape, but its copper is white. (Griaule, 1948:16.)

Having made the earth as a female form from more clay, the God Amma copulated with it, its sex-organ being an anthill, its clitoris a termite hill. From this was born the first of the twin beings symbolised in the linked pottery bowls placed on family altars at the birth of human twins. Subsequently God created humans directly from clay but the Earth had been polluted and must be purified by the mud of a granary that fell from Heaven with the seeds of cultivation.

These mythologies are very complex but seem to operate within a severely circumscribed area of culture. Among the Dogon, clay for potting or grog is often taken from ant- and termite-hills. Granaries are made of dried but unfired earth. Potters work in wet clay to a cycle decided by the sun. So this myth brings together all the various sorts of earth important to the potter in a single vast narrative of cosmological creation in which Nature is formed by divine Culture.

Earth is often, as here, associated with female creativity and fertility and African ideas of human biology relate easily to agricultural models. Thus, it is not uncommon for males to have exclusive charge of sowing of seed or threshing floors to be dangerous to gestating women.[22] As Jedrej (1989) has pointed out, such ideas are so widespread as to be semi-universal and therefore particularly difficult to analyse in a manner that roots them in the culture of specific places and events. They end up either stridently generalised as necessary and inevitable or vague and unfocussed, curiously immune to factual disproof. A treatment of the meaning of African pottery must chart a course between these extremes, exploring the ends to which it readily lends itself but located in specific contexts.

Pottery roof-finial in the form of a female figure. Gwarin Genge people, Northern Nigeria. The figure stands on a large hemispherical spiky vessel. Kandert (1974:94) shows a somewhat similar piece (fig. 103) from the Gwarin-Genge. Shuaibu Na'ibi (1969:15) notes: 'Some Gwarin-Genge have terra-cottas with markings similar to those on their own bodies, which are kept in the burial hut of their chief [a small hut built over the tomb] or sometimes on the top of the hut's roof. If the chief dies, they remove the terra-cotta from the roof and wrap it in a white cloth until a new chief is appointed and a ram sacrificed. There are terra-cottas of this kind in Kwaka, Diko, Bwari and Mandalla.' H. 38 cm, w. 22 cm, L. 27 cm. 1972.Af33.1.

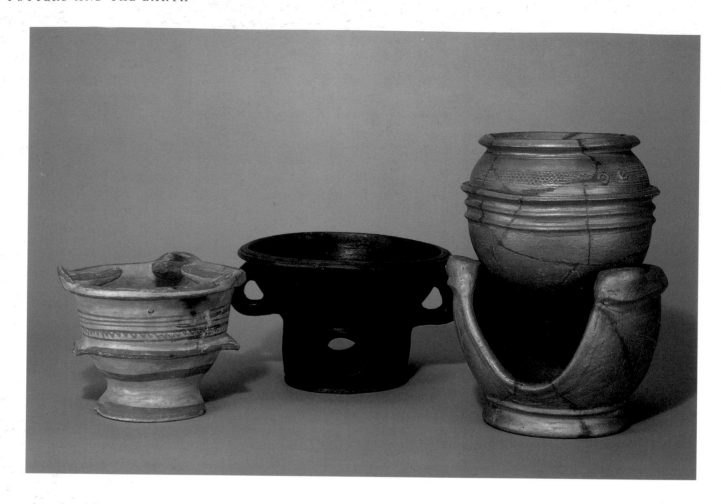

Above, from left to right Clay brazier with red slip decoration made by the Reguibat Arabs of Morocco; clay brazier of pedestal form from Nigeria; and a clay brazier with a pot made from clay with a mica slip made by the Hausa people, Kano, Nigeria. In Africa, hearths take a number of different forms (Kandert, 1974:79). Pottery braziers greatly increase the efficiency of fuel use and have been strongly promoted in some parts of Africa as a way of overcoming the shortage of firewood. H. 21.5 cm, D. 29 cm. 1968.Af25.1. H. 22 cm, D. 35 cm. 1924.12–17.61. H. 40 cm, W. 31 cm. 1946.Af18.248. Presented by the Chief Secretary to the Nigerian Government.

Right Red pottery vessel with open top, large protuberance and applied decoration. Mwona people, Northern Nigeria. The Mwona make anthropomorphic vessels of this kind for divination, protection and curing (Hare, 1983). Slye (1977) notes: 'Among the many figures produced and used by the Mwona are those especially favoured by mothers. When a woman becomes pregnant she wants a terracotta charm to safeguard her and her child until birth. This is a small terracotta vessel, sometimes plain, sometimes decorated with miniature tassels or cowrie shells. Protruding from the side at an acute angle is a stylized head representing the foetus . . . Possessed of this charm, the woman feels secure until her baby is born.

Following delivery, the woman again consults the diviner and obtains another charm; a small pear-shaped vessel with a baby carried on the mother's back . . . The wide-open mouth of the parent figure, with the tongue showing at the base, is typical of the genre, as are the protuberant eyes and supra-orbital ridges indicating forehead and ears combined.' H. 18 cm, W. 13.5 cm. Af1978,2.14.

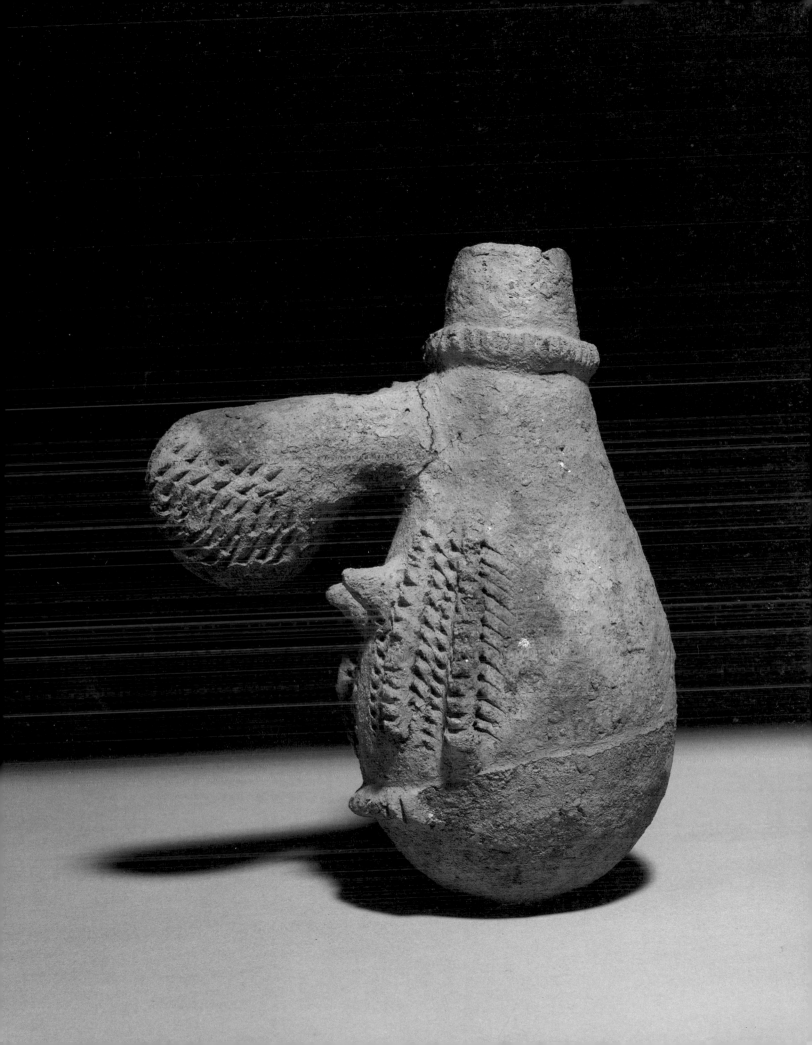

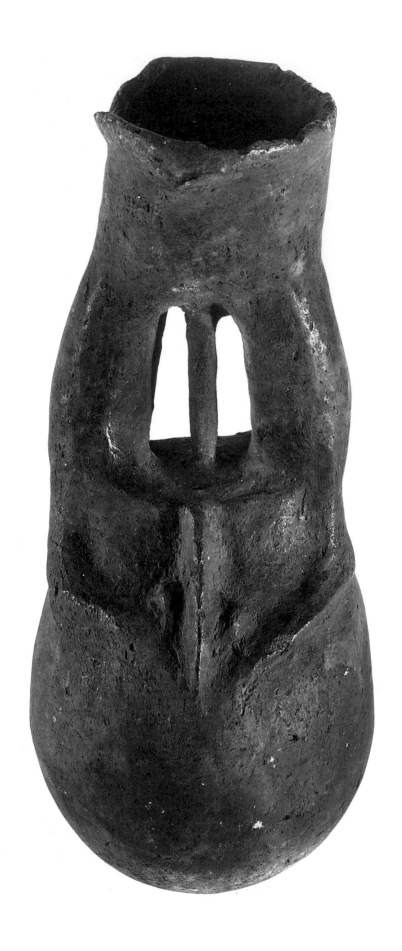

3
Male and Female in the Making of Pots

Dark grey pottery vessel with stirrup neck and raised bosses. Bura people, Bauchi Province, Northern Nigeria. Pots as habitations for ancestral and natural powers play an important role among the Bura. Meek (1931:164–5) remarks, concerning this vessel, 'There is another type of pot sacred to the Bura and known as Hywel Kir or "God at the Head". It has two necks and on the body has a design that is said to represent the female pudenda. Young Bura men put this pot beside their heads at night to bring them luck, and every year at harvest and sowing make offerings (cotton is stuck on it and a chicken sacrificed). The owner, with his most trusted friend, drinks beer ceremonially from the pot, and when he dies the pot is buried with him. H. 29 cm, W. 13 cm. 1926.4–14.1. Presented by C.K.Meek Esq.

For the most part, African pots can be said to be made by hand and by women.[23] But this broad generalisation conceals a multitude of local variations and the precise relation of female to male potters and potters to non-potters requires closer examination in each area. Furthermore, amongst some peoples such as the Beti (Cameroon) every woman makes her own pots.[24] Amongst others such as the Kuba – it is said – none does and pots are wholly imported. Specialisation varies enormously.

Occasionally, potters may produce a few types of pots only or make a vast range of wares. A single potter may make a whole pot from start to finish or duller and less demanding tasks may be allocated to apprentices or the less gifted. The degree to which pots are made for sale or use varies widely throughout the continent and the universal presence of pots in markets obscures the fact that they are not always just another market commodity. Many are supplied without payment according to links of kinship. In West Africa 'normal people' sometimes maintain a patron/client relationship with specialist potters and smiths so that services and goods may be exchanged rather than paid for in cash and the breakdown of such arrangements is a marker of the advance of the cash economy into new areas of social life.[25] A widespread market convention in Africa is that the price of a pot is the grain that it can contain and pots may well be excluded from the haggling that marks the purchase of other goods. While some sorts of pots are made and offered for general sale others may only be made to order. In Fes there is a long-standing tradition of pilgrims exchanging their money for that of a potter before leaving on the *haj*. It is explained that this is because to use ill-gotten gains for the pilgrimage to Mecca robs it of its spiritual effectiveness. Since a potter's wealth comes directly from the soil and cannot involve short measure – unlike the buying and selling of agricultural produce – potter's money is the epitome of honest gain. Pots, then, may have a special place in spheres of exchange.

Even where it is established that both men and women of a particular subgroup make the pots, as among the Mossi of Burkina Faso, men may be dominant in one geographical area and women in another. The result is that men and women may not make the same pots.[26] Moreover, the potting techniques used may be different. Thus, in West Cameroon, both men and women work in clay. Men, however, only pot in particular locations such as Bamessing where they make specialised vessels for prestige use. Elsewhere, men make elaborate clay pipes but by carving the clay rather than modelling it. There is common sense in this division since each sex makes the things it uses. But it is important to note that Cameroonian Grasslands pottery is made in the midst of active male woodcarving and brasscasting traditions that involve subtractive techniques but different materials. In Bamessing, the carving technique is also used to make the bowls and so masculinises what is elsewhere a female skill.[27]

In Upper Egypt, the facts are somewhat different – depending seemingly on a greater or lesser use of technology. In some parts, both men and women pot but – while men use a potter's wheel – women make their vessels entirely by hand. Men, however, often add a wheel-turned rim to women's pots while women hand decorate men's pots.[28]

The distinction between male and female spheres of influence is explained in

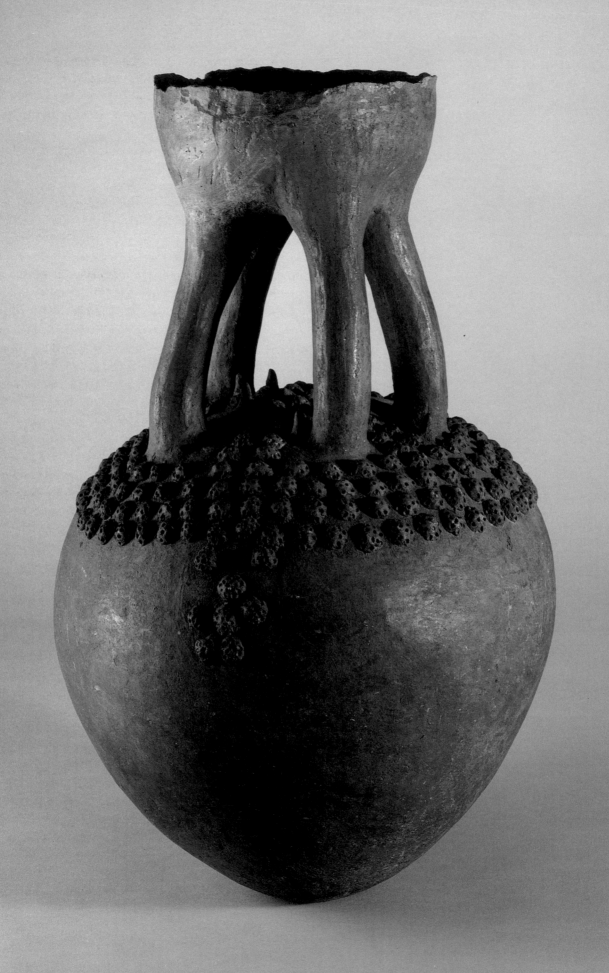

Fumban (Cameroon) in terms of the making of images. Women make images through their production of children, men through carving and casting.[29] It is a widespread idea in West Africa that women's fertility can be compromised by artistic activity, a neat inversion of the sexual ambiguity held to characterise artistic males in the West.[30]

A similar division of labour occurs in other parts of the continent. Thus, Stoessel (1984:66) remarks:

The production of usable vessels within the framework of a traditional canon of forms demands technical ability that cannot be acquired without the expenditure of great time and constant practice. This is why it is often especially old women who make pots, as among the Soko of Zaire or even the 'female experts' such as the Pare potters of Tanzania.

Perhaps, but it may also be the case that only post-menopausal i.e. infertile women may undertake certain tasks involving the making of images without risk.[31] So the fact that the researcher always finds himself talking to little old ladies when studying the pots that are most interesting anthropologically is not merely further evidence that potting is dying out. The same would have been the case a hundred years ago. The demographic bias is built into the nature of the cultural world. Perhaps then we should speak less of a line drawn between male and female in the making of African pots than of a line between fertile women and everyone else. In this, the structuring of African gender differs significantly from that of the West.

In West Africa, female potting is widely paired with male smithing and is normally phrased in terms of the potter being the wife of the smith and both belonging to a closed caste.[32] 'Smithing' here may simply involve forging iron or extend to smelting and brasscasting. The Dogon myth (p.53 above) explicitly depicts potting as derived from smithing. However, I have suggested elsewhere (Barley, 1984) that this linguistic usage is a far from accurate way of describing the general West African situation and reflects a European obsession with male smithing as *the* magical activity to the detriment of potting. Moreover, in Africa 'smiths' may also be the foremost undertakers and diviners, circumcisers, car-mechanics, carvers, arbitrators and tailors while 'potters' are also midwives, female circumcisers, healers and hairdressers. McNaughton (1988), from a much more convincingly African perspective, sees the centre of smiths' activities to lie in the knowledge and power of sorcery rather than mere technology. However, it is important to note that it may well be the potter who is more important as a source of rites that change human beings than her husband (Chapter 5).

In West Africa, the separateness of potters/smiths and other groups is expressed across many forms of life. Often, intermarriage between this artisan group and 'normal' people is forbidden. Often potters/smiths may be regarded as of entirely separate racial origin as amongst the Senufo (Ivory Coast). It is believed among the Mafa (Cameroon) that violation of this marriage rule would cause the offenders to die and their bodies to swell up and ooze pus and worms (Sterner and David, 1991:361). It is a significant mark of royal power that a Marghi ruler can marry a potter with impunity (Vaughan, 1970:87).

Other regulations, in other domains, enforce the marginality of potters/

Pot of two interconnected vessels, the lower decorated with clay bosses, Angas people, Northern Nigeria. The vessel is formed of an upper and lower container connected via the hollow legs. The upper vessel is a well-known form in Northern Nigeria that allows cooking without a hearth and is associated with hunting and male cookery that does not involve women and the domestic hearth. This pot was used for ceremonial beer drinking at an ancestral cult. H. 62 cm, W. 40 cm, 1924 3-3 1. Presented by C.K. Meek Esq.

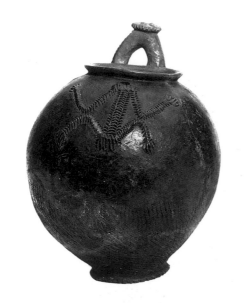

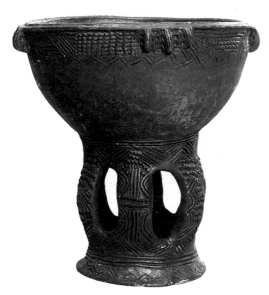

Top Large, brown, globular vessel with applied lizard motif in raised keloids, rouletted decoration and vertical handle. Below is a large pedestal vessel with moulded and rouletted decoration. Bamileke people, Cameroon. H. 37 cm, D. 35 cm. 1937.2–17.19. 1937.2–17.18.

smiths. Among the Dowayos of Cameroon, they must live apart and may not enter the huts of others. They cannot share food or even draw their water from the same source and never eat from the same vessel. Elsewhere, all the rich invective reserved for outsiders may be heaped on them and they are described as dishonest, smelly, promiscuous, diseased, filthy eaters (Van Beek, 1982), disrespectful, wayward and steeped in witchcraft and sexual perversion.[33]

It would be wrong, however, to ignore the fact that artisan groups are not just apart. Rather they are ambiguous, treading a line between being part of 'us' and part of 'them'. Traditionally, an attempt has been made to distinguish between those parts of Africa where smiths/potters are privileged and those where they are despised.[34] Unfortunately, such attempts take no account of the 'swings and roundabouts' nature of cultural classification. They can be scorned and envied at the same time. Thus, Dowayos will concur that potters are *diibto* ('dirty') then often add, 'But they are rich'. Ironically, potters are the only women in Dowayo villages with the means to buy imported enamel bowls in preference to their own products. It is not simply that potters make a lot of money (many in fact do not) it is rather that they are among the few women who have access to cash at all rather than merely having claims on produce or cattle. Their separateness is most strongly maintained by a belief that potters may be injurious to others. They cause diseases. Amongst the Dowayos, in men they cause piles, in women, a sort of ingrowing vagina. The worst thing that could happen is that a rainchief should come into contact with a smith/potter. Both would die. The smith/potter would swell up with moisture, the rainchief perish of a dry cough. Yet both are fundamental to the Dowayo map of the world. Since the rainchief, too, needs pots to control the rain an elaborate series of arrangements must be made whereby the extreme ends of the Dowayo social world can be brought together and he can be supplied. It involves a post-menopausal potter baking the rainchief's pots, on a moonless night, in the shelter used to house dead male bodies and passing them to a ritual sorcerer for transport.

Some potters assiduously maintain their own separateness, rather than seek to overcome it, their knowledge being a scarce resource that must be carefully guarded. Such is said to be the case with specialist potters of Bida (Nigeria) whose daughters are urged to marry back into their own extended family (Nadel, 1942). Marriage outside requires that they give up potting rather than risk communicating family knowledge to others, while girls who marry in may learn to pot under their mother-in-laws' control.[35] As in other places this almost amounts to a guild system. Thus, Herskovits (1938,1:76) remarks concerning the market in Abomey:

Pottery is often marketed cooperatively. A woman who does not get on with the others of her group, particularly if she cuts her prices, is punished not only by having her stock of pottery broken by her associates, but also by being forced to work for a time without remuneration before she is readmitted to all the privileges of the guild.

Among the Senufo (Ivory Coast), potting skills are only passed on to a woman after her marriage as a way of controlling the young for it is feared that early apprenticeship could encourage insubordinate independence in young girls and even resistance to arranged marriages (Spindel, 1989:71).

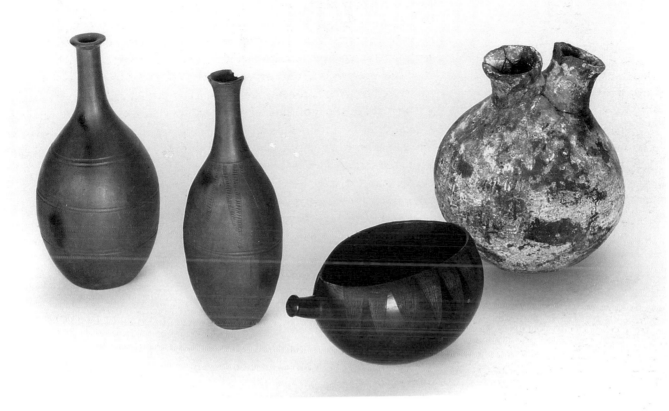

Left Burnished red pottery vessels, *akanyweru*, for mead, made by the Twa for the Tutsi people, Ruanda. *Centre* Thin, black, burnished pottery cup with handle and incised triangular motifs. Twa people, Ruanda. *Right* Double necked pot, *minwihiri*, rubbed with chalk, used for drinking beer possibly as part of religious cults. Made by the Twa for the Hutu people, Ruanda-Burundi.

The Twa are a pygmy people of Ruanda and Burundi. The area has been dominated by other peoples, the cattle-keeping Tutsi and agricultural Hutu. Pygmy groups are mainly forest-dwelling hunters but the Twa have also made a role for themselves as entertainers, fishers and potters. Both men and women pot but only men make prestige items and religious vessels for the politically dominant Tutsi, who otherwise use wooden containers and despise pottery as a mark of agriculturalist life. With the Hutu, pots might be exchanged for agricultural produce – a trade interpreted by the Hutu as begging. With the Tutsi, special pots could be rewarded by disproportionately large gifts, for example a cow (Seltz, 1977:148). Clearly the symbolism of political relationships was heavily involved in this exchange between groups who stressed their differences and tightly controlled goods and people passing from one group to another.

While Fonck (1900) relates the patterns on the pots to those on shields and knives, they seem rather to show no more than a genuflection towards Tutsi/Hutu patterns. Since smithing and carving is mainly in the hands of the Hutu and mat-weaving, tatooing and elaborate hair shaving a particularly Tutsi preoccupation, it is not surprising that such motifs as are shared are used in very different ways. H. 18 cm, W. 9.5 cm; H. 18 cm, W. 7 cm. 1921.5–12.19 and 22. H. 7.5 cm, W. 10 cm, L. 14 cm. 1940.Af16.65. H. 17 cm, W. 14 cm. 1948.Af8.101. Presented by Capt. J. Philipps M.C.

The wealth that may accrue to potters depends on trade. Since pots are a relatively bulky, low-value and breakable merchandise, it might be thought that they would be inappropriate objects of trade. Nothing could be further from the truth. Everyday pots are regularly found hundreds of miles from their place of production and few African markets have no potters' quarter.[36] An alternative to transporting pots is for the potters themselves to become itinerant and travel in the dry season when agricultural activity is minimal.[37]

Potting is generally associated with the dry season in Africa since it cannot normally be carried out at any other time for a mixture of practical and symbolic reasons. Pots are mostly worked out of doors and require sunshine to dry them to a certain hardness before firing. Failure to prepare pottery in this way may lead to cracking. In Zaire, clay is mainly from the banks of rivers and only accessible as the water level drops. The rainy season is also the time of agriculture when even potters are busy in their fields and have neither the time nor the energy for potting. Moreover, the firing of pots must be carefully controlled in time and space to avoid supernatural sanctions such as the disturbance of the rain or the destruction of the pots.[38] It is these natural consequences of cultural actions that have strengthened the case for seeing potters and smiths as belonging to a separate 'caste' in Africa.[39] In a new twist to the argument, Sterner and David (1991) have suggested that caste in the Mandara mountains of North Cameroon is based upon logically prior notions of gender, so that relations between smith/potters and 'ordinary' people would be structured by those between women and men. In such a context artisan men end up relatively dependent clients and 'feminised'. Added to this is that in Africa, respected paragons of femaleness such as Queen Mothers can often end up classed, paradoxically, as 'male'. This all leaves open to the symbolic system the possibility that the productive wives of artisan men may themselves appear relatively *independent* and 'masculinised' which does, indeed, often seem to be the case with African potters.

This fact, in turn, has attracted to potting the attention of researchers keen to redress the neglect of female technologies in Africa.[40] For while the potter is doubly excluded from many crucial events on the grounds of her sex and her membership of an unclean group, it is often she who provides models by which the world may be made comprehensible.

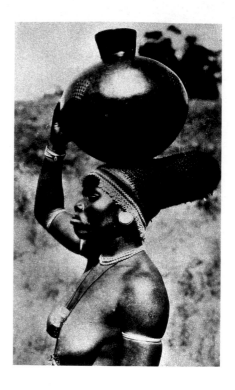

A Zulu woman, with a hairstyle reserved for married women, carrying pot of beer. S. Africa.

Right Graphite-glazed pots, *ensumbi*, reproducing the shapes of gourds. They stand on ornamental woven pot-rings of vegetable fibre. Ganda people, Uganda. Pots of this kind were made for the royal court and other notables and contrast with the coarser red ware commonly used. Both kinds are made by men. The royal potters, *Kujona*, were a special group who received land in exchange for pottery. Pottery is said to have been introduced to the Ganda by Nyoro captives (Trowell, 1941:58). The decorative finish is achieved after firing (and smoking?) by the application of graphite and polishing. H. 30 cm, W. 18.5 cm; H. 21 cm, W. 20 cm. 1901.11–13.50 and 51. H. 34 cm, W. 20 cm. 1971.Af38.2. Presented by Sir H. Johnson GCMG.

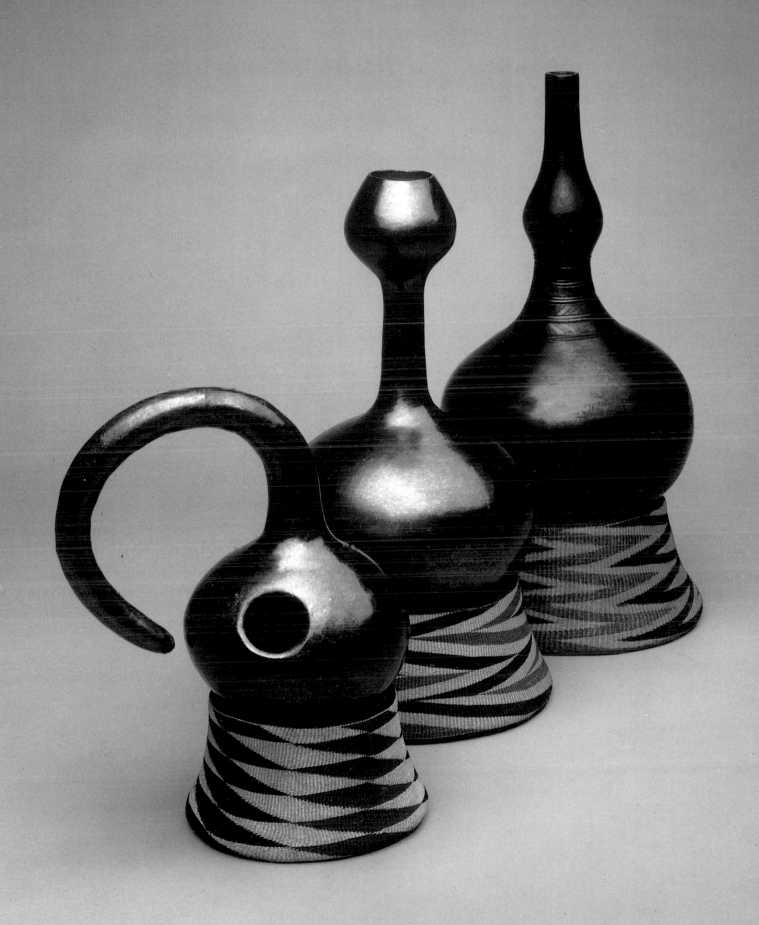

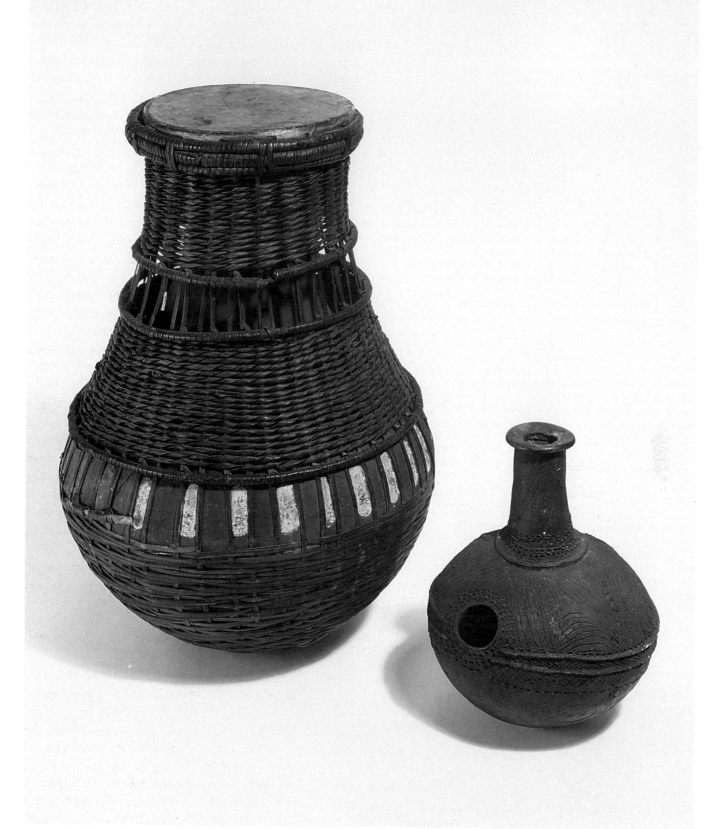

4

The Role
of Pots

Left Large pottery drum, *kpezi*, with raffia
support. Fon people, Republic of Benin.
Drums of this kind are among those
supplied by a son-in-law at the funeral of
his wife's parents (Herskovits, 1938
1:363). At the end of the ceremony they
are buried with other musical
instruments and a great deal of pottery.
Centre Black, rounded vessel, *abang*, with
open spout, incised and applied
decoration and a hole in the side. Igbo
people, Southern Nigeria. This is a
musical instrument played by women.
Slapping the palm of the hand over the
openings produces a resonant booming
sound. H. 56 cm, w. 39 cm. 1938.10–
10.14. Presented by Mrs F. Halligey-
Charles. H. 28 cm, w. 22 cm.
1950.Af45.85. Presented by P. Amaury
Talbot Esq.

Pots have a particular place in the grammar of African objects.[41] Pots are
naturally used for the storage and cooking of liquids but have a much wider role
than the Western saucepan and African clay is almost as versatile as plastic in
the West. This is clear from the way that pottery is often used to produce skeuo-
morphs (representations of objects usually made in one material executed in
another) so that pottery designs overlap with those of wood, basketry and
leather. Pots are regularly used for keeping and measuring bulk solids such as
grain and flour but are also important as wardrobes, handbasins, piggybanks
and receptacles for valuables of all sorts. Pottery provides pivotal elements of
architecture such as pipes, roof-finials, skylights, well- and latrine-linings
(Prussin, 1986:189). Glazed roof tiles, mosaic work and the architectural use
of pots are a basic feature of Moroccan style while the incorporation of plates
into buildings is a widespread African fashion. The Hausa bake special flat,
circular tiles that are stuck to the outside of mud buildings and deliberately shat-
tered to create a decorative and protective layer. Pottery supplies lamps, beads,
strigils, lip-plugs, coffins for the dead,[42] funerary monuments, furniture, musi-
cal instruments, sieves, milk churns, mortars, grindstones, gambling chips,
dolls, beehives, fumigators, even rat-traps. The possession or not of pottery is an
important indicator of who one is. The modern plastic kettle is an infallible sign
of the Muslim religion just as the use of an ornate calabash instead of a pot
marks off the nomadic and the sedentary Fulani from neighbouring pagan
peoples.[43]

In the West, our own eating and drinking vessels are used to categorise
ourselves, their contents and the events at which they appear. The matching
dinner service shows our wealth and the formality of the occasion, the status of
host and guest – as do the different types of glasses on the table. In Britain,
dishes, plates and glasses are made appropriate to contents and users so that in
a North of England pub, we must tell the barman the sex of a half-pint drinker
of beer so that he can put it in the 'proper' glass.[44] African usage is only
superficially different, appropriate pottery being assigned according to the qual-
ities of food, user and event, transmitting messages about participants and the
relationship between them.[45]

A guest in a Zulu household will traditionally be offered beer in a large deco-
rated pot, an *ukhamba*. There is also a smaller vessel known as an *umancishanem*
that may be used for the same purpose. Levinsohn (1983) remarks:

The word *ncisha*, from which the name is derived, means 'to be stingy'. When beer is
served in this container, it probably suggests that the guest should visit for a short
period, drink his beverage, and leave, or it may mean the host is short of beer.

In Bamessing (Cameroon), each adult will have his/her own individual food
bowl that is as inalienable as the British pub 'regular's' pewter mug while in a
Dowayo village black, ball-footed pots are the normal recipients for sauce but
not millet. An alternative is the black pot with the pedestal foot. Within the
grammar of local usage these forms are 'the same'. Widows, however, must eat
sauce out of a pot of this shape but coloured red so that in local usage they are
'different', despite their identical form. Boiled, ground millet – the staple – is
served in a calabash, not a pot, but when a man or woman is in mourning this
is the appropriate vessel for *all* food and drink. Cooking takes place in a stan-

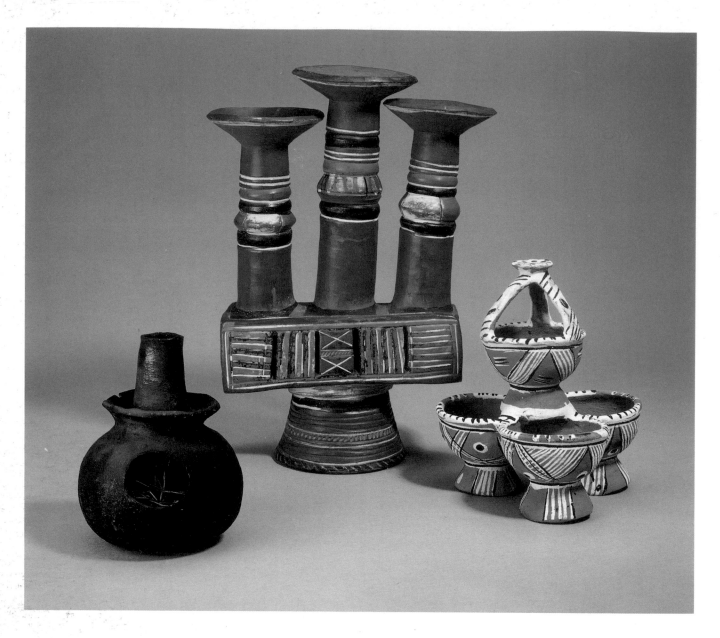

Above, left Black pottery fumigator made by the Tutsi people, Ruanda. Burning pungent leaves and grass, such utensils are used to clean and fumigate milk-containers and clothes. *Centre* Multiple incense burner with black-and-white lined decoration. Geneira, Darfur, Sudan. *Right* Triple lamp with geometric decoration coloured with red and white slip. Nupe people, Bida, Nigeria. The lamp, acquired in 1869, has a hollow central section in which aromatic leaves were burned. H. 22 cm, W. 20 cm. Af1980.21.159. H. 41 cm, W. 29 cm, D. 12.5 cm. 5085. H. 18 cm, W. 14 cm. 1906.6–15.52. Presented by T. Behrens Esq.

Right Small lidded tureen of glazed pottery with soldered metalwork surround. Fes, Morocco. This is a new style of pottery, devised in the 1950s, made to cater for a tourist public. A normal glazed vessel is surrounded in soldered wirework to produce a more elaborate, exotic effect. H. 16 cm, W. 11 cm. Af1992,1.29 a and b.

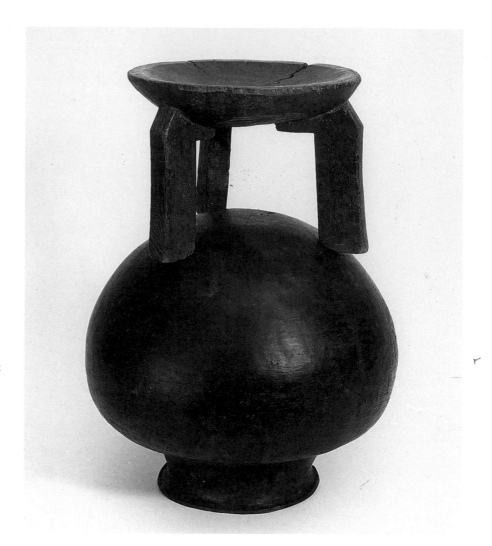

Musical instrument, *amangwengwe*. Bemba people, Kapozwa, (near the Kalambo Falls), Zambia. This composite musical instrument is made of a conventional water-pot and a three-legged stool. The pot is placed faced downwards on the ground and the stool placed over it so that the legs rub against it when turned. The pot resonates to produce a rasping sound. Similar instruments are played by the Mambwe, Lungu and Fipa peoples at festivals, ceremonies and beer parties. As is the case with most pottery instruments, these are played exclusively by women as a sort of counterpart to male drumming. H. 33 cm, W. 38 cm (pot); H. 21 cm, W. 28.5 cm (stool). Af1981,2.80 a and b.

dard shallow, red pot. Widowers, however, cook in a pot on three legs that contains an inbuilt hearth. Dowayos find these vessels intensely funny, embodying as they do the idea of a man doing woman's work. Since there is an absolute ban on sharing food with smiths/potters, the latter can protect their trees, crops and water from theft by attaching to them pots from which they have eaten or drunk. Even touching them would cause disease.

Pots, then, slide over into views about the world and each pot is intimately connected with the social and cultural milieu that creates it. It follows that the stages by which traditional pottery is displaced by imported crockery are not without interest. In Dowayoland, during my first visit some fifteen years ago, it was only the potters who were rich enough to buy imported Nigerian enamelware. My own attempts to buy their pots were interpreted as meanness and greeted with disbelief that my wives would tolerate the imposition of such shameful, old-fashioned pots on them. Even the potters, however, while using old margarine cans to fetch water from the spring, insisted that every woman must have her own pottery water-jar otherwise it would be impossible to organise the ceremonies following her death that involve decorating and dancing with the jar and its use as a 'vessel of spirit'. When I revisited the same village,

several years later, the use of enamelware had spread and now marked off formal occasions, pottery being used for everyday meals. In a pattern that seems to be much the same over most of West Africa, we might expect the next stage to be the disappearance of pottery from everyday use and its restriction to ritual occasions. This is a major innovation in cultures which are traditionally marked by a very restricted range of material culture that is then richly reinterpreted in different contexts. The ritual aspect of much of mundane reality is one of the things that accounts for the distinctive feel of African life. A Romantic might wish to see in this the destruction of that unity of experience that we associate with traditional non-Western cultures.

Even in the nineteenth century, however, there was play with notions of authenticity. Among the Southern Nigerian Kalabari, for example, after the death of a great trader, a feast was organised at which imported food and drink were offered to guests who had to wear imported dress and eat off English china, while speaking only English. Talbot (1932:237) records local explanations of this: 'Now our dead father has become a very great man indeed; so great as even to dine with white men in the ghost world.' Yet even here, a pot of local manufacture was placed on the actual grave.

This process of adjustment between 'native' and 'imported' may now well be going even further. On a recent visit to a smart Nigerian urban home, I was surprised to find that traditional pottery was used both as high status table decoration and as serving dishes marking the formal nature of the event. In the city, it was the (Japanese) imported glazed crockery, still not yet available in the village, that was now regarded as everyday.

Similar processes have clearly been going on in Africa for a long time.[46] The blue-glazed ware that is regarded as typical of Fes (Morocco) and has been made for many centuries is locally classified as *rumi* (i.e. 'Roman', 'foreign'). The simple, single-fired, striped pottery known as *baldi* is locally believed to be the 'original' pottery of the area and is nowadays restricted to ceramic drums (for the *ashura* festival and marriage) and the bowls used to break the Ramadan fast.

At the end of Ramadan, pots should be smashed to mark the return to normality but pots may have many sorts of 'careers'. In our culture, a chipped pot is held to be irrevocably spoiled. There is a cultural concern with matching sets. The tension between the permanence of pottery and its fragility constitutes part of the fascination of pots. The pot that was 'too good to use', once damaged, may be demoted and serve to feed the cat. In other cultures, of course, different ideas may obtain. In Japan the value of an ancient pot may be enhanced by an aesthetically provocative repair or an attractively formed crack. In Morocco, chipped pots are not regarded as spoiled. Indeed, the use of spacers in the kiln ensures that most pots have blemishes around the lips and body. It is a mark of the penetration of foreign tastes that some urban potters now retouch these for the tourist market. Elsewhere in Africa, pots may be carefully mended with wire, gum and beeswax – or nowadays with a patch of cement – but even a completely smashed pot still has value. Broken pottery provides floor tiles – often nowadays alternated with metal bottle tops for longer wear – spindle whorls for spinning, finials for thatched roofs, loom weights and chicken coops and above all, tools and roundels for making new pots.[47]

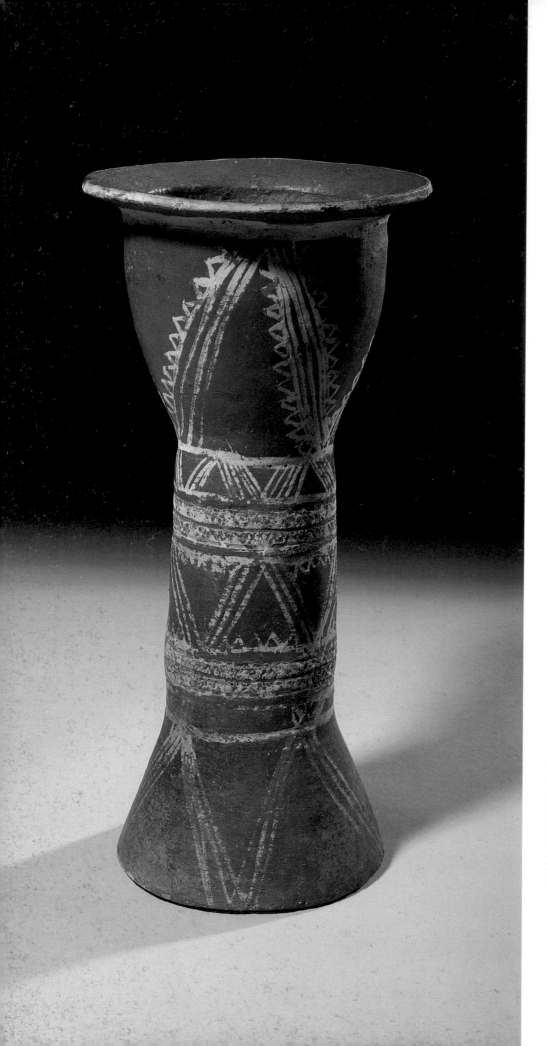

Pottery gargoyle with geometric decoration in white slip. Fika people, Bornu, Nigeria.

This piece was collected by the ethnographer Olive MacLeod on her trek through northern Nigeria, Cameroon and Chad in 1910–11 and illustrated (MacLeod, 1912:267) with the comment, 'Big clay pipes act as gargoyles to run the rain off the roofs, and wooden runnels jut from beneath them to carry the water still farther out.' This is unlikely to have been their only function, however, since they have the classic shape of pot-stands as used by several peoples near Lake Chad. MacLeod herself notes the Fika custom of displaying pots around the walls of a room and an almost identical piece is illustrated as a pot stand among the closely-related Bolewa (Leith-Ross, 1970:39). H. 45 cm, D. 22 cm. 1911.12–14.17.

On the left is a traditional water-pot, with incised and rouletted designs, from the Gwari village of Ido in Minna State, Nigeria. After firing, it was splashed with an infusion of the pods of locust trees to make it water-resistant and guinea corn flour was rubbed into the designs to make them stand out. On the right is a glazed stoneware vessel from the Pottery Training Centre in Abuja, produced under the supervision of the potter Michael Cardew. From the 1950's on, Cardew experimented with the application of the potter's wheel and high temperature firing to traditional African forms. The present example is based on a water-jar like the first piece. The design was introduced to the Abuja centre by the Gwari potter Ladi Kwali (Kwali being her village of origin) who probably made this pot. The Training Centre example uses a modern Western glaze so that it is much heavier and unlike the traditional form it does not 'sweat' to cool its contents. The bottom is flat instead of rounded so that it stands more easily on an even surface. So it is unsuitable for the transport and storage of water. It is also much more expensive to produce than the original vessel, being fired in a kiln. H. 44 cm, W. 45 cm. Af1989,14.11. Presented by Michael O'Brien, Esq. H. 29 cm, W. 27 cm. Af1993,2.114. Presented by William Fagg Esq, CMG.

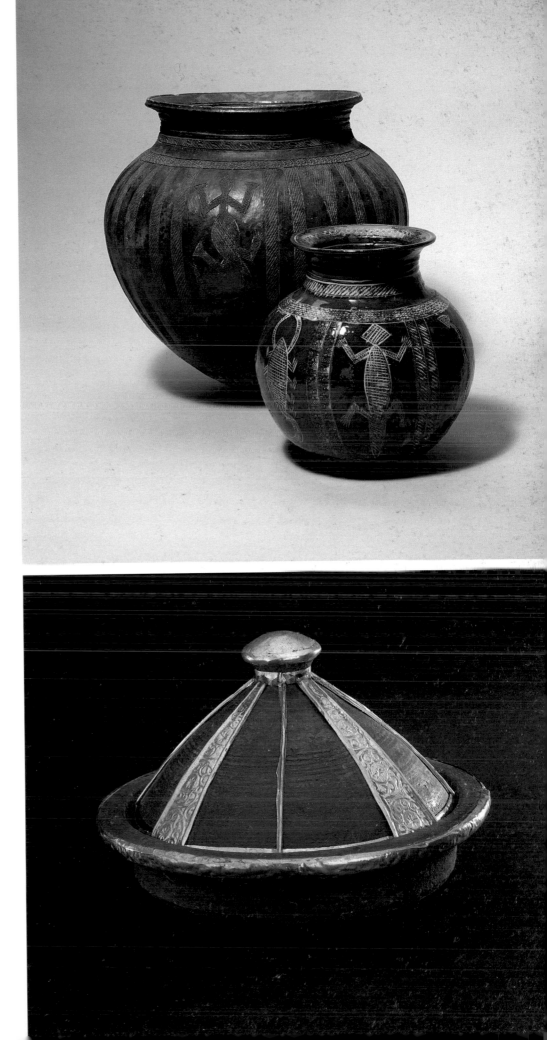

Brown pottery *tagine* dish with applied strips of stamped brass. Marakesh, Morocco. This is a new style of pottery, spuriously exotic, made to meet tourist demand. The *tagine* stew is a typical Moroccan dish for which this shape of vessel has traditionally been used. The body of the pot is made of ordinary country ware that is dyed brown to 'age' it. Strips of brass are snipped out of larger sheets and soldered or even glued to the lid. H. 14.5 cm, D. 22.5 cm. Af1992,1.82 a and b.

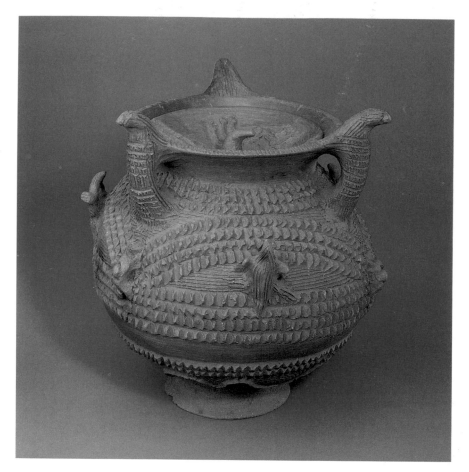

Lidded, three-handled jar in orange clay with heavy relief decoration. Made by Winnie Benson, Oja village, Akoko-Edo people, Nigeria. H. 33 cm, w. 34 cm. 1971.Af36.262.

From left to right Burnished red pot with an incised geometric pattern coloured black and white; burnished red pot with band of black-and-white geometric decoration below the rim; burnished red pottery bowl with graphite panels. Venda people, South Africa. H. 19 cm, w. 29 cm. 1933.1–9.1. H. 17.5 cm, w. 27 cm. 1933.1–9.3. H. 18 cm, w. 18.5 cm. 1933.1–9.5. Presented by I. Wansbrough Esq.

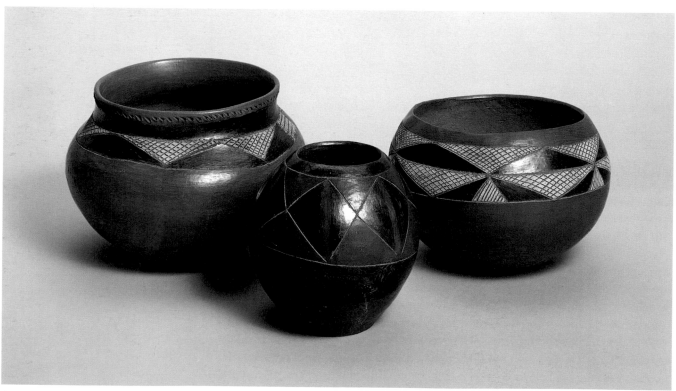

Pottery vessel with handle, decorated with a geometric pattern executed in black resin. Fes, Morocco. A whole range of vessels – bottles, beakers and cups – are made in this light ceramic material. They are decorated by hand. The craftsman holds the pot on his lap, spinning it with the left hand while the fingers or thumb of the right hand are dipped in resin and dabbed up and down the revolving vessel. A geometric pattern rapidly emerges. The tar imparts a special taste to the water contained in the pots and to this are attributed all manner of medicinal properties. H. 36.5 cm, w. 16 cm. Af1992,1.83.

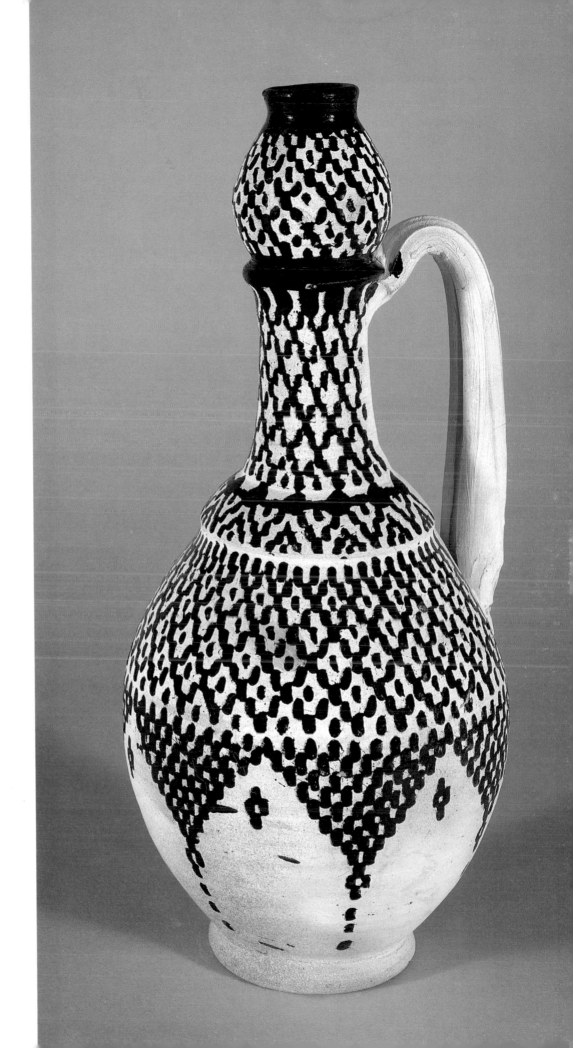

Left Ritual vessel, *iran*, encased in red felt with attached antelope horns, cowrie shells, elephant hair and bell. Bijogo people, Bissagos Islands, Guinea Bissau. Among the inhabitants of the Bissagos archipelago, many objects – carvings, drums, stools – are locations of power, *iran*. While the number of spiritual forces is enormous, a common ingredient is antelope horns filled with animal and vegetable matter such as are attached to the present pot. Bells of European manufacture are worn by humans at festivals and may be hung on ritual objects and shrines to attract the attention of special powers. As early as the sixteenth century, European navigators remarked on the insatiable Bijogo appetite for red cloth. Red is said to be especially associated with royalty, sacrifice and fire and often linked with *iran* (Gallois Duquette, 1983:167). H. 36 cm, w. 18 cm. Af1979,19.9.

Right Heavily ornamented pot with handles and moulded and incised decoration. Edo people, Benin, Nigeria. The pot is from a woman's Olokun shrine, kept filled with fresh water and associated with her fertility. The pregnant female figure is a cult devotee. The pythons moulded around the vessel are the messengers of the god. H. 34 cm, w. 28.5 cm, L. 30 cm. 1948.Af2.12.

Vessels of Spirit

Even in English usage, pots have lips, mouths, necks, shoulders, waists, feet, bellies and bottoms. Pots lend themselves to thinking about the human form. This is an old intuition but the richness of the image is such that it constitutes something of a cultural theme in West Africa. Barley (1984:99) has remarked:

> Potting involves a number of changes. It takes formless matter and shapes it. It transforms, through the operation of heat, from wet to dry, soft to hard, raw to cooked, natural to cultural, impure to pure. Broken pots can be reground and incorporated into new pots to show the reversal of time. Pots lend themselves to abrupt fracture to mark isolation, destruction, 'a clean break'.[54] They are above all vessels and so may be used to refer to bodily cavities – heads, wombs, bellies, rectums. They lend themselves readily to discussions of spirit, conception, essence and the like.

African pots – like human bodies – often provide locations for spiritual essences whether these be ancestors, nature spirits or 'deities', diseases or human capacities.[55] Pots readily lend themselves to a language of inside/outside, container/contained. Often this may involve the creation of a humanoid image although not necessarily so.[56] Rather, it presupposes the body as a container of forces. The precise nature of this containing power of pots is often unclear. It may be in the clay of the vessel or the cavity itself. It may involve a disease directly or the 'spirit' that causes that disease. African notions of this sort are at present ill-analysed and ill-understood.[57]

In conscious and unconscious symbolism, however, thinking with pots is extremely common in Africa. In more general terminology, the potting process is a scenario (Lakoff and Johnson, 1980; Lakoff, 1987; Fernandez, 1991) that provides a concrete experience that can serve as a model for organising other experiences. In the West, such scenarios are often drawn from technology and used to structure – amongst other things – models of the body. Thus, the notion of the circulatory system of the human body, developed in the seventeenth century, was dependent on the previous invention of pumps of a new sort. In the 1950s the human brain was conceived of as a sort of 'network' based upon the latest forms of telephone exchange. Nowadays, following the invention of the computer, the brain is understood as a data-processor. Such scenarios, it is urged, directly influence the way we talk and think about ourselves and the cultural world we live in.

In a recent article, Onians (1991) has argued that the ancient Greek philosophical concern with form and identity – as shown by both Plato and Aristotle – draws on the vocabulary and techniques of artisanal production, especially that of pottery. Problems of identity and the relation between ideal and concrete form are related to the problems of small-scale production and long-distance trade where *deigmata*, demonstration examples of pots to be copied, provide the link between the metropolitan centre and peripheral consumers and imitators.

We have seen (Chapter 2) that in West Africa there is a widespread model by which potting and procreation are assimilated to each other. Fardon (1990:30) writes of a wholly typical example among the Chamba (Nigeria/Cameroon):

> Sometimes an analogy with the potter's art is made, and the creation of a child is imaged in the act of God as a potter forming the child from the claylike substance of the mother. The analogy is carried through in the conceptualisation of the newborn child as wet, soft and red.

Dowayo water-jar, Cameroon.
Photo: N. Barley.

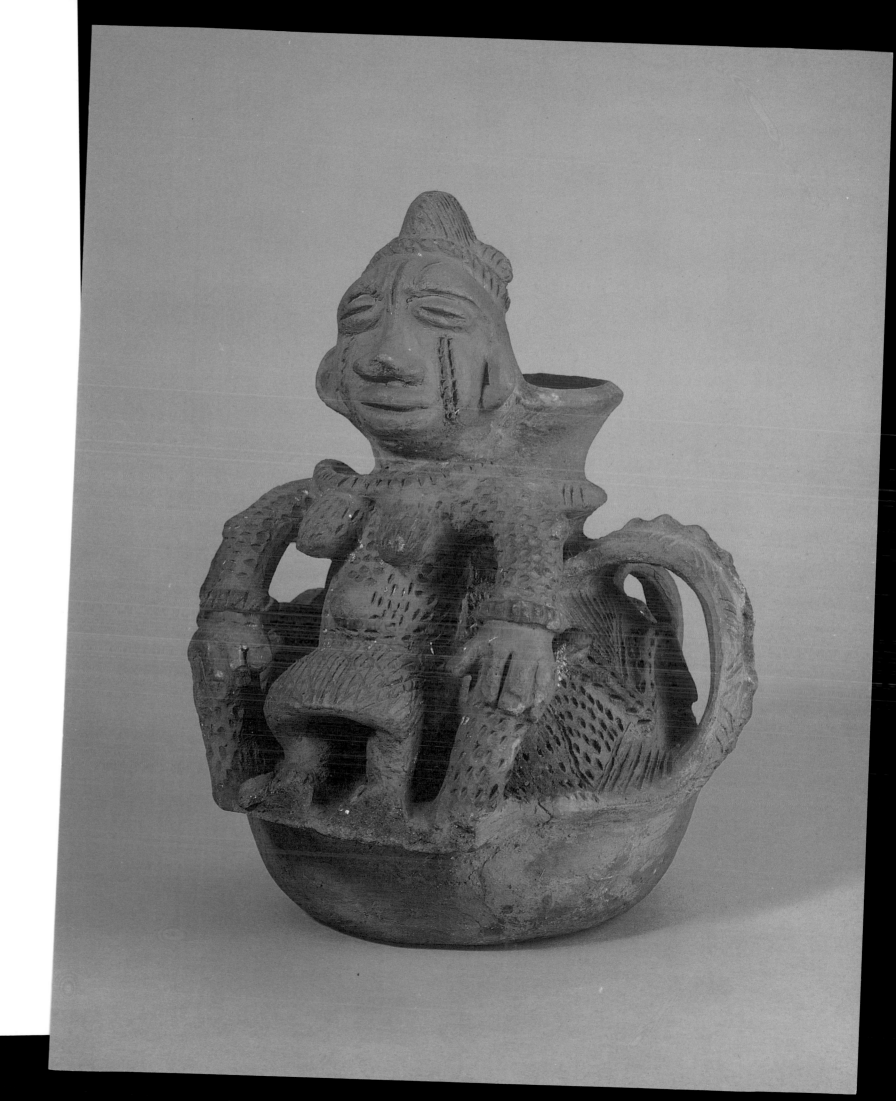

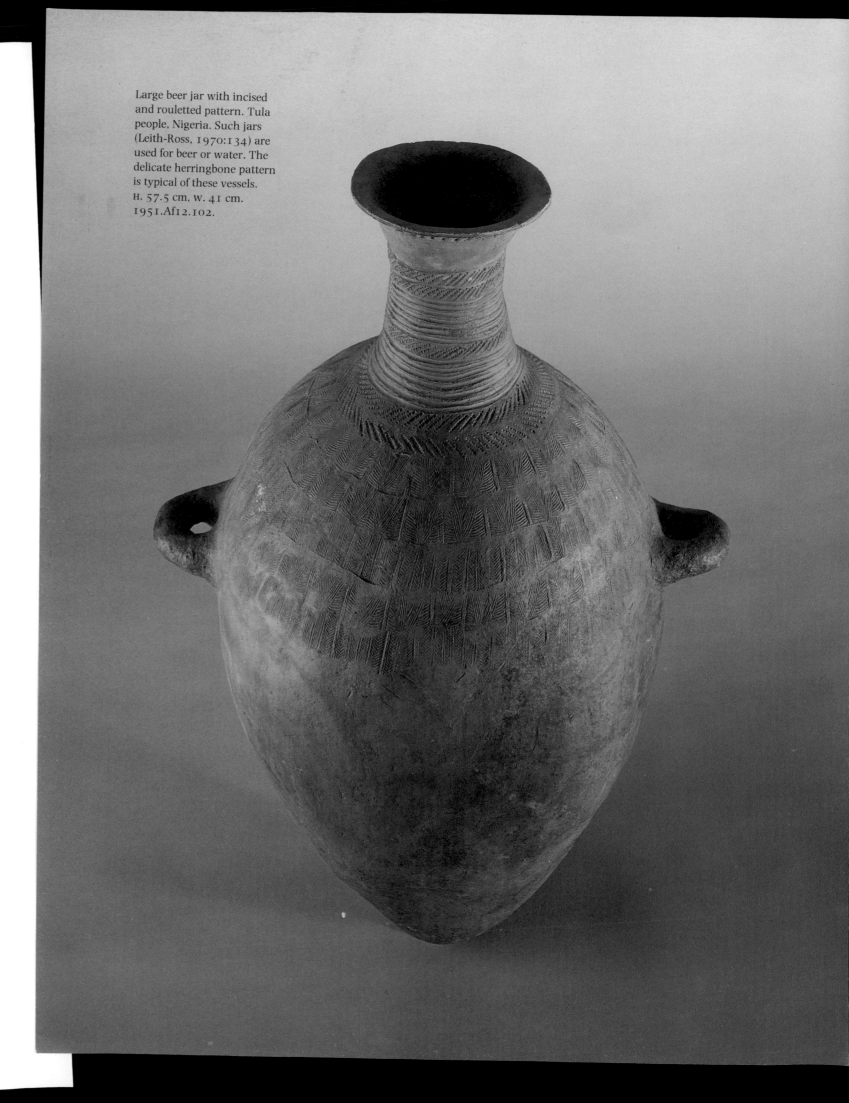

Large beer jar with incised
and rouletted pattern. Tula
people, Nigeria. Such jars
(Leith-Ross, 1970:134) are
used for beer or water. The
delicate herringbone pattern
is typical of these vessels.
H. 57.5 cm, w. 41 cm.
1951.Af12.102.

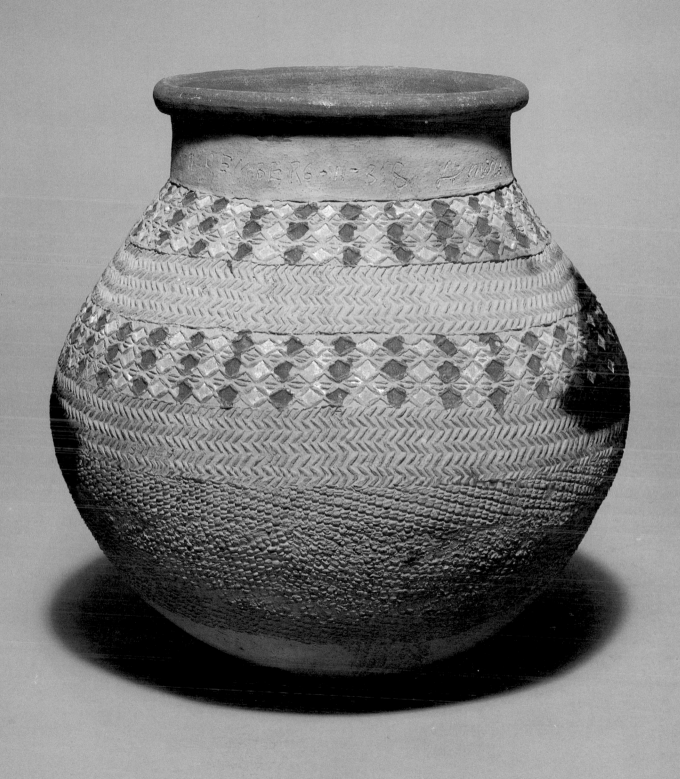

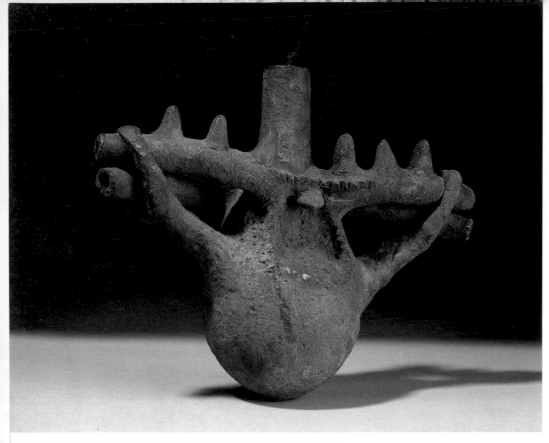

Small red pottery vessel with spiky transverse arms and projecting tongues. Waja people, Bauchi Plateau, Nigeria. No information is available on this unusual vessel. A formally comparable piece has been published by Pearlstone (1973) as having been recorded among the neighbouring Mwona people by Arnold Rubin in 1970. There it is used for the curing of a chronic cough which is enticed into the vessel. H. 24 cm, W. 28 cm, L. 28 cm. 1913.10–13.10. Presented by Mr. and Mrs. C. Temple.

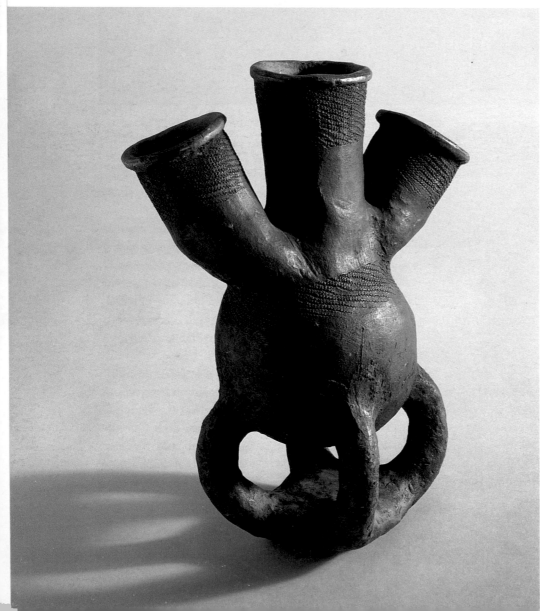

Large pottery vessel with multiple spouts and rouletted decoration incorporating a hollow stand. Ganda people, Uganda. According to Roscoe (1911:335) vessels of this kind were used among the Ganda for administering treated beer to those about to be immolated to the gods. The documentation associated with the piece remarks, 'From it victims before sacrifice drank "medicine" to kill the spirit. Princes drank from the mouth marked *a* [the central spout], Peasants from that marked *c* [the right] and Chiefs from that marked *b* [the left]. The victims were sliced up with a knife and the pieces roasted on a framework over a fire.' H. 37 cm, W. 31 cm, L. 20.5 cm. 1902.7–18.11. Presented by Rev. E. Millar.

Janus-headed, red pottery vessel with bulbous, spiky body. Longuda people, Wala Longuda village, Bauchi Plateau, northern Nigeria.

Concerning the Longuda, Meek (1931:351) writes: 'Longuda religious ritual is directed mainly towards the pacification of the spirits of disease. Small pottery images known as *kwandalowa* are used for this purpose. In these pots the disease-producing spirits take up their abode, and diseases are transferred from the human body to the pots, which are kept in miniature huts as shrines.

Each disease or class of disease is personified, and there is, therefore, a great variety of *kwandolowa* cult ... These cults may be passed on from father to son, but normally a man obtains his own cult or cults for himself. Thus if a man is suffering from a general feeling of sickness accompanied by headache he will go and consult an old woman who knows all about the *kwandalowa* ... The woman takes some soft clay and touches the patient's head and abdomen. It is believed that the disease-producing spirit enters the clay ... The spirits are always given a human form, i.e. the belly of the pot represents the body, the neck the neck. A headpiece with eyes, ears, nose and mouth is added, and arms are fashioned along the body of the pot. But each spirit has differentiating features. When the woman has completed the shaping of the pot she circles it round the patient's head, and then hands it over to him. The owner takes it home, fires it and deposits it in a shrine close to his house.' H. 40 cm, w. 14 cm. 1929.7–14.2. Presented by S. Walker Esq.

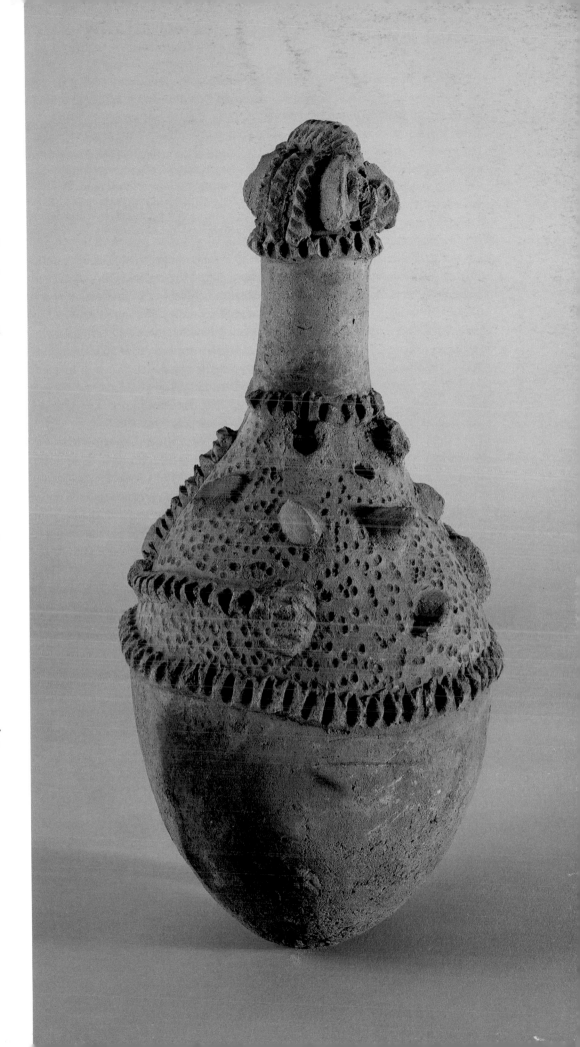

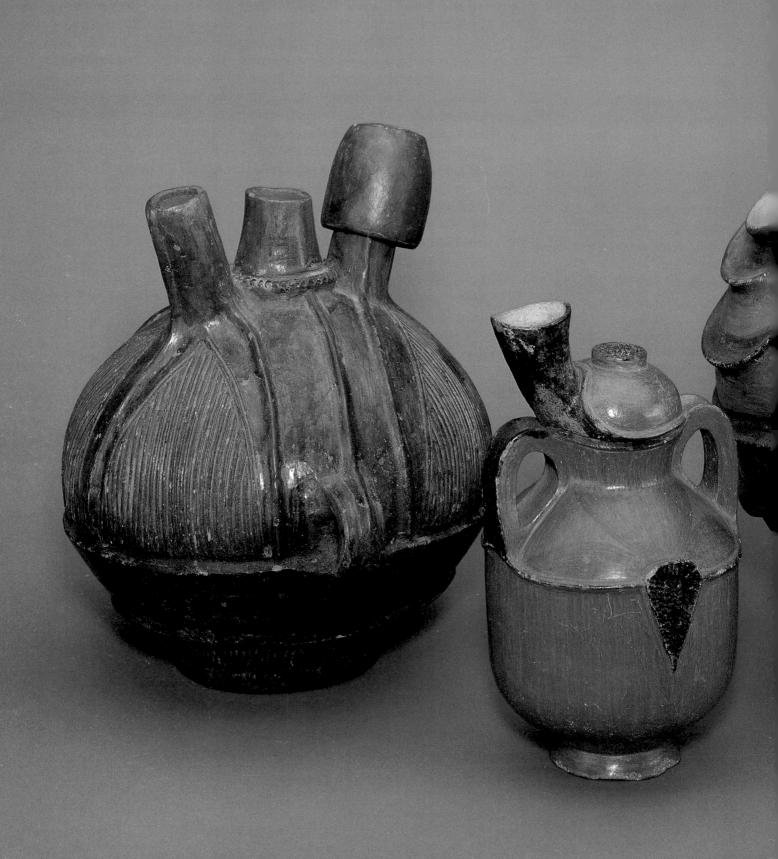

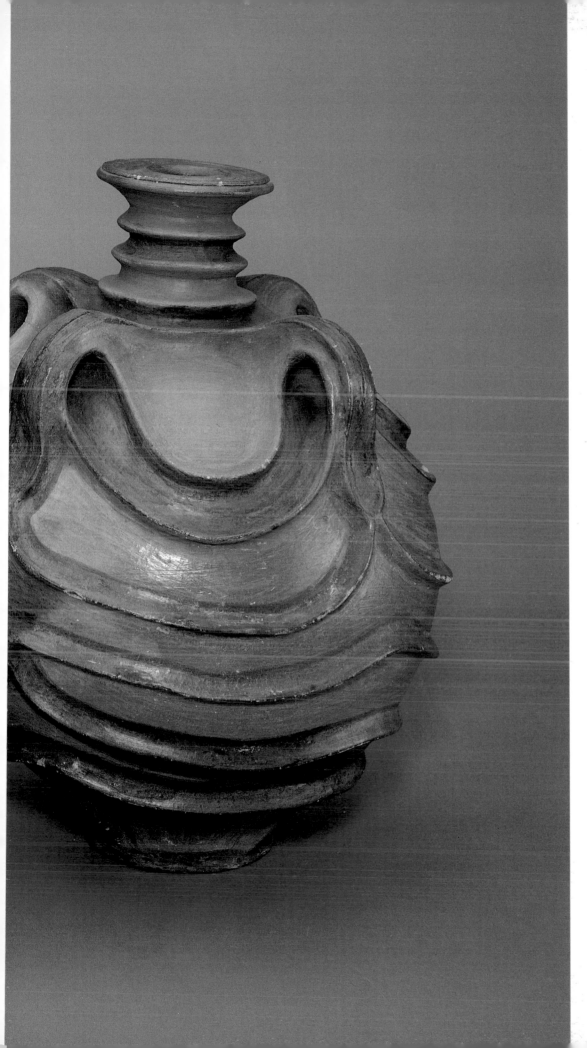

From left to right Red clay
beerpot with incised and
rouletted decoration and a
cup that acts as a stopper.
Igbo people, Igede,
Nigeria; burnished red-
and-brown-ware water-
container with flared
spout and handles. Igbo
people, Nigeria; brown
pottery water-jar with
four handles and curving
patterns in relief. Igbo
people, Inyeriye, Nigeria.
H. 32 cm, W. 29 cm,
L. 36 cm. Af1978,18.28
a and b. H. 28 cm,
W. 16.5 cm.
1954.Af23.1062.
Presented by the Trustees
of The Wellcome
Historical Medical
Museum. H. 44.5 cm,
W. 29 cm. 1924.12–
17.62. Presented by the
Chief Secretary to the
Government of Nigeria.

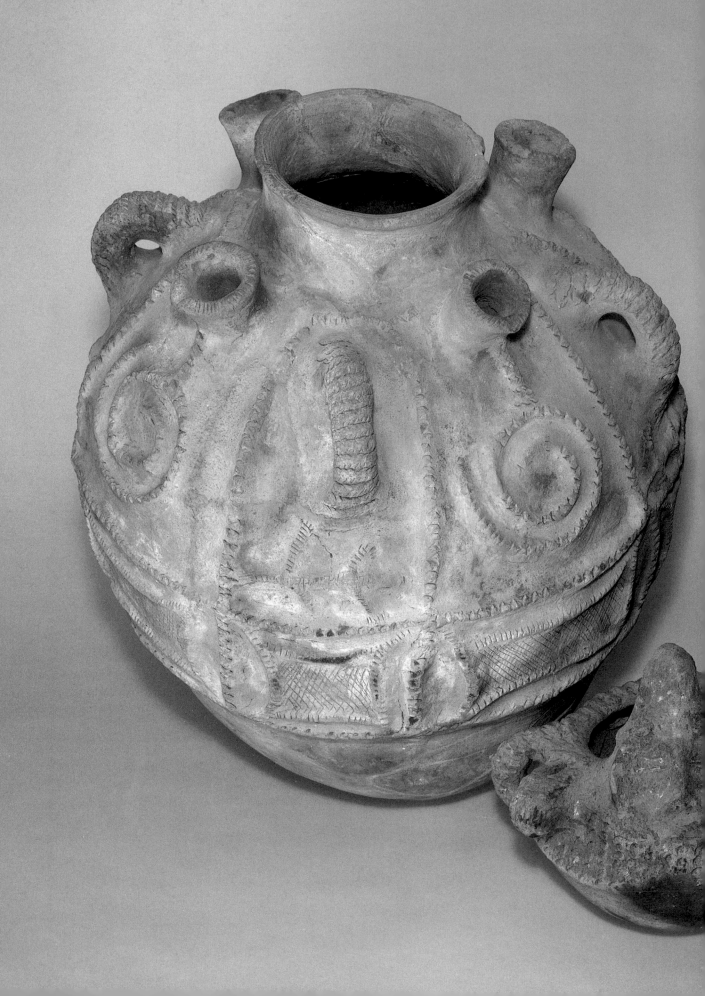

Large, pottery vessels ornamented with snakes and lizards and a pot with a human face made by the Ijaw people, Okrika, Southern Nigeria. These *oko* pots were made as part of the funeral rites of notables. They were kept with other ritual paraphernalia in the house shrine. The twisted ornamentation recalls the twisted brass bracelets of this area that are symbols of wealth and often found on ancestral altars. Fish and other offerings were laid in the vessels. H. 51 cm, w. 44 cm. 1950.Af45.7. H. 61 cm, w. 47 cm. 1950.Af45.9. H. 26 cm, w. 29 cm. 1950.Af45.1. Presented by P. Amaury Talbot Esq.

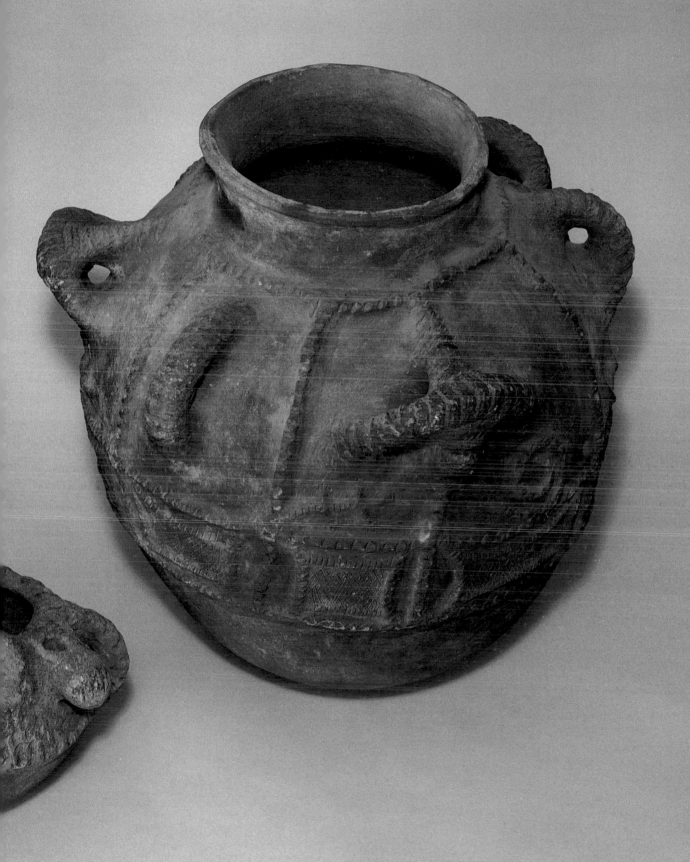

Red pottery water-vessel with decorative plaitwork about the neck. Bagirmi people, Fort Lamy, Chad. H. 27 cm, W. 19 cm, L. 21 cm. 1911.12–14.82. Presented by Miss O. MacLeod.

Right Large, slip-painted, pottery water-jar. Igbo people, Southern Nigeria. The pot is ornamented with panels and circles of different colours, separated by raised lines. A comparable but uncoloured vessel is discussed by Trowell as a titled woman's palm wine container used to make offerings at a shrine (1970:166). The ornamentation is taken to represent a sling of knotted cord. This is an old Ibo form (Stoessel 1984:40) going back at least as far as the Igbo-Ukwu pots (ninth or tenth century). H. 49 cm, W. 40 cm. 1954.Af23.997. Presented by the Trustees of the Wellcome Historical Medical Museum.

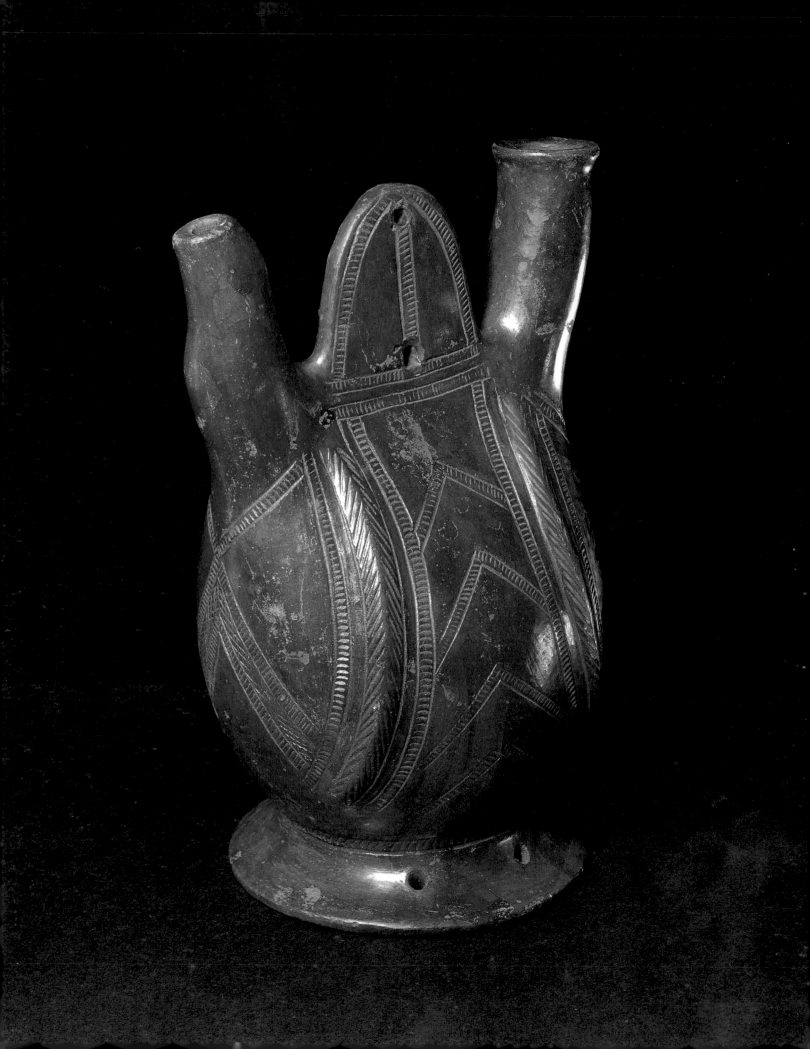

—6—
Pots as Instruments of Harmony

In their treatment of American Shaker furniture, Edward and Faith Andrews (1950:336-7) document the way an aesthetic can acquire the status of a morality:

Suppose a table were required for the ministry's order . . . The piece had to meet the minimum specifications for strength and convenience. But even a crude table would meet such standards. The Shaker joiner went further. The aim was to improve, to perfect, to make a table superior to any world's table. The 'Holy Laws of Zion' had admonished him to labour until he 'brought his spirits to feel satisfied': whatever is fashioned, they ruled, 'let it be plain and simple, and of the good and substantial quality which becomes your calling and profession, unembellished by any superfluities, which add nothing to its goodness and durability'. 'Think not that ye can keep the Laws of Zion while blending with the forms and fashions of the children of the unclean!' For conscience sake, then, the table must be well-proportioned, have grace and purity of line, as well as plainness akin to the humility of Shaker life.[67]

African pottery, should its career lead it to a museum in the West, often similarly acquires the status of an object testifying to the virtue of a way of life. There is little evidence that most Africans use it in quite this way. In East, Central and Southern Africa, however, there is a widespread ritual use of pottery in the teaching of moral knowledge to the young. Terracotta figurines may be used in puberty, birth and ancestral rites (Cory, 1956) or for initiation into special groups. Such terracottas are often representational figurines and as such appeal to European artistic taste. The best documented tradition however, that of the Bemba *chisungu*, uses principally pottery vessels (Richards, 1956; Corbeil, 1982) and local terminology lumps these together with figures and plant samples under a single didactic heading of *mbusa*, 'emblems'.

Chisungu is a female puberty rite now greatly in decline.[68] It normally occurred between onset of menses and marriage and, among other things, marked the assumption by a girl of full responsibility for female procreative powers and the dangers that went with them. Girls were initiated by older midwives undergoing instruction, humiliation and testing at their hands. The focus of the process was the exhibition of the *mbusa* 'emblems', principally of pottery, with associated 'explanations' and songs, together with an arcane 'secret' vocabulary for everyday things.[69] Not surprisingly, given the context, the burden of the explanations homes in on the duties of wife- and motherhood. Thus we have:

'The husband with the plumes' . . . This is a pineapple-shaped vase with an irregular hole at the apex about eight inches high. It is covered with small projections and painted half white and half red . . . The company sings the honour due to the husband who comes with plumed head-dress like the warrior or chief of old days. While she still wears this head-dress, the initiate takes the little [clay] spoon and pretends to pour the water over the husband's hands with it and rubs the floor beneath with the other hand. This is a further representation of the wife's duty to wash her husband's hands with the water out of the ceremonial pot after intercourse . . .

'Nkololo', the tattoo marks . . . [a lidded pot with raised ridges]. The Bemba people laugh at the Bisa saying, 'You must remove your tattoo marks.' The lesson for the wife: If you are Mubemba, do not laugh at your husband's manners which are strange to you, nor must you laugh if he is poor or crippled. He is still your husband. (Corbeil, 1982:57.)

When discussing the corresponding rite of *cinamwali* among the neighbouring Cewa, Yoshida (1992:266) remarks that female initiation depends on the

Red burnished pottery vessel with two spouts from Omdurman, Sudan. The vessel imitates in clay the leather water-bottles used throughout north-East Africa. The incised decoration mimics the stamping and contrastive stitching found on leatherware. H. 22.5 cm, w. 15 cm. 1948.Af6.33.

Previous page Pottery *mbusa* emblems from girls' initiation rites. Bemba people, Zambia. *From left to right* The first emblem is called 'the squatter'. It is accompanied by a song: 'These are the hills/Those are the hills/We lived in a ravine' (Corbeil, 1982:58), referring to a man with two wives. This is a situation which a young girl is urged to avoid by being a good wife. The 'hills' (the difficulties of life) are represented in the ridges on the pot. The second emblem is 'the waste of firewood'. It represents the husband, sitting at home all day, wasting firewood on the fire, because he is jealous over his wife. The third is called 'the lion', which represents the husband or midwife. A roaring noise can be obtained by blowing into the vessel. The fourth is 'the pestle and mortar', representing an ideal married couple. The fifth emblem is called 'cover up the headdress'. The associated song announces the closure of the ceremony and the girls are urged to cover up the long feathers of their headdresses that are represented on the pot. The emblem on the far *right* is 'the beerpot'. Only initiated girls may drink from such a vessel. H. 18 cm, w. 16.5 cm. 1972.Af14.297. H. 15 cm, w. 19.5 cm. 1972.Af14.305. H. 26.5 cm, w. 24 cm, L. 23 cm. 1972.Af14.296. H. 13 cm, w. 15 cm. 1972.Af14.302 a and b. H. 16 cm, w. 18 cm. 1972.Af14.293. H. 25 cm, w. 19.5 cm. 1972.Af14.304 a and b.

female skill of potting while males use *men's* plaiting and weaving skills, otherwise used in roofing, to make masks. It is these masks that initiate boys and deal with the dead just as women's skills deal with matters of birth and rainfall, a ritual division of labour that corresponds to the way other tasks are divided between the sexes. After initiation, boys are specifically forbidden to touch pots as part of their new adult, male status.

Amongst both peoples, fertility and rainfall are associated with the python so perhaps it is significant that the python 'emblems' (Richards, 1956:82; Yoshida, 1992:249) are executed in wet clay and not baked. While Richards (1956:68) describes the *mbusa* as being made afresh for the *chisungu* ceremony, Corbeil (1982:10) declares:

The pottery models which are fired are not made before each ceremony, but are dug out from the bottom of the river, from a secret place known only to the midwife in charge and her daughter. They are decorated with red and white powder at the beginning of each ceremony and buried again at the end of it, at the original place in the river bed.

Through the ceremonies, then, there runs a thread of symbolism drawing on the qualities of heat and damp. This recalls the West African concern with 'vessels of spirit', in which potting may be seen as a way of thinking about cultural transformation. Thus, an uninitiated Bemba girl is scorned as *citongo* 'an unfired pot' (Richards, 1956:120) and the whole ritual basis of chiefly power is implicated in the use of fire, sex and the relations between the two. In Eastern Africa, however, this is often articulated into a broader more wide-ranging pattern that de Heusch (1980:39) terms 'a perfectly original thermodynamic philosophy'.

Ethnographies of East Africa are full of remarks about the political place of fire, the risk of pollution through the hearth, the semantics of 'hot' as a word that encompasses danger and excitement and the use of heat as a way of enforcing moral sanctions about sexuality.[70] It is almost inevitable that potting will enter into this. In a reanalysis of Junod's (1910;1931) ethnography of the Thonga of Southern Africa, de Heusch (1980) shows convincingly how concepts of the gestating and maturing body are related to heat and danger. A clearer picture will emerge from the events surrounding childbirth.[71]

At the birth of the first child the relatives visit the mother, clap and dance as they sing, 'I praise my cooking pot which did not crack!'[72] Birth is like firing, which amongst this people takes place in a pit.[73] All illness is like temporary excessive heat and the term *hola* for the recovery of a sick person is described as applied to a 'cooking pot, heated by fire that is put aside to cool' (Junod, 1910:138). Sex always involves heat and different sorts of childbirth are at different points on the heat scale.

The hot blood of miscarriage is particularly dangerous since it causes scorching winds that dry up rain and (Junod, 1910:140) may shrivel up a man who has sex with the woman who has miscarried. In some areas, drought can only be prevented by digging up the bodies of aborted children and reburying them in damp soil near rivers.

Twins, like miscarriage, threaten the country with drought. There must be constant applications of water to the mother of twins and to the graves of such children. They are referred to as 'sons of the sky' and are dangerously involved

Shallow pottery bowl with chevrons of red slip on a graphite background. Venda people, South Africa. H. 18.5 cm, D. 23 cm. 1930.1–28.6. Presented by H. Braunholz Esq.

Overleaf from left to right Brown pot with buff, geometric pattern. Sotho people, Lesotho; lidded red pottery vessel with three handles made by the Sotho people, Lesotho. The vessel shows clear European influence although it entered the museum collection in 1891; yellow clay bowl used as a milk vessel. Sotho people, Lesotho; red slipware bowl with raised ridges and bosses. Kgatla Sotho people, Lesotho. H. 18.5 cm, W. 26 cm. 6083. H. 28 cm, W. 24 cm. +5165 a and b. H. 18 cm, W. 24 cm. 3122. H. 15 cm, W. 19.5 cm. Af1985,11.43. Presented by Miss Powles.

with celestial fire, excessive heat. They are not laid on ashes and shown to the moon like other children after their birth.

Premature children, on the other hand, 'insufficiently baked', are placed in pots and exposed to the sun.

If normal children die, they are buried in a broken pot in ashes, that is, as 'pots that broke in the fire'. The process of maturation after birth is regarded as one of progressive cooling. Little by little, children may be incorporated into normal life. Shortly after birth in the 'potsherd ceremony' a boy is smoked and rubbed with grease. He may not drink ordinary water. At the end of the first year, the mother will resume menstruation and the parents begin sexual intercourse again after another ceremony. If the child dies up to this point it is buried in a damp place, afterwards in dry earth.[74] Mother and child are regularly strengthened with steam baths.

At the onset of menstruation, girls are soaked up to their necks in water. They may not approach the fire. At circumcision, boys are forbidden to drink water and sex is prohibited. 'Heat' is the subject of obscene joking between men and women. In the morning, the boys are soaked in pools until the sun appears and they must sleep with hot heads and cold feet. Should such a boy die, the mother will be informed by a notch being cut on the pot she uses to bring him food.

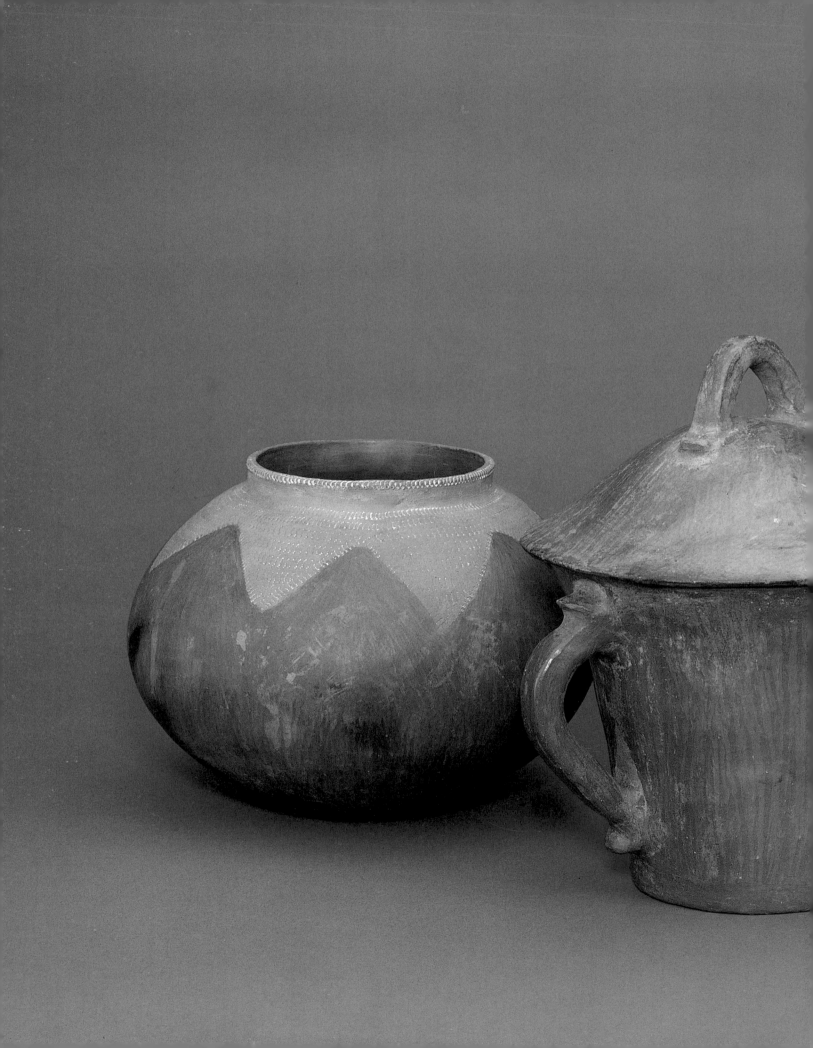

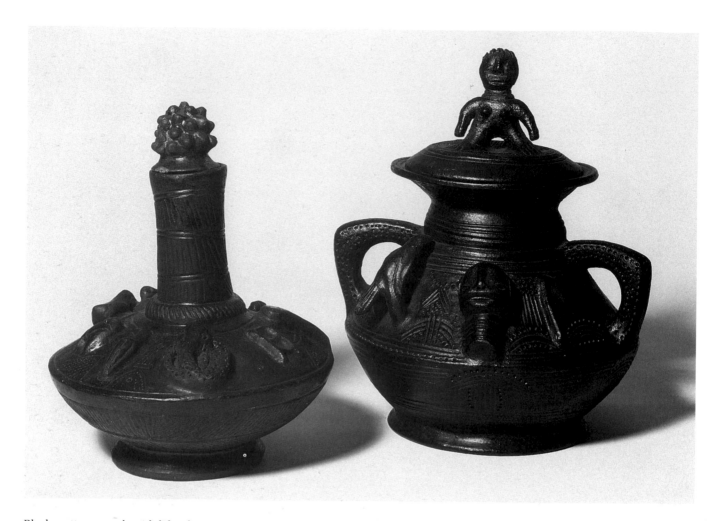

Black, pottery vessels with lids, *abusua ngkuruwa*, or 'family pots'. Asante people, Edubiase Adansi, Ghana. The pots are decorated with images of birds, heads, spiders, ladders and walking sticks. Although such pots are not made any more, Rattray (1927:164) describes their use at funerals of important people as part of a ceremony that definitively separates the dead from the living: 'This pot generally has a lid or cover which has been fashioned to represent the dead ... All the blood relations of the deceased now shave their heads; this hair is placed in the pot. About sundown some of the women of the clan take the whole of the utensils from the *sora* hut [a rough temporary hut on the outskirts of town], the food and the "family pot" containing the hair ... and proceed, being very careful not to look behind them, to the "thicket of ghosts" i.e. the burial-ground where all these articles are deposited, not on the grave but in a part of the cemetery known as *asensie*, "the place of the pots". Here the mortar is set down, the cooking stones are set in position, the cooking pot is placed upon them, the strainer on top, and the "family pot" set down beside them.'

McLeod (1982:158) states that nowadays they may well not be abandoned at cemeteries but kept for safety in a special room with the stools of the dead.

Such pots were made by men and – almost certainly – post-menopausal women and – according to Rattray – closely resemble the ornamental water-pots used by notables in life. The objects represented on both kinds of pots may call to mind proverbs.

Similar pots are made in other parts of the Akan-speaking area but with variations of use. In the Agona district, for example, motifs on 'family pots' are interpreted as showing body scars, body parts and 'fetters'. Motifs are often in triplicate, recalling a saying that 'a god is consulted three times'. The pot is left on the grave of the deceased and placed directly above the head. H. 29.5 cm, W. 25.5 cm. 1935.11–4.2a and b. H. 28 cm, W. 20 cm. 1933.11–8.2a and b. Presented by Capt. R. Wild.

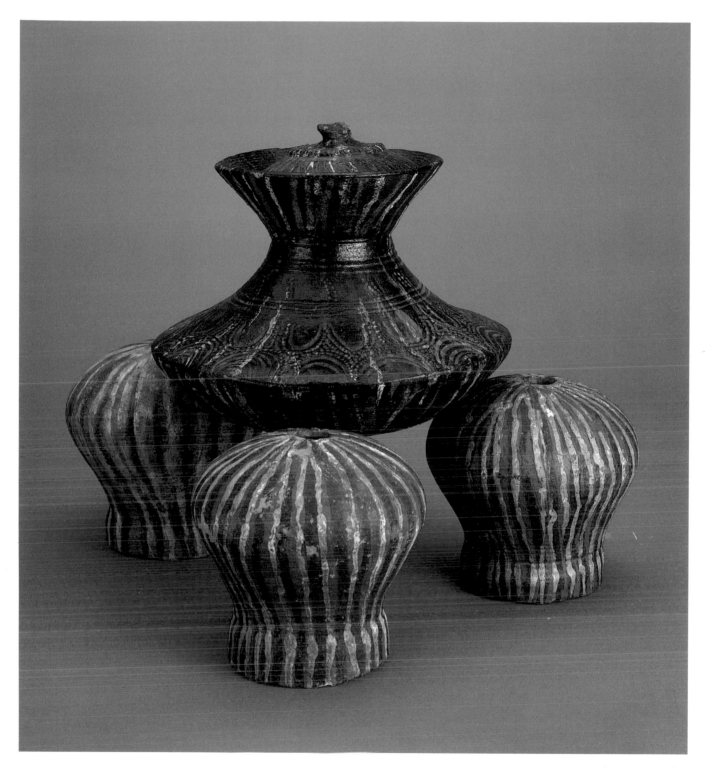

Lidded pot, striped red, black and red, *abusua kuruwa*, resting on a hearth of three striped and pierced pots. Asante people, Abuakwa, Ghana. Assemblies of pots such as these were occasionally used at funeral ceremonies, the pierced pots replacing the conventional hearthstones. H. 39 cm, W. 34 cm, L. 39 cm. 1935.12–12.2 and 2a–c. Presented by Capt. R. Wild.

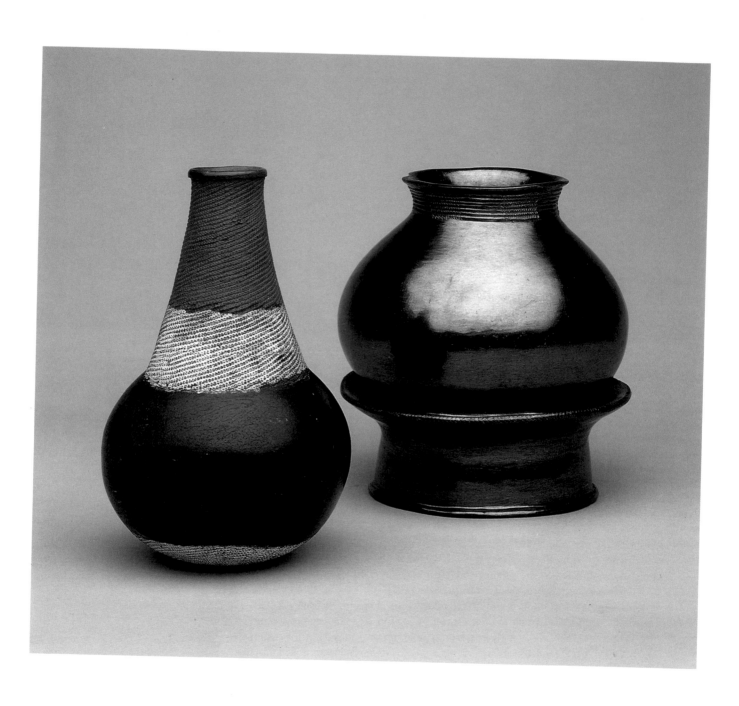

7

Decoration and Innovation

It may seem absurd even to ask the question, 'Why are pots decorated?' It seems obvious to us that it must be that decorated pots are considered more beautiful than undecorated. After all, in many parts of Africa pots are a foremost part of domestic display, being ranged round walls and stood on special stands to amplify their attractions. Yet different cultures differ enormously in the degree to which they engage in surface decoration and the discussion of anything that can be equated with Western concepts of beauty. Moreover, in writings on Africa, the aesthetic has often been subsumed under the sociological because objects and decoration have a sumptuary aspect and are correlated with particular classes of people or stages of life. The question arises partly because recent writers on African objects have been anxious to redress a previous neglect of the aesthetic aspect of artefacts and have stressed the 'artistic' as part of a revaluation of other cultures.[75]

For, according to the crude folk yardsticks of the West, the possession of art and the concern with aesthetic matters confer a culture with status and to deny their central relevance to Africa is – by implication – to deliver a low appraisal of the whole continent.[76] It follows from such views that decoration and 'finish' are to be seen as the expression of a cultural or even universal concern with aesthetic form. At its least extreme, the perspective is that of Boas:

We recognise that in cases in which a perfect technique has developed, the consciousness of the artist of having mastered great difficulties, in other words the satisfaction of the virtuoso is a source of genuine pleasure. (Boas, 1955:25.)

Put more simply, things are better made than they have to be just to work. Such a view subsumes all regularity, concern with quality and decoration to a universal concern of Man mediated, in Boas's view, by motor habituation, so that pleasure seems to lie, for the artist, in the regular rhythms of creation rather than in the finished object itself. It is just this set of internalised gestures and physical routines that Gosselain (1992) sees as the part of potting technique most resistant to change.

Often the problem of aesthetics becomes confused with that of creativity. The West has long maintained a distinction between art (characterised by obsessive individual innovation) and craft (characterised by self-effacing constraint within a tradition). By such measures, African potters are eminently craftsmen/ women/-persons, being born to the task within a cultural tradition. Indeed, skills are frequently passed down from mother to daughter according to a principle that any deviation from convention is a 'mistake' and makes a pot 'wrong'. As a Dowayo potter once expressed it, 'You do not want your children to be unlike other people's children. They should be the same but better. So it is with pots'.

A good pot is thus a good rendition of an already received design but it should not be thought that this means that 'correct' pots are not criticised.[77] Even pots of accepted form will be turned, examined, the sound they make when struck will be noted, the decoration will be declared good or bad, too deep or too shallow. This is typical not simply of material objects but also of the oral literatures of some cultures. The greatest approbation may be reserved not – as in the West – for superficial novelty but rather for the best performance of a story that is already well known.

Milk vessel with graphite glaze, rouletted necks and red and white slip markings, and a pottery vessel with graphite glaze incorporating a ring-shaped stand. Ganda people, Uganda. H. 20 cm, w. 13.5 cm. 1901.11–13.49. H. 19.5 cm, w. 18 cm. 1901.11–13.44. Presented by Sir H. Johnson GCMG.

When innovation does occur, it may be within strict formal and thematic limits. Thus Chadli (1992:92), following Levi-Strauss, declares that the potters of Fes 'do not work to a pattern but improvise within the limits of a traditional set of themes . . .' Yet beside the variation within tradition of which he speaks, a whole set of new and – it must be said – hideous pots, ashtrays and planters are being invented and mass-produced for the tourist trade. Because they are made outside the traditional trade they are not taken into account.

On the other hand, attempts by Fagg (1969), Thompson (1969) et al. to study aesthetically the work of individual potters and sculptors in Africa and elsewhere always end up constituting 'artists' in a Western sense with a Western emphasis on individual creativity.[78] Along with this goes a thoroughly Western notion that individual variation is the proof of cultural and aesthetic importance.

That this is not necessarily the case may be seen from a consideration of Dowayo potters. While the form of pots is tightly controlled and innovation discouraged, each woman has a mud granary that is built by a man but that she decorates entirely according to her own tastes. Some are clearly anthropomorphised by the addition of breasts, hands and navels that also provide footholds for access. Others are decorated with lizards or faces, pie-crust edges, swirls and curlicues. Wild variation is the norm. Both men and women laugh at such play and wave away the earnest anthropologist's questions. These things, they say, are not serious. The proof of it is that everyone does them differently. In different contexts, then, the same women, using techniques that are at least broadly similar, may be either extremely innovative or highly conservative and some inherent lack of aesthetic sensibility or invention cannot be suggested. How, then, is this to be explained?

A woman's granary, it must be noted, is an intensely personal object. It is where precious and secret things are kept, identity papers, medicines, money. To look in another's granary without asking permission is a grave offence. To be assigned sleeping quarters near another's granary is a great compliment. The granary is the core of individual identity. It is the only large and valuable thing that is individually owned. It is very much apart.

Pots, on the other hand, enter largely into that exchange of meanings that constitutes everyday social life and defines relationships and events. Differences of form and decoration help create categories of vessels that may be easily related to categories of time and persons. Hence their tendency to retreat to contexts of ceremonial or display. It might seem obvious that the more ornate pots are, the greater will be their 'ritual' load. In a crude sense, this accounts for a certain amount of the differences between pots. In West Africa especially, lumpy, spiky or multi-spouted pots do tend to be associated with ritual. After all, there are few practical advantages in such friable forms. However, pots often pass from everyday to 'ritual' contexts and back again suggesting that the distinction is merely one of convenience for the outside observer rather than one of substance for the users themselves.

Savary (1970:39) remarks that Dahomean pots for the hearth are better made and finished than those for altars since greater practical demands are placed upon them. The fact that the latter recall the basic forms of the former is

Black pottery vessel with spout and stopper. Chokwe people, Zaire. The Chokwe have absorbed many European objects such as chairs and teapots that they have reinterpreted according to their own notions. Vessels such as this have incorporated the lid into the main body of the pot and transformed it into a human head with elaborate coiffure and facial scarification. Sometimes a removable stopper closes the spout.

Among the Chokwe both men and women pot but using different techniques. Water-containers such as this, incorporating human forms, are made only by men. H. 15 cm, W. 10 cm, L. 12 cm. 1948.Af30.3.

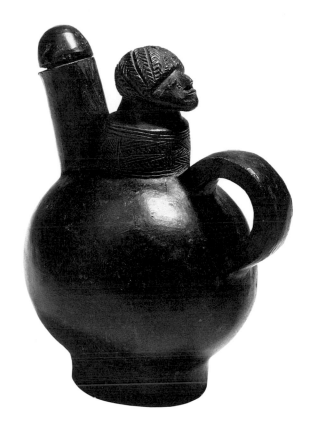

Decorated Dowayo granary in a potters' compound in Cameroon.
Photo: W. Grusch.

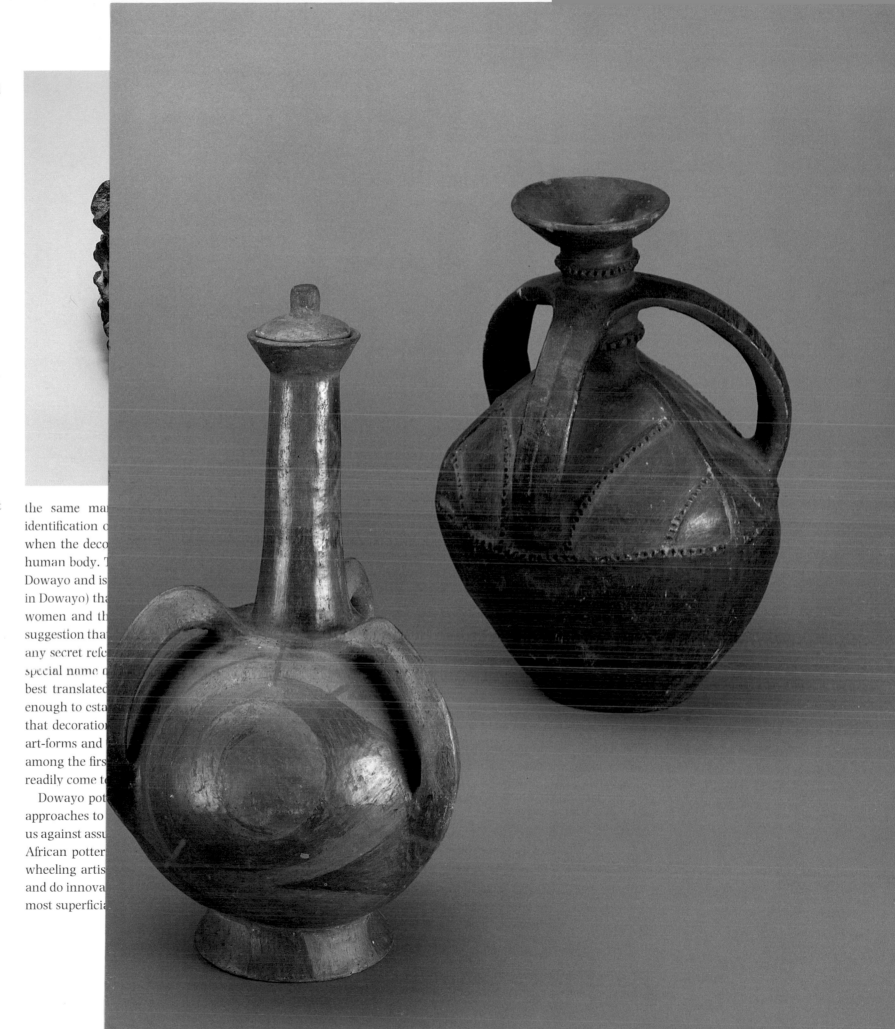

Right Small, spiky pot with four spouts with opposite quarters painted white and red. Ruwenzori Mountains, Uganda. This is a sacrificial pot collected by the explorer J. S. Moore in 1889–90. It was said to be used 'to pour blood to the four winds' following the immolation of a human victim. H. 14.5 cm, w. 18 cm. 1955.Af10.1. Presented by the National Art Collections Fund.

Left, above Black pottery vessel with embossed floral decoration and openwork lid. Asante people, Ghana. This very unusual pot was collected by R. S. Rattray, the eminent ethnographer of the Asante, in Abuakwa, north west of Kumasi. It may well be a unique pot with a unique function. A curiosity is that the handles do not match, despite the regularity of the pot. Rattray describes it (1927:304 and fig. 352) as a *mogyemogye* pot, 'i.e. a jaw-bone pot; it was used to contain the wine poured upon the Golden Stool ["the shrine and symbol of the national soul" (Rattray, 1927:130)]'.

In a personal communication, Malcolm McLeod has noted the close resemblance between the embossed design on the body of this vessel and that on the gold pectoral discs worn by the so-called 'soul-washers' of the Asante court. These, in turn, may be derived from other European sources. Asante is notable for absorbing numerous foreign influences, for example the brass *kuduo* and *forowa* vessels, and converting them for use in assertions of Asante identity. H. 46 cm, w. 30 cm. 1938.10–4.1.

Left Daughter of a deceased woman with a star pattern cut in her hair. Dowayo people, Cameroon. Photo: N. Barley.

the same ma[...]
identification [...]
when the deco[...]
human body. T[...]
Dowayo and is[...]
in Dowayo) tha[...]
women and th[...]
suggestion tha[...]
any secret refe[...]
special name [...]
best translated[...]
enough to esta[...]
that decoration[...]
art-forms and [...]
among the firs[...]
readily come t[...]

Dowayo pott[...]
approaches to [...]
us against assu[...]
African potter[...]
wheeling artis[...]
and do innova[...]
most superficia[...]

Previous spread, from left to right Slip-painted, pottery water-pot with raised ridges; buff water-pot with twin spouts, decorated with raised ridges picked out in red slip. Ekoi people, Southern Nigeria; three-handled, lidded water-pot with geometric motifs in red slip; and a brown water-jar with three handles decorated with raised ridges. Ekoi people, Southern Nigeria.

Talbot (1912:287) remarks: 'The belief has gradually grown upon me that among the Ekoi there exists the germ of a love of beauty almost Greek in character, though warped, and indeed all but overwhelmed by the introduction of blatantly hideous European wares, with which the country has been flooded.

'Wherever suitable clay is found infinite pains are taken to mould even the water-pots into beautiful shapes. None of these are used for house decoration, as would be the case with us, so that the time spent in moulding the many-handled, strangely graceful jars must be exacted by that indwelling love of beauty, which, debarred from expression on almost every side, finds an outlet in this one primitive art. There is no market for the pottery, it is made solely for domestic use. Obviously a jar with slender neck from which spring three or four thin, outstanding handles is far more likely to break than the plainer pottery in general use among more civilised peoples – such indeed as the comparatively cultured inhabitants of Northern Nigeria. H. 36 cm, w. 28 cm, L. 22 cm. 1932.7–8.1. Presented by P. Rattray Esq. H. 34 cm, w. 24 cm, L. 28 cm. 1950.Af45.107. Presented by P. Talbot Esq. H. 37 cm, w. 23 cm. 1949.Af30.1. Presented by L. Hooper Esq. H. 36 cm, w. 24 cm. 1950.Af45.109.

importa
expresse
Western
Commu
indicate

The d
tant 'soc
against

8

Motifs, Motivation and Motives

Western research on African 'decoration' has tended to stress certain topics while almost wholly neglecting others. The history and diffusion of individual motifs has been studied[81] while little work has been done to comprehensively compare different media among the same people.[82] The Nupe, for example, use similar patterns on calabashes, houses and hammered brass vessels but they overlap only partly with those on pottery (Leith-Ross, 1970:101; Trowell, 1960:pl.IV). There is no need to investigate such overlap in terms of one-way borrowing. Sharing of motifs between media may lend itself to very simple functional interpretations. Thus Gurense (Ghana) domestic pots are often only minimally decorated or quite plain while those used in burial ceremonies are decorated in ways that recall wall painting. This can be seen quite plausibly as establishing a link between the old and new home of the deceased.

But in Western perspectives on African decoration, there is always a tendency for the researcher to establish a lexicon of word-like, named motifs, assume that the name of a motif is what even a purely abstract pattern *really* represents and bestow a symbolic significance upon the represented object.[83] Should no clear dictionary-type identification be offered by locals, this will be explained as due to the ignorance or deliberate concealment of informants and a sad proof of the decline of the craft.[84] Such seems to be the case with Bynon's (1982) survey of the motifs used to decorate Berber (N. African) pottery, which are found on a whole range of other materials. There is a long tradition (e.g. Westermarck, 1926) of seeing the geometric motifs of Berber design – whether on textiles, leather, pottery or the human form – as deriving from earlier naturalistic depictions of objects and animals (Searight, 1984). Repetition, it was thought, encouraged a process of stylisation often related to a Muslim *pudeur* that avoids representational images. Inversely, other early scholars argued equally convincingly that decoration moves from purely geometric to naturalistic. While disclaiming this tendency, Bynon in fact takes it a step further and associates Berber design with sharp, dangerous objects evoking disgust, connected therefore with remedies against the evil eye.[85] According to this view, then, the 'decorative' motifs that a Westerner assumes to be intended to attract and delight the eye are there to repel and confuse it and avoid the disastrous effects of envy. So it alerts us to the possibility that the accurate identification and naming of motifs may be largely irrelevant to their meaning and function, while the mere 'decoration' of a pot may be intended to act as a protection for the contents.

Researchers on Africa have readily assumed Islamic *pudeur* or 'horror vacui' as an immediate explanation for geometric surface decoration.[86] Yet, there are other examples of a special place being allocated to figurative decoration that have no link with Islam. The following is a nineteenth-century description of the shrine of the Kalabari (Southern Nigeria) national deity Owamekaso:

Their Ju-Ju house in the original town was a much larger and more pretentious edifice than that of Bonny, garnished with human and goats' skulls in a somewhat similar manner, unlike the Bonny Ju-Ju house in the fact that it was roofed over, the eaves of which were brought down almost to the ground, thus excluding the light and prying eyes at the same time; at either side of the main entrance, extending some few feet from the eaves, was a miscellaneous collection of iron three-legged pots, various plates, bowls and dishes of Staffordshire make, all of which had some flower pattern on them, hence

Double-spouted, red water-pot with burnished leaf decoration from Angola. The vessel was collected in Angola before 1875. H. 30 cm, W. 15.5 cm, L. 14.5 cm. 1958.Af14.23. Presented by H. Bassett Esq.

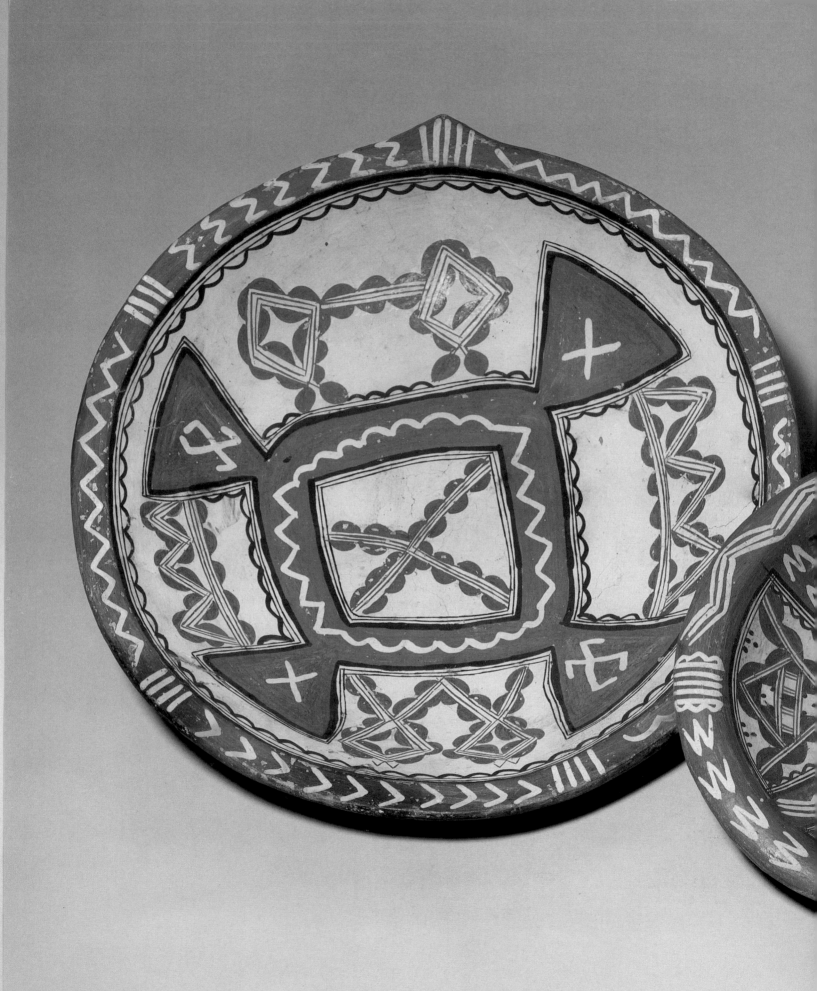

Shallow, red and white slip-painted bowls with
handles. Berber people, Maatka, Algeria.
H. 8 cm, D. 40 cm; H. 6.5 cm, D. 27 cm.
1974.Af20.34 and 36.

were Ju-Ju and not available for use or trade – the old-fashioned lustre jug, being also Ju-Ju was only to be seen in the Ju-Ju house, though a great favourite in Bonny or Brass as a trade article – at this time all printed goods or cloth with a flower or leaf pattern on them were Ju-Ju. Any goods of these kinds, falling into the hands of a true believer had to be presented to the Ju-Ju house. (De Cardi, 1899:506.)

A picture of a Kalabari woman (Talbot, 1926,II:393, fig.104) captioned 'just before the tying of the first cloth' (i.e. at puberty) shows leaf designs applied to her entire body, suggesting again that leaf designs have been pre-empted for ritual use. Indeed modern Kalabari still speak of an association between Owamekaso who protects women's bodies from male insult and the wearing of plants and plant patterns. So here the position of pots is reversed. Foreign vessels are forbidden and removed from the everyday world because they overlap with local designs on bodies.

We must not assume, then, that the appropriation and exclusion of certain figurative designs in Africa is always due to external Islamic influence.[87] More-over what is or is not figurative cannot be simply assumed. Roy (1987:57) in a discussion of a number of potting peoples of Burkina Faso, shows that all these themes may be involved in a single example when he remarks:

Finally, most groups apply modelled clay patterns to the walls of jars that are to be used for rituals or for spiritual protection of the contents. The Kurumba are famous for the large, heavy, fired-clay jars that women keep in their kitchens to store grain. These are decorated with patterns that represent the scars applied to the abdomen of a married woman who has borne a child, and are symbols of human and agricultural fertility.[88]

Similar problems seem to underlie even the study of 'trademarks' on African pottery. Among the Kamba of Kenya (Lindblom, 1920:539) the mark each potter makes on her pots is clearly to avoid confusion after communal firing,[89] similar to the 'short incised horizontal or vertical bands, short incisions on the mouth, and appliqué pellets' of the Dogon potter (Bedaux, 1988:379). It ensures each woman receives back all and only those pots she has made herself and that the ownership of broken pots cannot be disputed.

In the 1940s, Jeffrys (1947:84) noted some forty-five signs distinguishing the products of different potters in an Ogoni (Nigerian) market but he tells us nothing of the circumstances in which they are fired, nor of any local exegesis of the forms. In this area it is quite possible that this is an Nsibidi-type pictographic writing[90] and not simply arbitrary marks. Earthy (1933:56) remarks concerning the various potters among the Lovenge (Mozambique):

Designs are made with a thorn or shell. They represent the 'handwriting' of the potter, her 'trade-mark'. The designs are round the neck and mouth, and almost always are said to represent body scarifications . . .

The regularity with which Africans associate motifs on pots and those on the human body is very striking and it is abundantly obvious in old carved wooden figures that scarification was one of the primary arts of Africa. As Rubin (1988:15) comments, 'Tattooing was not practised among the dark-skinned peoples of sub-Saharan Africa, south Asia, Melanesia and Australia, since the pigment would not show up; cicatrization or scarification were typical of these areas.' It suggests the intriguing but ultimately unprovable possibility that here is to be found the explanation for the relative unimportance of polychrome and

Large pottery vessel, Fort National, Berber people, Grande Kabylie, Algeria.

Such vessels are made to contain water or oil and often leaned against a wall for greater stability. Berber pots traditionally stress symmetry and balance in the use of designs. Within a basic shape that recalls the female form including breasts and pubic triangle, the vessel is divided into two symmetrical 'faces'. Each of these is subdivided into two symmetrical but reversed panels. The overall form of the vessel also stresses balance with the decoration of the top echoing that of the bottom. Grande Kabyle pots use a background of burnished red and white slip on which designs in mineral colours are applied by brush before firing. The pot is then rubbed with plant resin to protect them, turning the white to yellow.

Berber patterns seem to draw on a common stock of geometric motifs that date back to the Mediterranean Bronze Age and show close affinities with Cypriot and Sicilian pottery of that period. Their distribution on pottery within North Africa closely correlates with zones of Roman occupation (Camps, 1987). Micaud (1970:40) remarks, 'Most of the women of North Africa have a strong predilection for this family of decor and use it on their rugs, their shawls, their pottery. They may well derive their repertoire of designs from their tattoos, of which they are exceptionally proud.' It is perhaps significant that the predominant blue dye of tattoos is potblack while pots must be hung on a wall with their blackened surfaces pointing to the outside.

The raised motif in the centre is known as 'the hand of Fatima' (daughter of the Prophet), a protective device against envy and witchcraft. H. 89 cm, W. 34 cm. 1973.Afi 1.1.

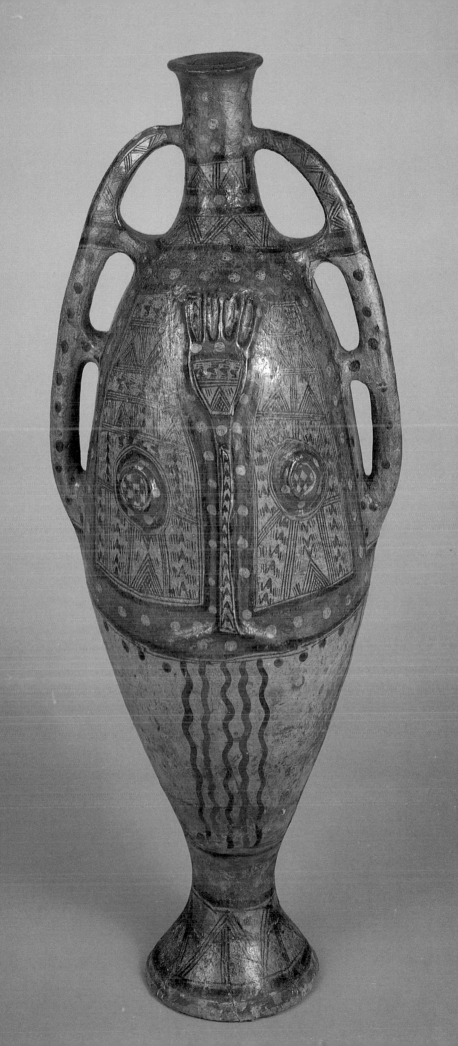

Dark brown pottery double pedestal vessel. Igbo people, Southern Nigeria. The vessel was collected by the anthropologist M. D. Jeffreys in Awka in 1930. Jeffreys (1939:138) was particularly struck by the occurrence on pottery of a form of ornamentation that he regarded as derived from wood-carving. Since the technique is subtractive in both wood and clay, there seems little reason to assume that it was translated in one direction only. The vessel was used for offerings. 'In them is placed the sacrificial food and oblation of wine when offered to a sky god *Chuku*, to *Alushi*, and to the ancestral spirits *Ndichie*.' H. 18.5 cm, W. 39 cm, L. 19.5 cm (max). 1954.Af23.1012. Presented by the Trustees of the Wellcome Historical Medical Museum.

ways. To detain them, they must be attacked in a similarly serpentine fashion. This can be done with the two votive signs. The same anti-witch and -sorcerer function can be exercised by wavy-line, wrought-iron staffs . . . armlets . . . and pendants . . . as well as pots with a wavy line on them.' The designs, then, are motivated by providing a schematic outline of a ritual and linguistic praxis that, in English, we might gloss as 'obliqueness' or 'indirectness' or whatever, but that may have no simple equivalent in the language of their makers – indeed may be a way of by-passing the lack of a term.

An argument has recently been advanced for a sociological model of decoration (David, Sterner and Gavua, 1988:365–89). The idea is that the human body is often used as a metaphor for the social body (i.e. society) and pots and bodies are often metaphorically linked. Lines of classification and concepts of pollution would ultimately tie up with protective patterns on pottery and the body. So societies of certain types would necessarily favour the decoration of pots with sociological and cosmological messages and others would not.

In a type of small-scale society . . . – the Anuak may serve as an example – social classification is much weaker but group pressure remains strong . . . Here the body is a subject of anxiety. Individuals are subjected to unresolvable conflicts, played out in the idiom of witchcraft. Accusations and therapy continually define the social boundaries. In such societies pottery would hardly be elaborated in such a way as to reinforce principles of social structure, and we would expect less homogeneity and standardization at the levels of motif and design. Where would we find elaboration? (David, Sterner and Gavua, 1988:388.)

Yam shrine at Osisa, Nigeria. 49–50/65/3. Photo: W. Fagg, courtesy of the Royal Anthropological Institute.

Right Pottery vessel with figures. Igbo people, Osisa village, Nigeria. The vessel was made for the altars of the yam deity, Ifijioku, probably in the late nineteenth century. The central, male figure represents a chieftain with signs of status such as hat, fan and carved elephant tusk. Over one shoulder, he wears a manilla, the currency of the area and thus a sign of wealth. The women on either side are heavily scarified and sport elaborate hairstyles. The one on the left is pregnant. The one on the right is suckling a child. Before them sits an attendant with a gong and an altar of the hand by which a notable may gain good fortune. The top of the chicken is a removable lid.

Decoration of possessions and the body with lined patterns such as those on the front of the vessel (known popularly as *ichi* lines) is a traditional mark of high standing. H. 47 cm, W. 36 cm, L. 25 cm. 1951.Af1.1.

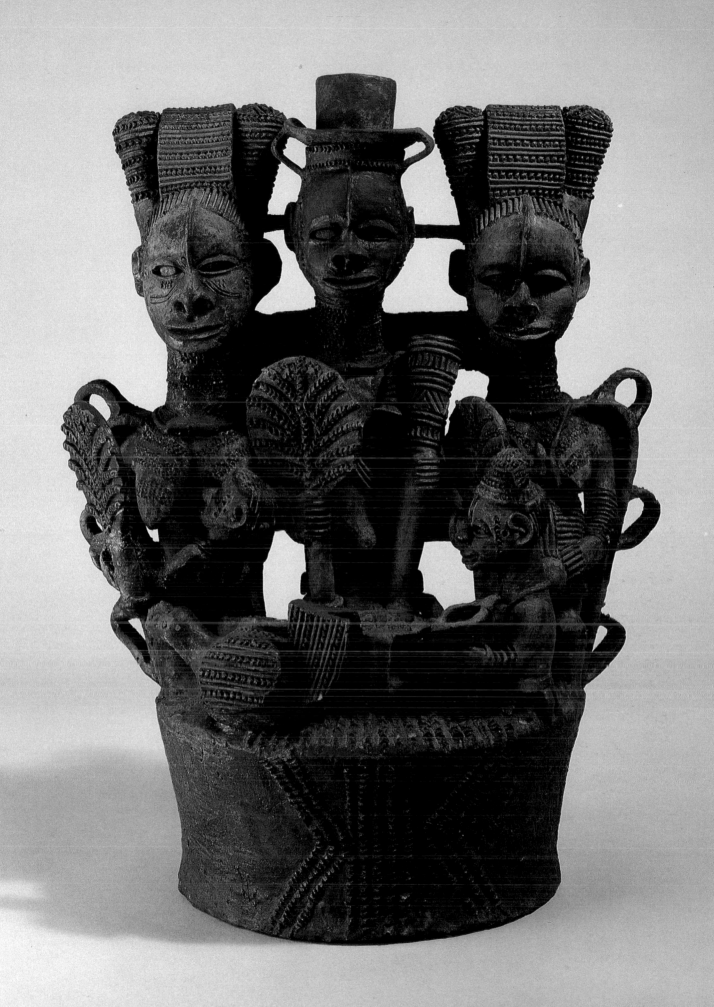

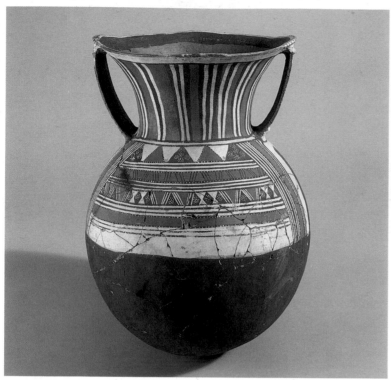

Large red pot with broad handles, painted with red and white slip patterns. Niamey, Niger. H. 49 cm, w. 35 cm. 1971.Af36.258.

Wisely, the writers do not even attempt to answer their own question which is perhaps a mere sign of archaeological wishful thinking, the desire to be able to automatically read off the structure and symbolic life of a community from one small part of its material culture. In fact the Anuak use few pots and those are relatively basic. Nevertheless they do elaborately decorate houses and human bodies (Perner, 1978) and the metaphorical collapsing of these two is itself a widely occurring cultural phenomenon.[95] In Africa, pottery is just as likely to be 'about' individual physiology, or the nurturing nature of femininity as to be providing a metaphor for society as a whole. Again, a full understanding of the use of 'decoration' would involve a prior analysis of the whole range and uses of containers, the decorative lexicons on which they draw and the relationships between them and not a rush to excessively sociological generalisations.

More rooted in ethnography is recent work by Hodder (1991) on the Ilchamus (Kenya). Here, pottery is not ornamented at all, decoration being preserved for calabashes used to prepare and serve milk. Males regard such decorative work as showing wifely concern but women can also see it as a way of carving out and marking off a sphere where men are dependent on them. The designs used link with those painted on the chests of desirable young men. Elders may perceive devotion to sons where women see the attractions of youthful lovers.

The 'potting model', then, is only one of many ways available to a culture to think about itself. It may transmit different messages to different sections of the community and the African predilection for it amounts to something of a regional stylistic feature. There are many examples of cultures that do not need to encode 'reflexive signalling ... to themselves' (Sterner, 1989:451) in material culture at all.[96]

Burnished, black, globular pot, *ukhamba*, decorated with patterns of raised bosses. Zulu, South Africa. This vessel is said to be made from clay taken from a termite hill and bullock's blood. An alternative description (Mueller, 1917) alludes to mixing soot with the clay before baking. Pots of this kind were used for drinking beer and the raised bosses are thought to recall raised scars on the human body and refer to the status of the user. Identical vessels are made in wood. The cover, *imbenge*, is modern and made of plastic-covered telephone wire. H. 21 cm, w. 25.5 cm. 1934.12–1.5. Presented by E. Martyn Esq.

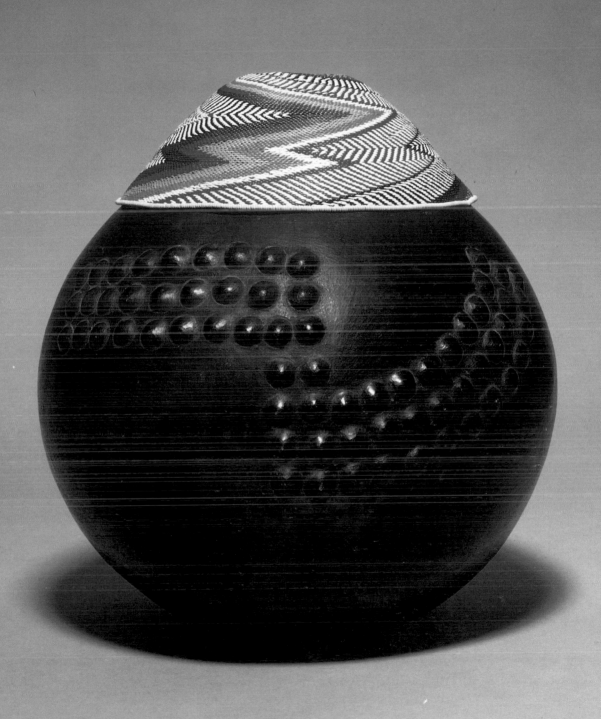

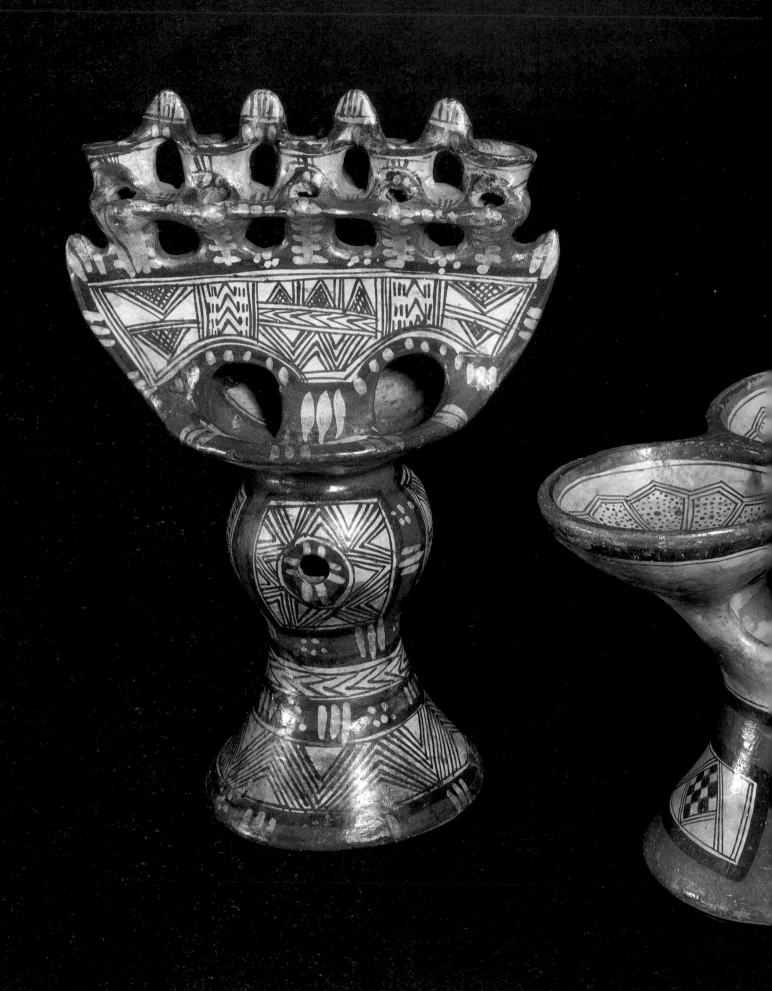

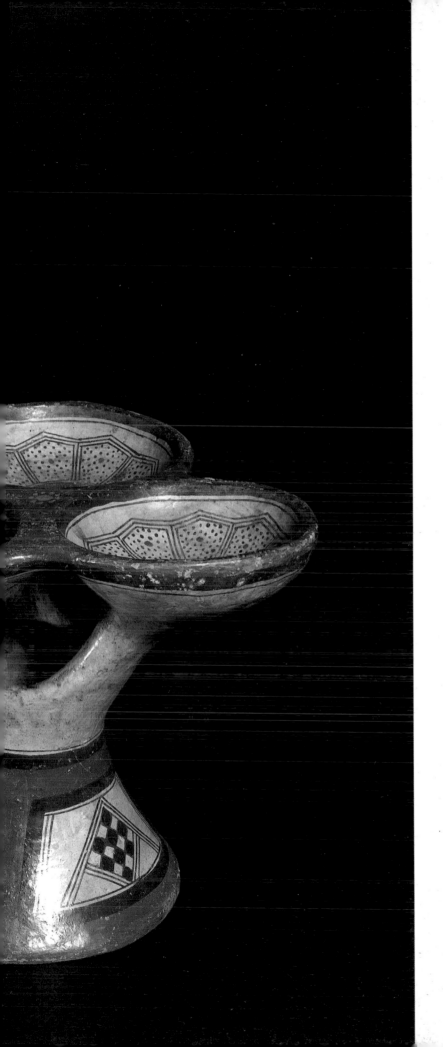

Multiple lamp with red, white and black geometric
decoration and a triple-bowled lamp with geometric
decoration. Berber people, Grande Kabylie, Algeria.
H. 34.5 cm, W. 15 cm, L. 23 cm. 1961.Af15.1.
Presented by Mrs. H. Beasely.

Left Fragment of an elaborate water-pot made by the Azande people, Sudan. The fragment was collected by the renowned anthropologist of the Azande, Evans-Pritchard, who himself trained as a potter amongst them. The form, with its many spouts, appears in other vessels surmounted by a female head suggesting that it may have been a model that was adapted for later anthropomorphic vessels. *Right* Water-pot of clay with mica, incised decoration and surmounted by a female head with elaborate coiffure. This is one of the first Zande water-pots of this type to be documented (Stoessel, 1985:129, Schildkrout and Keim, 1990:230). It was made by a male potter, Mbitim, at Lurangu – a centre of foreign contact – and may have been produced specifically for exchange with outsiders. It seems unlikely that this is a very old design and may only have originated after the turn of the century as a male development of what was otherwise a female skill. Azande people, Sudan. H. 30 cm, W. 30 cm. 1934.3–8.27. H. 32 cm, W. 16 cm, D. 16 cm. 1931.3–21.48. Presented by Mrs. and Major Powell-Cotton.

Opposite Large pottery vessel with incised decoration surmounted by female head. Azande people, Tembura, Sudan. H. 46 cm, W. 32 cm, D. 33 cm. 1931.4–11.3.

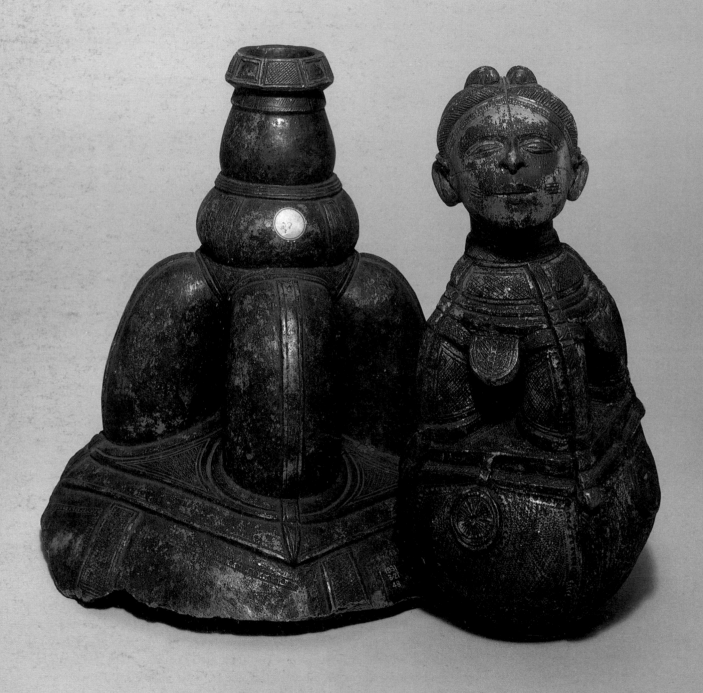

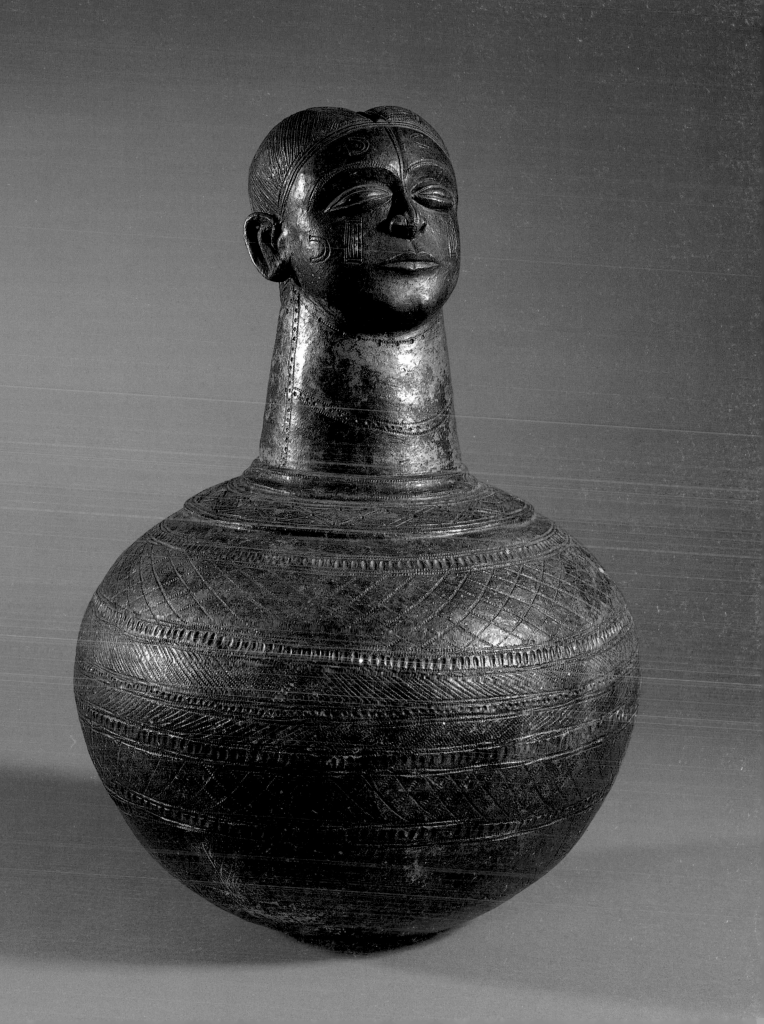

Left Pottery jug with rouletted and incised decoration, topped by a female head with elaborate coiffure. Mangbetu people, Buri (Bomokandi River), Zaire. On the *right* is a pottery jug topped by a female head wearing a brass earring and with two arms attached to the body of the vessel. Jugs of this form were apparently made by a number of neighbouring peoples who found the Mangbetu coiffure a striking visual feature. The documentation on the pot on the left associates it with the drinking of banana wine by elders at boys' initiations but similar vessels had a much wider use for water of palm wine. H. 25.5 cm, W. 14 cm, L. 15.5 cm. 1921.1–8.1. H. 25 cm, W. 18 cm, L. 19 cm. 1971.Af12.1.

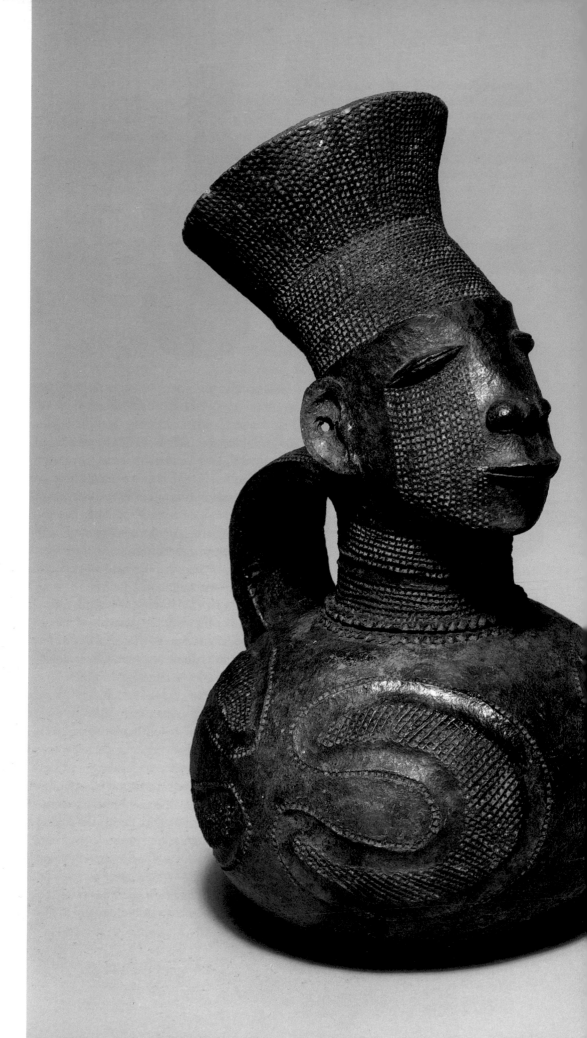

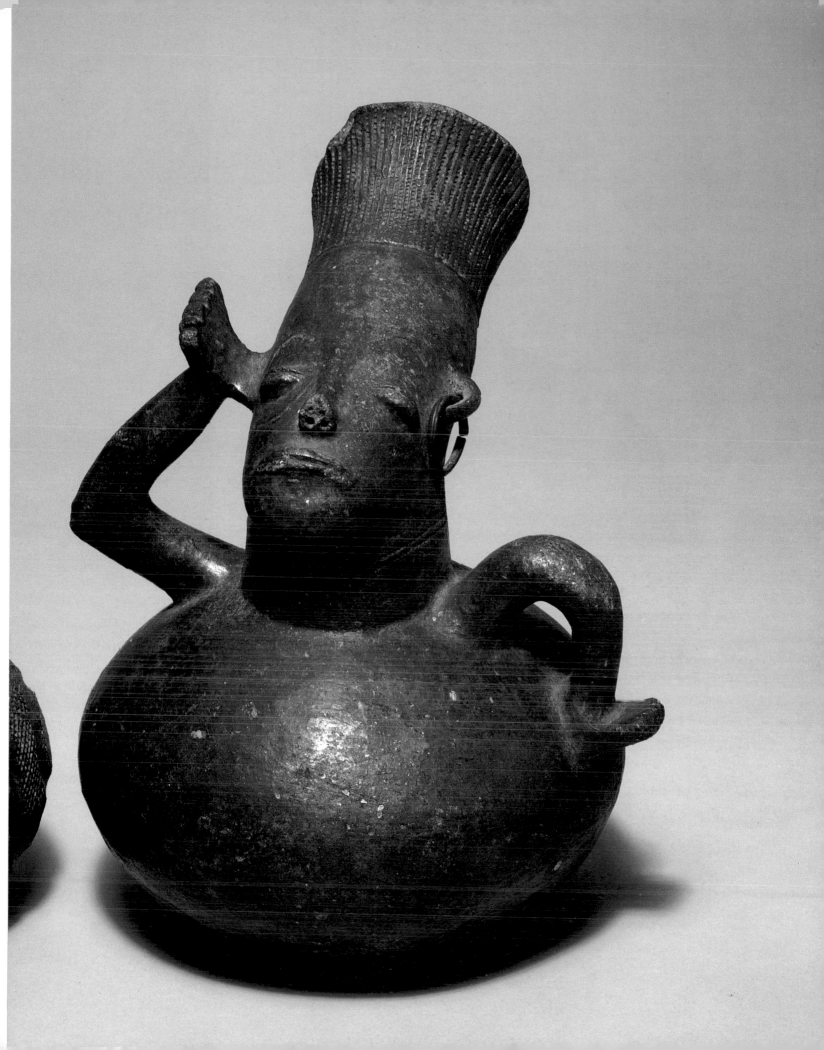

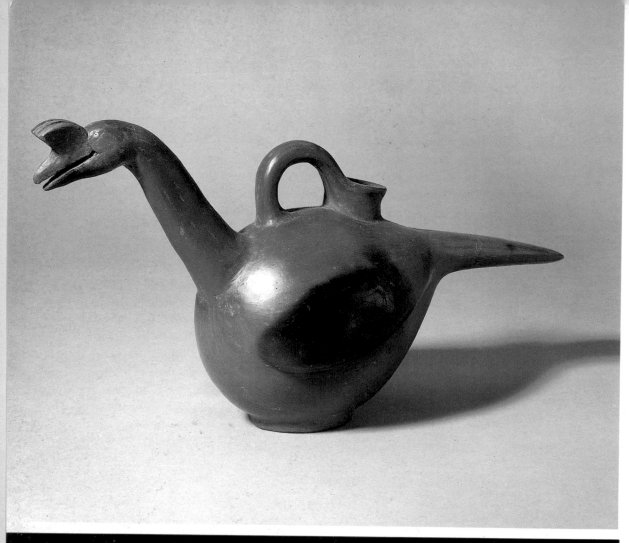

Water-vessel in the form of a cockerel. El Obeid, Sudan. H. 24 cm, L. 43.5 cm. 1948.Af6.31.

Right Large, yellow clay water-pot. Bron people, Ghana. H. 47.5 cm, W. 25 cm, L. 32 cm. Af1979.1.513.

Left Elongated stoppered vessel with zigzag decoration of red and buff slip. *Centre* Cylindrical, ridged vessel of yellow clay with red slip. Sotho people, Lewanika, Lesotho. *Right* Yellow clay vessel with red slip in the form of a pigeon. Sotho people, Lesotho. H. 21.5 cm, W. 17 cm. 1929.11–9.17. H. 29 cm, W. 14 cm. 1929.11–9.12. Presented by Sir Arthur Lawley. H. 12.5 cm, W. 9.5 cm, L. 13.5 cm. 1937.6–17.3.

Black pottery goblet with incised decoration painted with red and white slip and a black pottery vessel with incised geometric pattern rubbed with white slip. Nyoro people, Uganda H. 13.5 cm, D. 8.5 cm. 1949.Af24.44. H. 12 cm, D. 8 cm. 1925–23. Presented by Mrs. A. Milne.

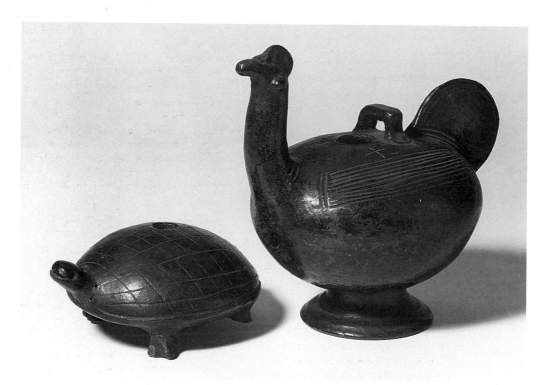

Black pottery vessels on the *left* in the form of a tortoise, and on the *right* in the form of a chicken. Kpandu, Togo. H. 7 cm, W. 3.5 cm, L. 16 cm. 1952.Af7.19. H. 20.5 cm, L. 22 cm, W. 15.5 cm. 1937.11–25.14. Presented by Capt. R. Wild.

Notes

1. The term 'pottery' refers to clay, fired at relatively low temperatures. Conventionally, it includes 'terracotta' (fired below 1000°C) and 'earthenware' (fired between 1000 and 1200°C). 'Pottery' is then contrasted with 'stoneware' (fired to 1300°C at which point the clay will be largely fused).

The main distinction is between those vessels whose bodies are permeable and those which are impermeable.

2. Quoted in Ross (1974:2).

3. In, for example, the work of Cardew (1956), who sought to apply European technology to the production of traditional African forms.

4. Gabus (1958:337) noted that one female potter in Tahoua produced and sold 33 miscellaneous pots in the course of a single week.

An outline of the modern industrial production of Nigerian pots is to be found in Nicolls (1987).

5. See Shaw (1978), McIntosh (1986).

6. See Smolla (1984).

7. An interesting suggestion is that of Gosselain (1992) who urges the study of style within the process of production as opposed to the style of the finished artefact. Since certain parts of the production process offer fewer technological options and are more internalised and less subject to change than others, he argues that these features will be stronger indicators of stylistic similarity than others.

8. African potters, like most non-Western craftsmen, are usually recorded simply by tribal identity and otherwise anonymous. On the other hand, the identity of the anthropological collector is carefully preserved.

9. See Schildkraut and Keim (1990); Vansina (1978). Since, however, this is an area that imports objects of power from the north, whence it also draws many of its pots, other factors than the grossly material may be involved.

10. This section has benefited greatly from the comments of Dr. Olivier Gosselain.

11. Certain incorporated elements are geographically restricted e.g. husks and excrement (Sahel), shells (Senegal coast). This ability of pots to incorporate all manner of material is also symbolically important. Thus, concerning the Bachama (Nigeria), Meek (1931b:41-2) writes: 'In connection with the cult of Nzeanzo there is a sacred pot that is kept at Fare. When a Bachama chief dies or when the pot gets worn out or broken there are special rites for the making of a new one. Application is made to the Ndako of Yimburu who is the guardian of a deep pool of water, at the bottom of which innumerable spirits are believed to have their home. It is Ndako's business to procure some mud from the bottom of the pool . . . The sacred mud is mixed with mud from the village of Kikeu, and parings of the nails of the deceased chief are included. With this mixture the pot is made . . . The pot is used for making first-fruit offerings of beer to the god. It is also a royal talisman. It is said that if the chief displays apathy towards the cult the pot is set out in the midday sun and the chief is immediately assailed with sickness. This is similar to the Kona practice. If the chief of the Kona offended the priest who was keeper of the royal skulls, the latter retaliated by exposing the skulls to the rays of the sun . . .'

12. 'Even if these added materials are often interpreted in functional terms (increased manipulability, reduced shrinkage during drying, improvement of water elimination during drying and especially during baking, better resistance to thermal stress . . .), it must be admitted that their true role – if they have one – often escapes us. The few tests that I have carried out demonstrate that explanations of origin in terms of function or technology are not necessarily relevant.' (Private communication, O. Gosselain.)

13. For example Barbot (1732:127): 'The potters prepare their clay much after the same manner as ours do; but their clay is much better . . . or else they bake, or burn it longer in their kilns or ovens: for their pots will boil fish or flesh much quicker than ours upon an equal fire, and are not so apt to break or crack.'

14. Drost (1967:129) discusses reported use of a foot-turned wheel among the Hausa.

15. Simmonds (1984:57): 'The surprising thing about this technique is that the pot, apart from its rim, is finished in about 4 minutes. The wall thickness is about 2.5–3 mm and is amazingly consistent. It is easy for a potter to make sixty pots in a day by this method.'

16. The Ganda (Uganda) similarly use graphite but only for royal pots.

17. See de Haulleville and Coart (1907:49).

18. The distribution of various potting technologies is exhaustively documented by Drost (1967).

19. Personal communication, M. Chadli.

20. Subsequently, royal Asante *mothers* literally mould the heads of their children to make them conform to Asante notions of beauty.

21. Among the Shai of Ghana, however, men may not touch potting clay on pain of impotence. Women dig it using a special tool that sets it apart from farm work (Johnson, 1984).

22. See Barley (1983).

23. More generally, Teilhet (1978) points out that in most parts of the world women work in soft media, men in hard.

24. Indeed, Drost (1968:149) sees male potting as originating in specialisation and the development of commercial markets.

25. Among the Asante, for example, Rattray (1927:301) notes that pots may traditionally not be sold for gold or money but only exchanged for food.

26. See Roy (1987:51). For many years it was a standard orthodoxy that in North Africa urban potters are male and rural (Berber) potters female. It is now clear that this is not the case. Females may be involved in the decoration of modern urban pottery while southern Berber potters in Morocco and Algeria are clearly male (Vossen and Ebert, 1986).

Elsewhere (Upper Egypt) men and women may be responsible for different stages of the production of a single pot. The Lobi (Burkina Faso) and Nupe (Nigeria) seem unusual in that each woman is a specialist in making only a very few kinds of the whole range of vessels. Among the Yoruba of Ilorin (Nigeria) pottery is either red or black and families will never make both while more generally water-jars and kitchenware may not be made by the same people.

27. A similar difference of technique occurs among the Chokwe and Lwena where men beat out pots and women form them from spirals of clay. Men seem to have a monopoly of making human images. Drost (1967:92) discusses this distinction from the perspective of conjectural history. It is more interesting to note that this is one of the few areas where the manufacture of basketry and pots by the coil technique is limited to women. Men produce both basketry and pots but by using different methods.

It remains to be investigated how potters *speak* of potting and so associate it with other crafts. Thus, it seems, Asante potters talk of 'weaving pots', *nyon nkuku* (Rattray, 1927:302), so that pottery becomes a sort of female equivalent to (exclusively male) weaving.

28. Personal communication, Julie Hudson.

29. It is unclear how far this holds for the making of unbaked images in mud in other parts of Africa. Data on the age of women is seldom given. Because lines are drawn at different points, very similar general ideas can look very different on the ground.

30. There is a more general point that creativity and sex are often held to be inimical. For sexual prohibitions and potting see Volavka (1977:63); Drost (1964). It should also be noted that sometimes midwives must be past childbearing themselves.

Where women are the exclusive potters, men may be not only forbidden to make pots but even to see the making of pots or to visit places where they are made. Among the Kangara (Zimbabwe) firing in the presence of a man would render him sterile while the presence of a pubescent girl would split the pots (Aschwanden, 1982:219). Where men are the potters, these restrictions may well apply to women. Behind bland statements about pots being the exclusive reserve of women may lie prohibitions on potting while pregnant or menstruating that also have implications for the relationship between pots and creativity. Both sexes may be forbidden sexual intercourse while involved in potting (Drost, 1964:104).

Relations between men involved in artistic creativity may similarly be expressed in terms of gender. Adams (1980): 'The Ashanti chief addresses the carver as "my wife" and the chief is forbidden to visit the carver who is executing the commission for the chief. Silver [1976] sees this role as parallel to the role of parents in the Ashanti theory of conception: that is, the chief as "husband" endows the stool with his spirit, while the carver is contributing the physical body.'

31. Often this aspect is unclear, being ignored through stress on a European 'artistic creativity'. Thus, Thompson's (1969) lengthy study of Abatan, a female Yoruba potter merely notes that she was 'between thirty and forty' when she took up the making of figurative pottery and seeks no further. Yet it is clear from elsewhere (Beier, 1980) that being 'bloodless' is an important qualification for making such pieces.

A typical tradition is that recorded by Rattray (1927:301) among the Asante of the female Denta who became barren as the result of having modelled 'figure pots'.

Spindel (1989:72) remarks concerning the Senufo medicine pot: 'Elderly women who have passed menopause run less risk when they are exposed to supernatural danger. On the other hand, although this pot is not technically difficult, it is sold for a high price. In this way, the profits from its sale remain in the hands of the older women.'

This raises other problems as far as Lobi (Burkina Faso/Ivory Coast) women are concerned. Only post-menstrual women make pots for altars because of the danger from the blood of sacrifice to their fertility. Even these, however, avoid buying food with the money paid for such pots.

Another factor that has to be considered is that the prohibition on sexual activity while engaged in potting, enforced by many peoples (e.g. Thonga), itself tends to make potting unpopular with younger women.

32. In East Africa, craft specialisation may also have a hereditary factor e.g. the Thonga belief that one must be 'called' by an ancestor to take over a skill (Colson, 1949:15).

Making pottery does not normally exclude even specialist women from engaging in agricultural work though potting may be limited to the dry season when little can be done in the fields.

33. Similar claims are made in Ethiopia and N.E. Africa concerning hunters/ animal-killers/tanners and their wives who are exclusively charged with potting.

34. See Cline (1937).

35. Such a situation lends itself equally to casting in terms of either privilege or oppression and may reconcile totally opposed views of the potters' position.

36. See Stoessel (1984:70).

37. See Simmons (1982:65).

38. On seasons and potting, see also Barley (1983:14, 80). Elsewhere, potting must be arranged according to the status of the moon e.g. among the Baganda (Roscoe, 1911:402), it being impossible to make pots when the moon is waning. Among the Kurumba (Burkina Faso) pots are made only in the *rainy* season (Schweeger-Hefel, 1962:742).

Potters may be held to have special power over disturbances in the weather. Thus, during a recent (1992) drought in Fes, Morocco, the (Muslim) potters were required to make a sacrifice to their patron saint, Sidi Mimun El-Fehhar, to appeal for rain on behalf of the whole community. It was explained that since they were the only ones to draw benefit from what was otherwise a collective calamity, their prayers would be especially beneficial.

39. See Tuden and Plotnicov (1970). The association of potters with the dry season and their husbands with fire may lead to a more general coding of artisans as 'hot' people with

more general restrictions on economic activities, food etc.

40. Gosselain (1992:578) points out: 'The techniques used by Bafia potters for successfully completing each stage are not exclusive to pottery. Most of them are employed in the realm of food production, procurement, preparation and preservation, which are always associated with women.'

41. A pioneer study is that of Frobenius (1894). Unfortunately, it is phrased in the evolutionist terms of that time.

A provoking study of the symbolic place of ceramics in the West is to be found in Yentsch (1991), showing how material and design entered into the classification of gender and space. Substantive rules about usage vary enormously e.g. 'Among the Nuba a man never uses a pot [made by women] for washing himself, he does this with a calabash or *bukhsa* (a vessel made of gourd, to which leather strips and coiled basket work with a lid, are often added). He waters his tobacco plants similarly with a *bukhsa*, never with a pot.' (Bentley and Crowfoot, 1924:19).

42. The ancient traditions of Jenne, Sao and Tellem all practised pot-burials. See Stoessel (1983) who lumps together many West African burial traditions involving pottery through a highly dubious generalisation of the 'primal egg' myth.

43. See Chappel (1977).

44. Traditionally, women receive half-pint drinks in a curvaceous, waisted glass, men in a straight one.

45. The sender and receiver may, of course, not agree about the message which is why food in chamber pots grossly offended those 19th-century Europeans to whom it was served as a mark of respect by Africans.

46. A separate but equally intriguing problem is the loss of most distinctively African style in the crude 'Colono' ware produced by transported slaves on the early plantations of the American South. Attempts to trace 'resistance in foodways' (Ferguson, 1991) have a somewhat desperate quality and suggest that social relations on plantations remain to be convincingly analysed.

47. Different objects may have their own relations of opposition – even enmity. Thus, Ravenhill (1992:20) describes a Wan (Ivory Coast) masquerade that attacks pots.

48. It is not clear whether, among the Sirak, only men cook meat as among neighbouring peoples. Often this goes with a prohibition on such pots being even touched by women (Jest, 1956:48).

49. Similar confusion may arise from usages such as that reported from Thailand where broken pots are buried, and the treatment of large Dahomean water-jars that, when broken, are carefully stacked near the family temple (Savary, 1970).

50. For further references, see Stoessel (1984:94). Spindler (1989:72) remarks that in some contexts Senufo women prefer metal pots because they heat up more easily and so greatly reduce the onerous task of collecting firewood.

51. Continuity may be similarly marked in the material of potting. For example, among the Kapsiki (Cameroon) each boy receives at adolescence a pot thought to be imbued with ancestral forces. Should it be broken, the pieces will be taken to the smith to be ground down for reincorporation in a new pot.

52. The expression is taken from the Japanese designation for artists and craftsmen who are seen as being of major cultural importance though economically unviable. The award of such a designation qualifies the recipient for special subsidies to insulate him or her from the demands of the rest of the economy. On Japanese potters as embodying a nostalgic view of community see Moeran (1984).

53. There are a number of Benin village cults dedicated to great culture heroes and warriors who have been transformed into rivers. See Bradbury (1957).

54. E.g. among the Gurensi of Ghana. 'A woman's eating bowl (*laar*), which is seen as a symbol of her persona, is broken at her funeral to signify that she has departed from the family.' (F. Smith, 1989). Or among the Ganda of Uganda. 'When a chief was condemned to be put to death at one of the sacrificial places, he was permitted to see his wife. She would come to him carrying her water-pot, and he would give her his final message, and take leave of her; thereupon she would dash her water-pot to the ground, and break it in front of him, in token that it would not be wanted in the future, and that he would no longer require her services.' (Roscoe, 1911:334).

55. This may be a fundamental line between the use of pots and gourds. See M. Berns (1985:42). 'It should be noted, however, that gourds are rarely used as containers for localizing or concentrating spirit forces of beings, which in this general region [N.E. Nigeria] is primarily reserved for ceramic vessels.'

56. Among the Senufo (Ivory Coast) and the Mumuye (Nigeria) vessels are made with heads echoing the form of the wooden masks worn by men.

57. Pots, of course, can enter into other relationships than merely containing. It is most improper to leap from the presence of vessels to the notion 'vessels of spirit'. Thus, it is clear among the Lobi that the many and various altar pots in no sense 'contain' souls or spirits (Schneider, 1986). Rather they seem to be places where spirits come to drink and so the model is rather that of offering sustenance, an extension of the social role of pots to a transaction with spiritual beings that still works by pots classifying people, occasions and relationships as with ordinary mortals.

58. This is a common idiom for smelting. Among the Mafa (N. Cameroon), for example, the furnace is the 'wife' of the smelter (Sterner and David, 1991:359).

59. The precise opposite is the case among the Northern Sudanese villagers studied by Boddy (1982) who have a culture strongly concerned with 'closure' of social space and the body. A distinction is made between porous water-vessels that sweat and the totally sealed *gulla* in which the batter of unleavened bread is soaked. A miscarried foetus is buried in a *gulla* vessel inside the house i.e. metaphorically still in the womb, a stillborn baby is wrapped and buried near the outer wall of the house i.e. metaphorically outside the body but not in the outside world. It is significant that these villagers prefer to marry close kin and practise Pharonic circumcision that 'seals' the female body. Pots enter into a more general social concern about dangerous leakage.

60. This is similar to a Hausa idiom whereby an initiated member of the Bori cult 'is then said to be "baked", whereas he was only unbaked before, like the unfinished clay pot.' (Tremearne, 1913:150)

61. Such pots contain an inner or upper compartment that is pierced with numerous holes.

62. This is the pot in which a baby is washed immediately after birth.

63. According to another rule (Aschwanden, 1982:220) a man should never be the first to eat from such a freshly fired jar. Like menstrual blood it could be dangerous and 'overheat' him.

64. During childbirth this is the pot that contains the vegetable slime with which the birth canal is lubricated.

65. Evers and Huffman (1988:739) remark:
'Other Shona potters decorate the shoulders of some pots with applique breasts and a pair of depressions representing eyes (Goodall, 1946). These eyes, breasts, belt and tattoo decorations are placed below the neck because Shona . . . see the neck of the pot as the neck of the cervix, and therefore the pot is upside down relative to the human body . . . Among many Shona groups there are zoomorphic pots (lions, zebras, guinea fowl, and so on) that are associated with male ancestor spirits and placed on graves or used for libations (Goodall, 1946; Hall and Neal 1904; Van der Merwe, 1957). These 'male' pots incidentally are right side up.'

66. It would not, one imagines, be difficult to find examples where the organising power of the anthropomorphic metaphor does not obviously determine other patterns of thought and action and is a purely linguistic matter. Thus, there is a common process by which new objects such as motor vehicles have been incorporated into African languages by anthropomorphising them, so that, tyres become 'feet', headlamps 'eyes', grille 'mouth' etc.

At the moment we do not even know how potters speak of their own skills. Recent research e.g. McKinnon (1989) has shown that male and female activities may be labelled in wholly different ways. Thus Tanimbar (Indonesia) men speak of 'killing' the ivory and metal of male goods while women's shellwork and weaving are phrased in terms of cool and creative activities.

67. Quoted in Leone (1975).

68. This summary necessarily does great violence to Richards's delicate and subtle ethnography of the precise existential nature of the ritual. It should be noted that Richards's ethnography refers to ceremonies observed in 1931 that have been much eroded by recent social change.

69. The association of visual and verbal forms seems not to be quite as fixed as in the case of Asante brasscastings or Woyo potlids (see below) which work through proverbs. It is perhaps closer to the woodcarving motifs of the Torajan people of Indonesia, which can evoke the most diverse ad hoc moral reflections (Barley, 1992).

70. E.g. in Krige and Krige (1951) fires must be extinguished on certain occasions and rekindled with royal fire.

71. This account is taken from de Heusch (1980), Junod (1910 and 1912) though in places my presentation differs.

72. Cf. the Yoruba proverb said of a woman who has miscarried, 'It is the water that spills, may the pot not break'.

73. Colson (1949) describes an alternative method using a hollowed-out termite mound.

74. Among the Karanga of Zimbabwe (Aschwanden 1982:285) a premature baby is buried in the pot in which beer is brewed. 'The process of brewing beer always starts with the gambe-jar. Since it has no neck it is an 'unfinished' jar and, thus, a sign of something that still has to grow. And this applies to the beer that is maturing in it as well as to the premature baby that, in its belly, must go on growing . . . They mean that between jar and uterus there exists symbol-identity. Now a uterus that has not yet given birth, cannot become pregnant again. Thus, it must somehow go through the whole process. A premature or an aborted baby is always buried in a gambe-jar, in the sand of a dry river-bed. The first rains swell the river, the sand is washed off the jar and the baby out of it. The 'birth' prepares the uterus for the next child.'

The maize pot in which a surviving baby has been washed for the first time is taken in charge by the midwife who thereafter has control of the sexuality of husband and wife as premature resumption of copulation could threaten the child. The pot is carefully stored in a cool place where no sexual activity is permitted.

75. The focus of aesthetic concern is often shifted on to the consumer rather than the producer as in Sieber (1980:167): 'I have watched a woman in the market at Ife select with care one particular pottery cooking pot from among a dozen or twenty nearly identical examples. I have been told by a Lobi woman in northern Ghana that she prefers a pyro-engraved decorated calabash cup to a plain one because the event of drinking is bettered if the vessel is decorated. The plain cup is useful, certainly not to be disdained, but clearly the decorated one enriches the experience.'

Talbot (1912:287) expresses wonder at the beauty of Ekoi (Nigerian) pottery, the infinite pains taken with everyday ware and the hideousness of the European goods that are replacing it. In another displacement of aesthetic focus, however, his greatest admiration is for the aesthetic effects on the Ekoi physique of carrying heavy water-jars on the head.

Chappel (1977:144-172) usefully shows how enormously complex are apparently simple notions such as 'aesthetic preference' in an environment of unfamiliar goods.

76. There can be no doubt that certain peoples have a highly developed sensitivity to ornament. Thus, it is recorded (Vansina, 1978:221) that in the 1930s a Belgian missionary sought to impress the Kuba monarch (Zaire) by showing him a motorcycle. The Kuba were apparently totally unmoved by the machine but greatly admired the tyre patterns in the sand, had them copied and gave them a name.

77. F. Smith (1979) warns, however, that the verbal expression of aesthetic judgements will itself be controlled by cultural norms: 'Despite the concept of bambolse [decorated], the Gurense [Ghana] do not make aesthetic judgements, at least publicly. In other words, they do not have a definite voiced aesthetic for the visual arts. To criticize or engage in formal analysis is considered a form of anti-social or disruptive behavior.'

Thompson (1975) also warns that aesthetic criteria among the Yoruba may be viewed as secrets of the trade and so deliberately concealed from outsiders. We must also bear in mind that it is not only in the West that artists have often the least interesting and well-formed opinions about their own productions.

78. See Price (1989:56-67) for the standard view on the unnamed tribesman/named artist debate. The ultimate mark of the emergence of the 'artist' is the signing of works. The effects of this on a specialist potting community have been documented in Japan by Moeran (1984). In Africa, signing now occurs primarily in North Africa – though urban North African potters, aware of the souvenir value of their wares in the tourist trade, often write the place of origin rather than the name of the potter. Signing presupposes both literacy and the importance accredited by the West to the name. It is not surprising then that the use of potters' marks is preferred elsewhere e.g. in 15th-century Kenya (Barbour, 1989:104) but the precise implications of this marking system remain to be explored. Dogon potters sometimes make marks on their pots to avoid disputes when they are fired communally (Bedaux, 1988).

On signing in another rural tradition see Babcock (1987:394) quoted in Price (1989): 'While supervising Pueblo pottery revivals, Kenneth Chapman of the Museum of New Mexico insisted that Maria Martinez authenticate and increase the value of her pottery by signing it – something that Pueblo potters had never done. When the other potters in the village realized that pots with Maria's signature commanded higher prices, they asked her to sign their pots as well and

she freely did so . . .'

79. It does not follow from this, as Wobst (1977) has suggested, that the most 'public' pots will be the most decorated. Indeed, as Sterner (1989) has pointed out, the very opposite may be true. Ethnoarchaeological attempts to relate 'microtraditions' of pottery decoration to patterns of social organisation and contexts of learning run up against the problem that different degrees of variation may be tolerated or required in different cultures or even when producing different vessels within a single culture.

80. The similarity between pots and humans is further strengthened by attaching articles of human dress and ornament e.g. necklaces to pots. Among the Fali (Cameroon), pots are classed as male or female depending on which set of jewellery – male or female – is echoed in the marks incised in the pot (Lebeuf, 1961). Among the Zulu of South Africa, the process by which humans come to be depicted as containers of powers seems to make great play of *inkatha*, rings on which kings and pots sit – shielding both from contact with the earth – and incorporating powerful products of ablution and vomit with which they are saturated.

81. E.g. Fraser (1972).

82. A striking exception is the excellent study by Berns and Hudson (1986:Chap.4) of the Ga'anda of N.E. Nigeria. See also Berns (1990).

83. As early as Torday and Joyce (1910:216), however, it became clear that even eliciting the names of motifs was no simple matter: 'For the natives themselves, the correct terminology for several designs – even very common ones that are perfectly familiar to them – is quite difficult. When we drew up the list of designs there were numerous disputes between our informants and we were often frequently obliged to resort to art experts to adjudicate . . . The reason for these various difficulties derives from the fact that a Bushongho does not look at a design in the same way as a European; he does not consider the design as a whole but decomposes it into different elementary designs, takes one of these as characterising the figure as a whole and gives the complete design the name of this part . . . From this follows the rather curious fact that, thanks to the analytical spirit of the natives, the same name can be given to two designs which are apparently quite unlike in general effect and that two natives of different sex will give the same design two different names . . .'

More recently, in a comment on N.E.

Nigerian gourd designs, Chappel (1977:54) has noted, 'Local observers, it seems, do not expect to find a clear-cut subject-content in gourd designs; therefore they do not generally look for one. An overt interest in the subject of designs and pattern elements was only apparent when I myself tried to elicit meanings from observers. Even then the level of interest which a request for meaning aroused tended to vary from individual to individual and from area to area.'

84. One of the best-documented examples of this, that of the Surinam Maroons, is summarised in Price (1989). Critical pressure from the West has established a spurious dictionary of meaningful carving motifs that carvers are nowadays obliged to conform to as the proof of the authenticity of the (inauthentic) works they produce. Failure to comply with Western presuppositions makes work unsaleable.

85. See E. Micaud (1970). Thus, the Middle Atlas Zemmour weavers give motifs names such as 'sabre', 'dagger', 'fibulan' – i.e. terms that are sharp and offensive. Pariente (1953) notes, however, that the same motifs occur in different areas with totally different names e.g. among the weavers of the Mzab the same motifs are given cosily domestic names such as 'birds and young', 'pomegranate seeds' etc.
On the use of similar protective motifs across media see Prussin (1976).

86. A strangely neglected area is the ways in which such designs are learned. Torday and Joyce (1910:204) for example, allude to children's games among the Bushongo where designs must be drawn continuously in the sand without raising the hand.

87. Chappel (1977:126) comments that the animist Yungur of N. Nigeria do not permit representational images on everyday objects. This is only permitted for ritual purposes.

88. I have argued above that this may well be a Western way of perceiving motifs. It must be left to others to investigate whether the marks indeed 'represent' the scars or are simply another placing of the same scars. It is equally open to question in what sense the scars are 'symbols of . . . fertility'. Perhaps more to the point is that even nowadays two such pots are still sometimes cemented together to provide a coffin for the dead and aid his reincarnation (Stoessel, 1986).

89. See also Gill (1981).
A similar situation is described by Tobert (1982) among the Zaghawa and Berti potters of Sudan. They can distinguish their pots by slight differences in handle shape and placing or the number of impressed finger marks

around the neck or (Zaghawa) by deliberate incised marks. If each woman sells them individually from her compound there is no need to make them different. If they are sold in the market variation is required.

90. See McGregor (1909) and Dayrell (1911).

91. Berns and Hudson's analysis of decoration in N.E. Nigeria (1986:132) suggests more generally that, for technical reasons, pressure-engraved gourds are most likely to share patterns with incised pots and those body scar designs executed with broad sweeps of the knife while hot-engraved gourds will have them in common with painted pots and body scarification based on careful accumulations of keloids.

92. Thus Bohannon (1988:78) remarks concerning the Tiv (Nigeria), 'The first notion of physical beauty, then, is that the body must "glow" or *wanger*. It is also the point of much ritual. The word means to be beautiful, to be clear and to be in a satisfactory ritual state.'

93. Rubin (1988) repeatedly documents the proposition that African concern with body scarification goes along with a notion of the natural person as requiring to be culturally completed. That both scars and use of pots communicate information about relative status follows on from this.

94. Mertens and Schoeman (1975).

95. Thus, among contemporary British, physical functions are mapped one-to-one upon the rooms of the house and a firm line is drawn between public and private parts. Only one sexually active couple is permitted per household and finalisation of marriage involves threshold-crossing ceremonies.
It is quite striking that those peoples (Bamana, Dogon, Bozo) of West Africa that possess well-documented systems of visual symbols (Griaule and Dieterlen, 1951; Dieterlen and Cissé, 1972) do not seem to apply them to pottery though they do turn up on gourds, textiles, houses and people, so that pottery is – in that sense – apart.

96. See for example the Azande of the Zaire/Sudan/Central African Empire region (Mack, 1990:217–231) where political power was expressed not by possessing objects of craftsmanship but principally by giving away utilitarian goods. Moreover, the very forced notion of sending messages to oneself suggests that the whole approach based upon meaning and messages is fatally flawed.
A revealing collection of the wild and contradictory sociological and psychological inferences made from stylistic analysis of

material culture may be found in Hatcher (1974).

97. For a full discussion of reports concerning the sex of potters from this area see Stoessel (1985:129).

98. Decoration on Zande vessels has been discussed more generally by Braithwaite (1982) who has suggested that decoration occurs to mark 'breaches of the conceptual order'. However, the only evidence offered for such breaches is the existence of decoration itself and the facts as stated seem to resolve into a much simpler distinction between public (decorated) and private (undecorated). It is quite staggering that an article that claims to examine the relationships between the genders does not even mention the fact of institutionalised bisexuality in the ruling clan and homosexuality in the warrior elite. See Evans-Pritchard (1970).

99. On the other hand, it must be noted that the high Mangbetu hairstyle so casually interpreted by Westerners as representing an ideal of physical beauty or marking the status of chiefly wives may well have had a pragmatic anti-witchcraft value. Such was certainly the case with head-binding among the Azande. Its use by Bedu and other potters may have sprung rather from the need to create a distinctive and marketable form rather than indigenous notions of beauty.

100. At a lower level, change of decorative motifs can also reflect local political process.

Chappel (1977:74) records a case involving decorated gourds in Nigeria: 'Several years ago, it seems, the settled Fulani women of Mayo Belwa and Mayo Faran became involved in a dispute as to which of them were the better carvers. To show how expert they were, the women of Mayo Faran introduced a motif into their designs which was supposed to represent the rather prominent ears of the District Head of Mayo Belwa. In reply, the women of Mayo Belwa introduced a motif representing the fat cheeks of the District Head of Nassarawo-Jereng who was, apparently, an extremely corpulent gentleman.'

101. See Volavka (1977).

102. Specifically, a collection made among Woyo of Cabinda, across the border from Muba.

103. Gerbrands states that a woman might inherit potlids from mother or grandmother, or even be advised by a local expert on commissioning a new one relevant to her complaint. If its message was sufficiently oblique, the husband might well be obliged to consult the same expert on its interpretation. It seems that on occasion a man might attempt to communicate with his wife by commissioning a lid and sending it to her.

104. De Haulleville and Coart (1907:108) note the existence of ceramic lids from the same area.

105. Voklava (1977:note 8) remarks that many such pieces were specifically made for the African export trade and recovered by researchers from Kongo graveyards.

106. We should note that 'airport' art developed very early in the Lower Congo in the form of the Afro-Portuguese ivory souvenirs produced there for European visitors of the 15th century.

107. A similar case arises in the Kongo 'nail fetishes', the carved human and animal figures in which nails and other sharp objects are embedded to control spiritual forces. Another – functionally identical – form of these objects exists, terracotta bowls containing mud in which nails are embedded. Needless to say, the former are among the most valued objects in Western museums and galleries. The second are largely unknown. (McGaffey, 1990).

108. Gathercole (1988) treats the forms and techniques of Maori (New Zealand) facial tattooing as heavily involved with woodcarving and textiles. In the same volume Roberts discusses the Hemba (Zaire) where body designs are similarly applied by woodcarvers.

109. A similar usage in East Africa often divides cattle-rearing and agricultural pursuits through the vessels involved. Milk should not come into contact with pottery, only gourds or wooden vessels (Stoessel, 1982:137).

Bibliography

Adams, K., 1975 'Style in Southeast Asian Materials Processing: Some Implications for Ritual and Art' in H. Lechtmann and R. Merrill eds, *Material Culture, Styles, Organization, and Dynamics of Technology*, Proc. American Ethnological Society.

Adams, M., 1980 'Spheres of Men's and Women's Creativity' in *Ethnologische Zeitschrift Zürich* 1:163-7.

Andrews, E. and Andrews, F., 1950 *Shaker Furniture: the Craftsmanship of an American Communal Sect*, New York: Dover.

Aschwanden, H., 1982 *Symbols of Life*, Zimbabwe: Mambo.

Babcock, B., 1987 'Taking Liberties, Writing from the Margins, and Doing It with a Difference' in *Journal of American Folklore* 100:390-411.

Balfet, H., 1984 'Methods of Formation and the Shape of Pottery' in S. van der Leeuw and A. Pritchard eds, *The Many Dimensions of Pottery*, Amsterdam: University of Amsterdam.

Barbot, J., 1732 *A Description of the Coasts of North and South Guinea; and of Ethiopia Inferior, vulgarly Angola* in A. Churchill, *A Collection of Voyages and Travels, some now first printed from original manuscripts, others first published in English*, London.

Barbour, J. and Wandibba, S., 1989 *Kenyan Pots and Potters*, Nairobi: Oxford University Press.

Barley, N., 1983 *Symbolic Structures of the Dowayos*, Cambridge: Cambridge University Press.

Barley, N., 1984 'Placing the West African Potter' in J. Picton ed., *Earthenware in Asia and Africa*, Percival David Foundation Colloquies on Art and Archaeology in Asia No.12, London: SOAS.

Barley, N., and Sandaruppa, S., 1992 *The Torajan Ricebarn*, British Museum Occasional paper 72, London: British Museum.

Barnes, R., 1974 *Kedang: A Study of the Collective Thought of an Eastern Indonesian People*, Oxford: Clarendon Press.

Basden, W., 1938 *Niger Ibos*, London: Seeley, Service and Co.

Bassing, A., 1977 'Grave Monuments of the Dakakari' in *African Arts* 6, pt.4:36-8.

Bedaux, R., 1988 'Comments on David, Sterner and Gavua' in *Current Anthropology* 29, 3:379-80.

Beier, G., 1980 'Yoruba Pottery' in *African Arts* 12, pt.3:48-53.

Ben-Amos, P., 1973 'Symbolism in Olokun Mud Art' in *African Arts* 6, pt.4:28-31.

Ben-Amos, P., 1980 *The Art of Benin*, London: Thames and Hudson.

Bentley, O. and Crowfoot, J., 1924 'Nuba Pots in the Gordon College' in *Sudan Notes and Records* 7, 2:18-21.

Berns, M., 1985 'Decorated Gourds of Northeastern Nigeria' in *African Arts* 19, pt.3:28-45.

Berns, M., 1990 'Pots as People: Yungur Ancestral Portraits' in *African Arts* 23, pt.3:50-60.

Berns, M. and Hudson, A., 1986 *The Essential Gourd: Art and History in Northeastern Nigeria*, Los Angeles: Museum of Cultural History.

Boas, F., 1955 *Primitive Art*, New York: Dover.

Boddy, J., 1982 'Womb as Oasis' in *American Ethnologist* 9, 4:682-98.

Bohannon, P., 1988 'Beauty and Scarification amongst the Tiv' in A. Rubin ed., *Marks of Civilization*, Los Angeles: Museum of Cultural History.

Bradbury, R., 1957 *The Benin Kingdom and the Edo-Speaking Peoples of South-Western Nigeria*, London: International African Institute.

Braithwaite, M., 1982 'Decoration as Ritual Symbol: a Theoretical Proposal and an Ethnographic Study in Southern Sudan' in I. Hodder ed., *Symbolic and Structural Archaeology*, Cambridge: Cambridge University Press.

Bynon, J., 1982 'Berber Women's Pottery. Is the Decoration Motivated?' in *Earthenware in Asia and Africa*, Percival David Foundation Colloquies on Art and Archaeology in Asia No. 12, London: SOAS.

Camps, G., 1987 *Les Berbères*, Paris: Errance.

Cardew, M., 1956 *Pioneer Pottery*, London: Longmans.

Chadli, M., 1992 'Ceramics: Contemporary and Domestic Pottery in Fas' in J. Hedgecoe and S. Damluji, eds, *Zillij: The Art of Moroccan Ceramics*, Reading: Garnet.

Chappel, T., 1977 *Decorated Gourds in North-eastern Nigeria*, London: Ethnographica.

Cline, W., 1937 'Mining and Metallurgy in Negro Africa' *American Anthropologist* 5.

Colson, E., 1949 *Life among the cattle-owning Plateau Thonga of a Northern Rhodesia Native Tribe*, Occ. Pap. Rhodes-Livingstone Museum 6, Livingstone.

Corbeil, R., 1942 'Quelques détails sur la fabrication des poteries indigènes à Siguiri' in *Notes Africaines* 32:29–30.

Corbeil, J., 1982 *Mbusa: Sacred Emblems of the Bemba*, Mbala, Zambia: Ethnographica.

Cory, H., 1956 *African figurines*, London: Faber and Faber.

Crowfoot, J., 1925 'Further Notes on Pottery' in *Sudan Notes and Records* 8:125–36.

David, N., Sterner, J. and Gavua, K., 1988 'Why Pots are Decorated' in *Current Anthropology* 29, 3:365–79.

Davison, P., 1985 'Southern African Beer Pots' in *African Arts* 18, pt.3:74–7.

Dayrell, E., 1911 'Further Notes on Nsibidi Signs with their Meanings from the Ikom District, Southern Nigeria' in *JRAI* 41:521–40.

de Cardi, C., 1899 'A Short Description of the Natives of the Niger Coast Protectorate' in Mary Kingsley ed., *West African Studies*, London: Macmillan.

de Haulleville, A. and Coart, M., 1907 'La Céramique' in *Notes Analytiques sur les Collections Ethnographiques* vol.2, fasc.1.

de Heusch, L., 1980 'Heat, Physiology and Cosmogeny: *Rites de Passage* among the Thonga' in I. Karp and C. Bird eds, *Explorations in African Systems of Thought*, Bloomington: Indiana University Press.

Dieterlin, G., 1987 *Essai sur la religion Bambara*, Brussels: Université de Bruxelles.

Dieterlin, G., and Cissé, Y., 1972 *Les fondements de la société d'initiation du Komo*, Cahiers de l'Homme x: Paris, The Hague.

Drewal, H., 1987 'Composing Time and Space in Yoruba Art' in *Word and Image* 3,3:225–51.

Drost, D., 1964 'Besondere Verhaltensweisen in Verbindung mit dem Töpfereihandwerk in Afrika' in E. Haberland, M. Schuster and H. Straube eds, *Festschrift für A. E. Jensen*, Munich: Klaus Renner Verlag.

Drost, D., 1967 'Töpferei in Afrika: Technologie' in *Veröffentlichungen des Museums für Völkerkunde zu Leipzig* xv.

Drost, D., 1968 'Töpferei in Afrika. Ökonomie und Soziologie' in *Jahrbuch des Museums für Völkerkunde zu Leipzig* XXIV:131–270.

Earthy, E., 1933 *Valenge Women*, London.

Erekosima, T. and Eicher, J., 1981 'Kalabari Cut-thread and Pulled-thread Cloth' in *African Arts* 14, pt.2:48–51.

Evans-Pritchard, E., 1970 'Sexual Inversion among the Azande' in *American Anthropologist* 72, 6:1428–34.

Evers, T. and Huffman, T., 1988 'On Why Pots Are Decorated the Way They Are' in *Current Anthropology* 29, 5:739–41.

Fagg, W., 1969 'The African Artist' in D. Biebuyck ed., *Tradition and Creativity in Tribal Art*, Berkeley and Los Angeles: University of California Press.

Fardon, R., 1990 *Between God, the Dead and the Wild*, Washington DC: Smithsonian Institution Press.

Faris, J., 1972 *Nuba Personal Art*, London: Duckworth.

Faris, J., 1982 'Significance of Differences in the Male and Female Personal Art of the Southeast Nuba' in A. Rubin ed., *Marks of Civilization*, Los Angeles: Museum of Cultural History.

Ferguson, L., 1991 'Struggling with Pots in Colonial South Carolina' in R. McGuire and R. Paynter eds, *The Archaeology of Inequality*, Oxford, UK: Cambridge, USA: Blackwell.

Fernandez, J., 1991 *Beyond Metaphor*,

Stanford: Stanford University Press.

Fonck, H., 1900 'Über Waffen, Geräte, Trachten' etc. in Urundi und Ruanda, *Mitterlungen aus den Deutschen Schutegebieten*, 13:128–31.

Fox, J., 1980 *The Flow of Life: Essays on Eastern Indonesia*, Cambridge, Mass.: Harvard University Press.

Fraser, D., 1972 'The Fish-Legged Figure in Benin and Yoruba Art' in D. Fraser and H. Cole eds, *African Art and Leadership*, Madison: University of Wisconsin Press.

Frobenius, L., 1894 'Die Keramik und ihre Stellung zur Holzschnitzerei im südlichen Kongobecken' in *Internationales Archiv für Ethnographie* 7:10–32.

Gabus, J., 1958 *Au Sahara. Arts et Symboles*, Mémoires de l'université de Neufchatel Ser. 2.

Gallois Duquette, D., 1983 *Dynamique de l'art Bidjogo*, Lisbon: Instituto de Investigaçao Cientifica Tropical.

Gathercole, P., 1988 'Contexts of Maori Moko' in A. Rubin, ed., *Marks of Civilization*, Los Angeles: Museum of Cultural History.

Gerbrandts, A., 1957 *Art as an Element of Culture, especially in Negro Africa*, Leiden: E. J. Brill.

Gill, M., 1981 'The Potter's Mark: Contemporary and Archaeological Pottery of the Kenyan Southeast Highlands', PhD thesis, University of Boston.

Gittinger, M., ed., 1989 *To Speak With Cloth: Studies in Indonesian Textiles*, Los Angeles: Museum of Cultural History.

Goodall, E., 1946 'Rhodesian Pots with Moulded Decorations' *NADA* 23:36–49.

Gosselain, O., 1992 'Technology and Style: Potters and Pottery among Bafia of Cameroon' in *Man* 27, 3:559–86.

Griaule, M., 1948 *Dieu d'eau: Entretiens avec Ogotemmeli*, Paris: Éditions du Chene.

Griaule, M. and Dieterlen, G., 1951 *Signes Graphiques Soudanais*, Cahiers de l'Homme, 3, Paris: Hermann.

Hall, R. and Neal, W., 1904 *The Ancient Ruins of Rhodesia*, London: Methuen.

Hallpike, C., 1972 *The Konso of Ethiopia*, Oxford: Clarendon Press.

Hare, J., 1983 *Itinate and Kwandalowa: Ritual Pottery of the Cham, Mwana and Longuda Peoples of Nigeria*, London: Ethnographica.

Hatcher, E., 1974 *Visual Metaphors: A Formal Analysis of Navajo Art*, American Ethnological Society No.58, St Paul/New York/Boston/Los Angeles/San Francisco: West.

Herskovits, M., 1938 *Dahomey: An Ancient West African Kingdom*, New York: J.-J. Augustin.

Hodder, I., 1991 'The Decoration of Containers: An Ethnographic and Historical Study' in W. Longacre ed., *Ceramic Ethnoarchaeology*, Tucson: University of Arizona Press.

Jedrej, M., 1989 'A Note on Ash Symbolism in Africa' in *Zeitschrift für Ethnologie* 114, 89:11-23.

Jeffreys, M., 1939 'Sacred Twin Vessels' in *Man* xxxix:137-8.

Jeffreys, M., 1947 'Ogoni Pottery' in *Man* 47, No.84:81.

Jensen, A., 1936 *Im Lande der Gada*, Stuttgart: Strecher und Schroeder.

Jest, A., 1956 'Notes sur les poteries Kapsiki' in *Notes Africaines* 70:47-52.

Johnson, M., 1984 'Two Pottery Traditions in Southern Ghana' in J. Picton ed., *Earthenware in Asia and Africa*, Percival David Foundation Colloquies on Art and Archaeology in Asia No.12, London: SOAS.

Junod, H., 1910 'Les Conceptions Physiologiques des Bantous Sud-africains et leurs Tabous' in *Revue d'Ethnographie et de Sociologie*, 1,126-69.

Junod, H., 1912 *The Life of a South-African Tribe*, Neuchatel: Attinger.

Kandert, J., 1974 *Folk Pottery of Nigeria*, Annals of the Naprstek Museum, Prague.

Krige, E. and Krige, J., 1951 *The Realm of the Rain Queen*, Oxford: Oxford University Press.

Labouret, H., 1931 'Les Tribus du rameau Lobi' in *Travaux et Mémoires de l'Institut d'Ethnologie* 15, Paris.

Lakoff, G., 1987 *Women, Fire and Dangerous Things: What Categories Reveal About the Mind*, Chicago: University of Chicago Press.

Lakoff, G. and Johnson, M., 1980 *Metaphors We Live By*, Chicago: University of Chicago Press.

Laman, K., 1953 *The Kongo*, Studia Ethnographica Upsaliensia IV, Stockholm.

Lebeuf, J.-P., 1961 *L'Habitation des Fali*, CNRS, Hachette.

Leith-Ross, S., 1970 *Nigerian Pottery*, Switzerland: Ibadan University Press.

Leone, M., 1975 'The Role of Primitive Technology in Nineteenth-Century American Utopias' in H. Lechtman and R. Merrill eds, *Material Culture: Styles, Organization, and Dynamics of Technology*, Proc. American Ethnological Society, St Paul/New York/Boston/Los Angeles/San Francisco: West.

Levinsohn, R., 1983 'Amacunu Beverage Containers' in *African Arts* 16, pt.3:53-5.

Levi-Strauss, C., 1969 *The Raw and the Cooked*, New York: Harper and Row.

Lindblom, G., 1920 *The Akamba in British East Africa*, Uppsala.

MacGaffey, W., 1990 Review *Objets Interdits*, Fondation Dapper catalogue, *African Arts* 23, pt.4:30-6.

MacGregor, J., 1909 'Some Notes on Nsibidi' in *JRAI* 39:209-19.

McIntosh, S., 1986 'Recent Archaeological Research and Dates from West Africa' in *Journal of African History* 27, pt.3:413-42.

Mack, J., 1990 'Art, Culture and Tribute among the Azande' in E. Schildkrout and C. Keim eds, *African Reflections*, Seattle and London: University of Washington Press.

McKinnon, S., 1989 'Flags and Half-Moons: Tanimbarese Textiles in an "Engendered" System of Valuables' in M. Gittinger ed., *To Speak with Cloth: Studies in Indonesian Textiles*, Los Angeles: Museum of Cultural History.

McLeod, M., 1982 'Akan Terracottas' in J. Picton ed., *Earthenware in Asia and Africa*, Percival David Foundation Colloquies on Art and Archaeology in Asia No.12, London: SOAS.

MacLeod, O., 1912 *Chiefs and Cities of Central Africa*, Edinburgh and London: Blackwood.

McNaughton, P., 1988 *The Mande Blacksmiths: Knowledge, Power and Art in West Africa*, Bloomington and Indianapolis: Indiana University Press.

Meek, C., 1931a *A Sudanese Kingdom*, London: Kegan Paul, Trench, Trubner.

Meek, C., 1931b *Tribal Studies in N. Nigeria*, London: Kegan Paul, Trench, Trubner.

Mertens, A. and Schoeman, H., 1975 *The Zulu*, Cape Town: Purnell.

Meyer, P., 1981 *Kunst und Religion der Lobi*, Zurich: Museum Rietberg.

Micaud, E., 1970 'The Craft Tradition in North Africa' in *African Arts* 3, pt.2:38-43

Moeran, B., 1984 *Lost Innocence: Folk Craft potters of Onta, Japan*, Berkeley/Los Angeles, London: University of California Press.

Mueller, A., 1917 'Zur materiellen Kultur der Kaffern' in *Anthropos* 12-13:852-8.

Nadel, S., 1942 *A Black Byzantium*, London: Oxford University Press.

Nadel, S., 1947 *The Nuba*, London: Oxford University Press.

Nicolls, A., 1987 'Igbo Pottery Traditions in the Light of Historical Antecedents and Present day Realities' PhD thesis, Indiana University.

Omosade Awolalu, J., 1979 *Yoruba Beliefs and Sacrificial Rites*, Longman.

Onians, J., 1991 'Idea and Product: Potter and Philosopher in Classical Athens' in *Journal of Design History* 4, pt.2:65-73.

Pariente, R., 1953 'Les Tissages Mozabites' in *Cahiers des Arts et Techniques de l'Afrique du Nord*, No.3:52-67.

Pearlstone, Z., 1973 'Sujang: A Stirrup Spout Vessel from Nigeria' in *American Antiquity* 38 (4):482-6.